seduction

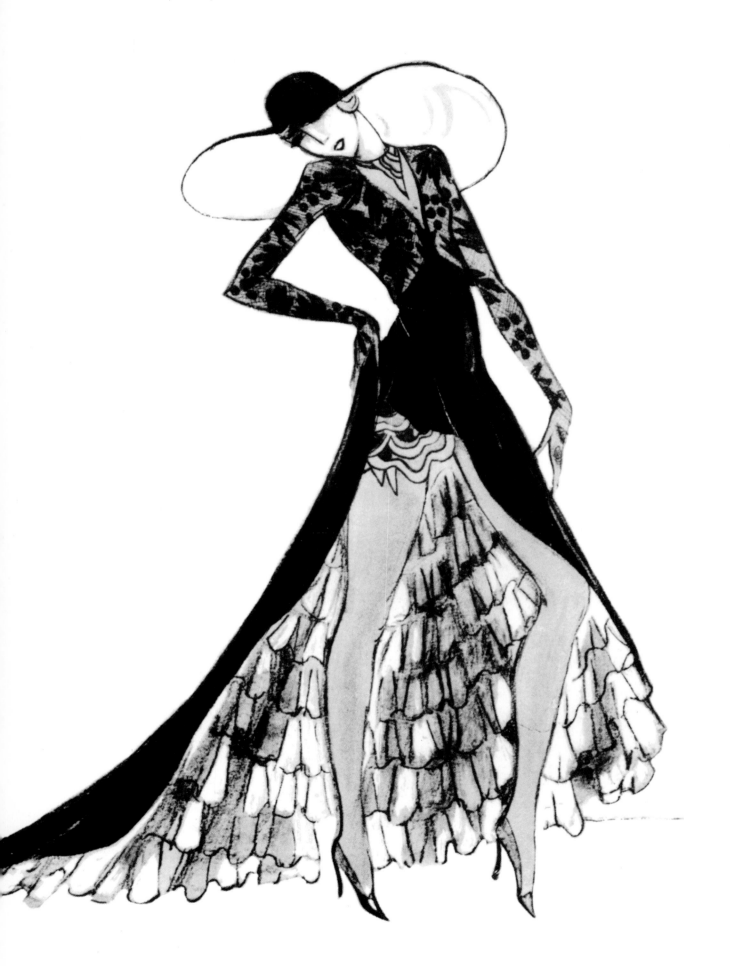

CAROLINE COX

seduction

a Celebration of Sensual Style

COLLINS | DESIGN

An Imprint of HarperCollinsPublishers

SEDUCTION
Copyright © 2006 Octopus Publishing Group Ltd
Text copyright © Caroline Cox 2006

HarperCollins books may be purchased for educational,
business, or sales promotional use. For information, please
write: Special Markets Department, HarperCollins Publishers
Inc., 10 East 53rd Street, New York, NY 10022.

First Edition

First published in the United States in 2006 by
Collins Design
An Imprint of HarperCollins*Publishers*
10 East 53rd Street
New York, NY 10022
Tel: (212) 207-7000
Fax: (212) 207-7654
collinsdesign@harpercollins.com
www.harpercollins.com

First Published in the United Kingdom in 2006 by
Mitchell Beazley
an imprint of Octopus Publishing Group Ltd,
2–4 Heron Quays
London E14 4JP

Distributed throughout the United States and Canada by
HarperCollins*Publishers*
10 East 53rd Street
New York, NY 10022
Fax: (212) 207-7654

Library of Congress Control Number 2006920766

ISBN-10: 0-06-113815-0
ISBN-13: 978-0-06-113815-7

Commissioning Editor: Hannah Barnes-Murphy
Executive Art Editor: Penny Stock
Project Art Editor: Sarah Rock
Project Editor: Catherine Emslie
Picture Research Manager: Giulia Hetherington
Production Controller: Jane Rogers
Editor: Alison Bolus

Front cover: A woman seductively rolls on (or off...) her
stockings. (Elena Segatini Bloom/CORBIS)
Back cover: Jean Harlow reclines luxuriously in a white satin
peignoir trimmed with marabou. (Bettmann/CORBIS)

Colour reproduction by Bright Arts, HK.
Printed and bound in Hong Kong in 2006 by
Toppan Printing Company Limited

previous page *In the 1930s, Hollywood films created new notions of glamour and seduction which influenced fashion designers and illustrators and, in turn, mainstream fashion.*

opposite *A frothy fifties seductress arranging her assignations by telephone in the boudoir. A woman was encouraged to maintain a glamorous appearance at all times.*

contents

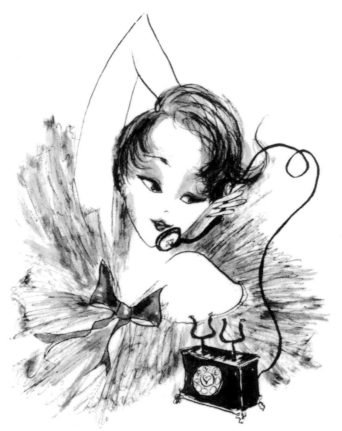

below *In* The Graduate *of 1967, directed by Mike Nichols, a seminal seductress was born – the sophisticated, dangerous older woman, Mrs Robinson, played by Anne Bancroft, who seduces the virginal college boy Benjamin as played by Dustin Hoffman.*

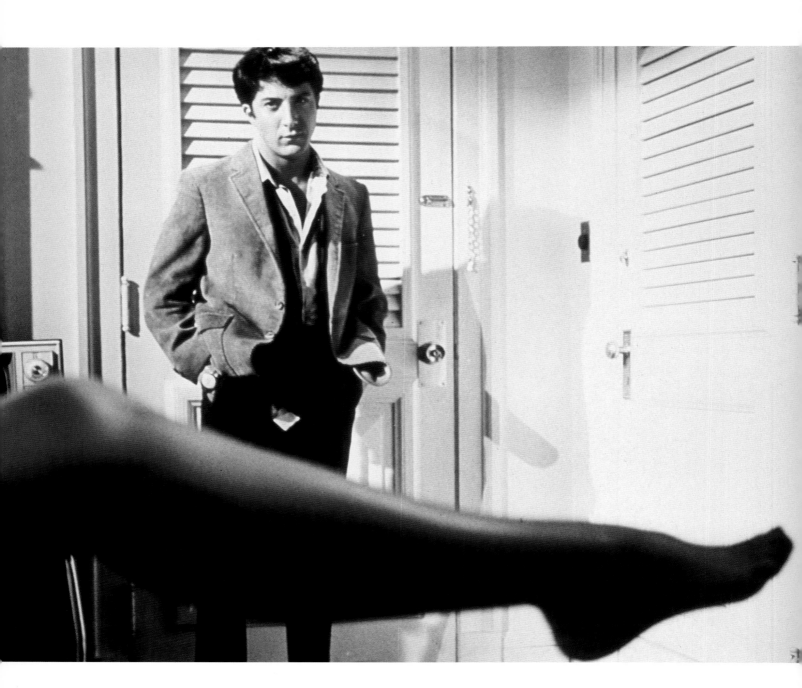

"To seduce is to render weak."

Jean Baudrillard [1]

Throughout history, women have skilled themselves in the art of seduction, one of the only routes to female power before the twentieth century. Creating an uncompromisingly erotic presence with lingerie, feather, furs, and heady perfume, the seductress has set the stage, whether in the eighteenth-century boudoir, on the city streets of 1920s New York, on the Hollywood screen, or on the twenty-first-century catwalk. Fashion gives potent force to the seductress, rendering men weak and her strong, flipping her from a position of disadvantage in patriarchy to one of surreptitious control and social advancement – and "eclipsing the power of her masters," [2] according to cultural theorist Jean Baudrillard.

Although outwardly dispossessed of her rights in culture, the seductress, Baudrillard believes, creates mystery and elusiveness through the use of symbols and appearances, tricks and artifice, and, in particular, her erotic presence. And the key to the seductress's sexual success is her skill at creating what philosopher Jane Billinghurst calls an "expectation of delight":

"there are those women who, observing how men's eyes instinctively slide down over the curve of a breast or up the smooth slope of a calf, hang their fortunes on the very feature that sets them apart from men: their femininity. Historically, temptresses … have decided that if they play their cards right, they can come out ahead. The temptress can do this because men responded so beautifully just to the idea of sex. All the woman needs to do is create the expectation of delight, and the man will willingly part with money and power." [3]

In every era there have always been women skilled at this game of love: the *maîtresse en titre* in her boudoir in eighteenth-century Versailles, the *grandes horizontales* of *belle époque* Paris, the New York flapper of the 1920s, and the 1950s blonde bombshell. One of the first skilled seductresses of whom we have a contemporary description is Imperia, a Roman courtesan of the sixteenth century, who was well versed in the art of setting a scene:

opposite *In a typical glamour shot of the mid-1950s, Diana Dors is at the epicentre of an artfully constructed scene of seduction. The chandelier, padded headboard, and pink satin throw were the hallmarks of a fashionable boudoir.*

"the house was so furnished and in everything so provided, that whatever stranger entered it, seeing its decorations and the array of servants, thought that a princess lived there. In the little room, to which she retired whenever visited by some great personage, the tapestries that covered the walls were of cloth of gold woven into many different and beautiful designs [There were] beautiful vases of precious materials ... coffers and presses, richly carved and such that they were all of a very great price. There was also in the middle a small table, the most beautiful in the world, covered with green velvet, on which was always a lute or a zither, with books of music, and with other musical instruments. There were also on it small books, richly ornamented." [4]

This was the lair of no mere mistress: this woman was accomplished, well versed in the arts, politics, and science as much as in the game of love, and the objects displayed carefully within her apartment hinted at these important aspects of the owner's education and accomplishments. If a man could afford to keep a woman such as this, it reflected well on his own intellect and masculinity and made him the envy of his friends.

For the kept woman of the eighteenth century, it was the boudoir where she showed why she was worth the money invested by her protector. Here she made sure the conversation was sparkling and her manner alluring, witty, and cultured in a space specifically devoted to luxury, femininity, and pleasure. Veiling her body in seductive *déshabille*, a woman could put herself in an "excellent bargaining position", as the notorious courtesan of the 1890s, La Belle Otéro, advised. It was she, with her ruthless attitude to admirers, who was reputed to have said, "A man becomes yours, not the moment you spread your legs but the moment you twist his wrist."[5]

By the late nineteenth century, a woman could be the initiator of seduction, even if a man thought otherwise, by subtly displaying her wares through her appearance in a manner very different from that of the gentlemen in her life. Why was male dress so dowdy and female so delicious? Anthropologist Bernard Rudofsky tried to explain it:

"Hers is the first move; she has to track and ensnare the male by looking seductive. Being devoid of anything comparable to the extraordinary antennae and giant legs that serve animals for apprehending a partner she exerts her powers by way of artificial plumage. To prevent the male from escaping, she has to keep him perpetually excited by changing her shape and colours by every means, fair and foul. In the traditional battle of the sexes, dress and its accessory arts are her offensive weapons." [6]

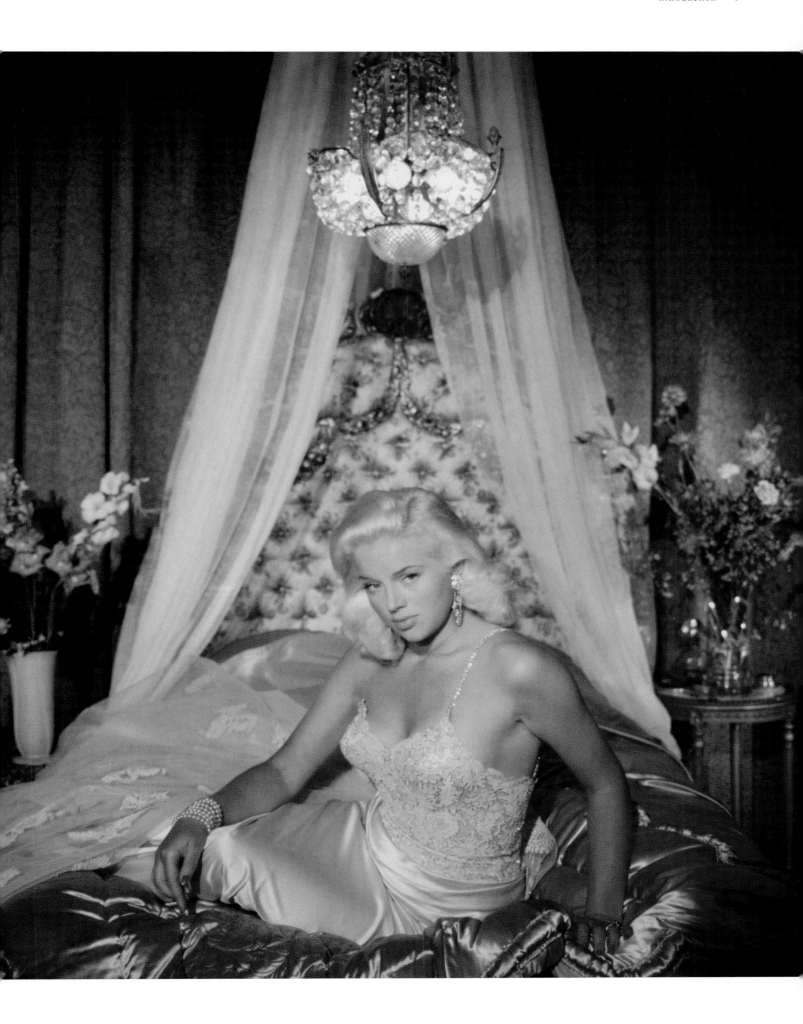

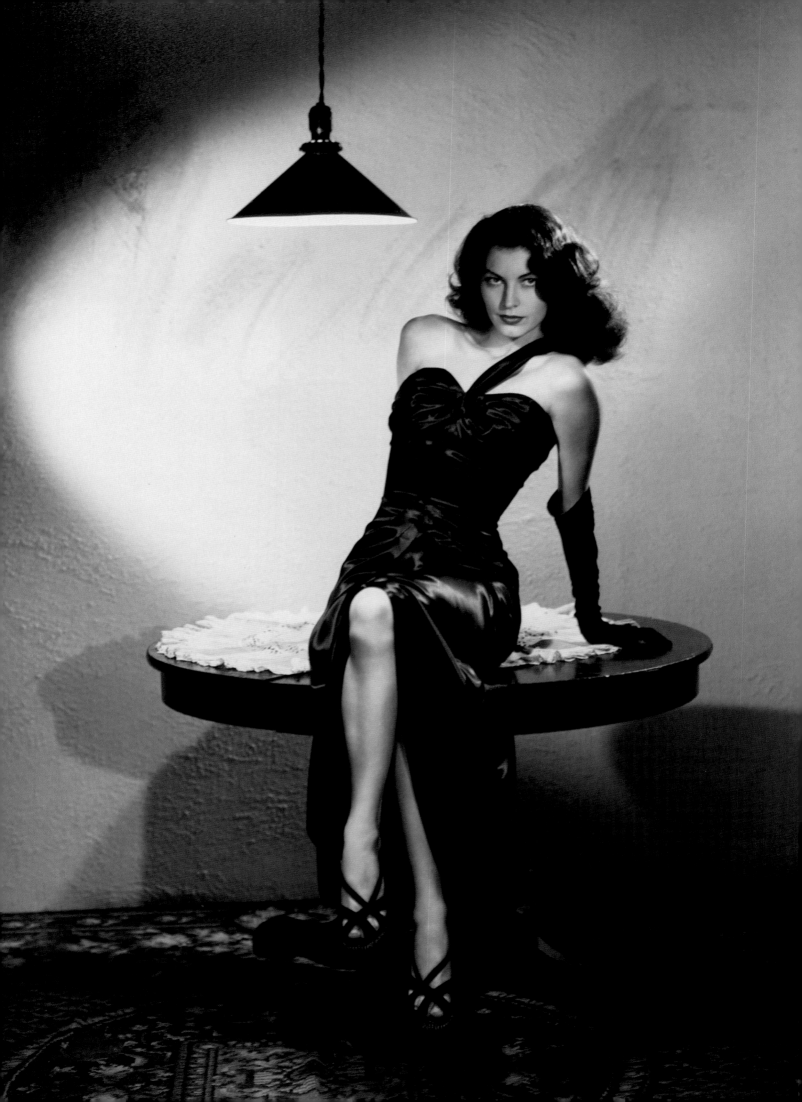

Thus the *grande horizontale* presented her body as a delicious package to be unwrapped, seemingly passive yet extraordinarily predatory, stimulating what Freud was to dub the "libido for looking". As international fashion expert Tony Glenville remarks, "Women like La Belle Otéro, whose breasts were said to precede her by a quarter of an hour before she entered the room, had security in their own physicality, and the spangles and glitter of their clothing were the bait for men who could read the signs, far more sexy than just flashing their naked bodies." [7] Art historian Quentin Bell agrees:

"If we wrap an object in some kind of envelope, so that the eyes infer rather than see the object that is enclosed, the inferred or imagined form is likely to be more perfect than it would appear if it were uncovered. Thus a square box covered with brown paper will be imagined as a perfect square. Unless the mind is given some very strong clues it is unlikely to visualise holes, dents, cracks or other accidental qualities. In the same way, if we cast a drapery over a thigh, a leg, an arm or a breast, the imagination supposes a perfectly formed member; it usually cannot envisage the irregularities and the imperfections which experience should lead us to expect. The art, if one may thus describe it, of the stripper consists in always being about to reveal all; she pursues nudity as Achilles pursued the tortoise, never quite achieving it; the visible charms of her person always being enhanced by those which are yet to be revealed. And this is true also of dress: it heightens the sexual imagination partly by revealing the body but partly by judicious discretion." [8]

It is understanding the arts of titillation, flirtation, and tease that makes a seductress, especially now in an era suffering from an over-abundance of naked bodies, particularly of the female kind. Historian Betsy Prioleau, predicting the return of seduction in the 2000s, writes: "Our senses have been anaesthetized through overkill. And sex itself has grown banal in the tell-all, show-all carnival of frankness. What's required now is erotic shock treatment, a way to kick up sensuous turn-ons again …. We've been terrorized into underperformance." [9] Lifestyle guru Jan Birks agrees, "With so much exposure to sex these days (it's everywhere you look) most folk are craving mystique and seduction more than ever. Nobody wants cheesy one-liners and one night stands – dressing up, role play and fantasy sex are increasingly important now." [10]

Fashion historian James Laver is one theorist who has attempted to define what is specifically alluring about women's fashion at any one time; his explanation is the "shifting erogenous zone". [11] According to Laver, fashionable styles zone in on a particular area of the

body that is deemed erotic, and women in particular take pains to display it for the delectation of men. As men become used to this delicious sight and eventually satiated by it, fashion moves on, creating an entirely new erogenous zone and thus arousing men's interest once again. Fashion for women is thus an endlessly shifting series of erotic tableaux: the ankle "accidentally" espied beneath a froth of frilly petticoats in the 1890s, the rouged knee of the flapper revealed during a particularly athletic Charleston in the 1920s, and the breasts fashioned into a rigid *embonpoint* in 1950s Hollywood, for instance. Women's clothes follow this seduction principle, calling like sexual sirens to men's unconscious desires, whereas men's clothes are sober, responsible, and hierarchical. Women want a man of substance resplendent in his business suit; men just want a quickie.

This is all a bit simplistic of course – men don't necessarily shy away from breasts because they're not in fashion, and of course men can dress sexily too – but it does seem that at certain points in time seductive clothing has been wielded by women to get what they want. There are items of clothing that remain seductive to this day: the negligee, which originated in the eighteenth-century boudoir, the lingerie of the *belle époque*, and the bra, stockings, and suspenders of the 1950s all remain stalwarts in setting the scene for a modern night of passion. These items of dress may not be intrinsically sexy in themselves – mere bits of cloth, whalebone, and steel – but they are deemed sexy because of their relationship to intimate parts of the body, for the associated meanings ascribed to them at various moments in time, and precisely because of the role they play in seduction.

And it's never one-way traffic, although in the past the man has had the need to feel he is in control, "the pursuer in the operations of love," as John Chandos put it in his *Guide to Seduction* of 1953, with the woman feigning resistance, although, "ultimately there must be acceptance by the conventionally passive party of the intentions of the conventionally active one". However, "this is not to say that even here the real initiative may not often lie with the woman in inviting and provoking the chase, as a toreador may tease and goad a slothful or 'cowardly' bull into the attack." [12]

The tools of seduction may not have changed much over the decades, or even over the centuries, but fey submissiveness on a woman's part has all but disappeared by the twenty-first century, as she has achieved both economic and sexual success and is no longer dependent on a man for her social advancement. Madonna led the way in the 1980s, showing today's independent women that:

below *In* Breakfast at Tiffany's
*(1961), Audrey Hepburn (with a little
help from writer Truman Capote)
created the character of high-class escort
girl Holly Golightly, in public a
sophisticated, seductive New York
socialite, in private a bundle of nerves
and neuroses.*

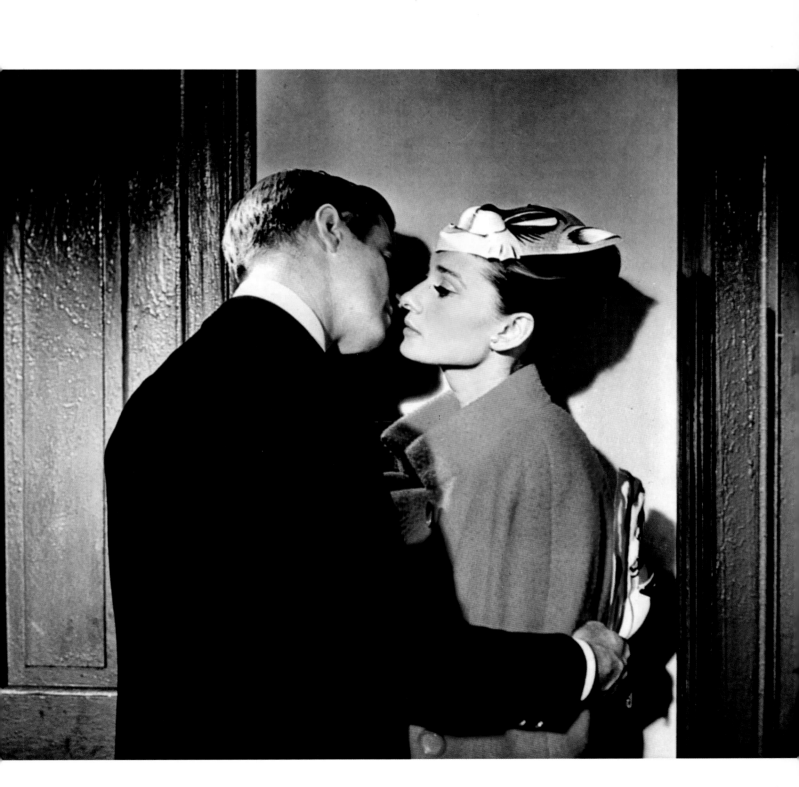

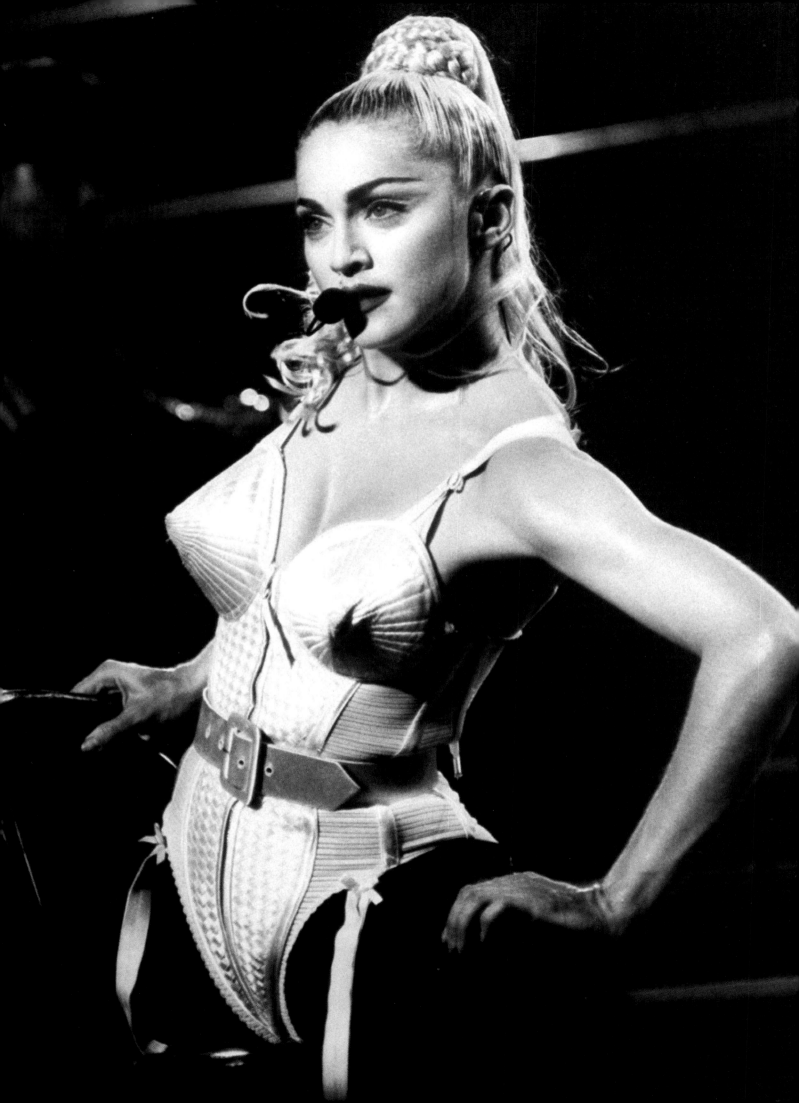

"the world was one huge sexual supermarket. She could browse the aisles of historical seduction, pull out items that caught her fancy, and whip up an original recipe of her own. Her main messages were power, control and muscle. Hers was a vigorous in-our-face sexuality that reminded women of their sexual power and encouraged them to embrace it in whatever ways best suited them. She was opening the door to an overt and flexible female sexuality that could accompany the advances women had made in other areas of their lives." [13]

Twenty-first-century *femmes fatales* luxuriate in lingerie, play with the rules of fashion, and retain control over their sexual lives, with men no longer doing all the picking and choosing. Seduction is fun, ironic even when women play with the language of the boudoir, burlesque, or the 1950s glamour puss, all togged up in Agent Provocateur or a sexy Vollers corset, and, as Jane Billinghurst points out:

"those men who realized that social and political gains made by women were not necessarily achieved at their expense relaxed and discovered what extra delights could be offered by women who accepted the hard wiring of their men as a potential source of pleasure rather than as the seat of male dominance. Feminine beauty and intelligence … became part of the package of adventurous sexuality just waiting to be explored with the satisfaction of both partners in mind." [14]

And as fashion journalist Hazel Curry writes, "a man with enough stomach will enter the game and worship his female with a little mirroring … for a woman's sexual sense blossoms most when she seduces." [15]

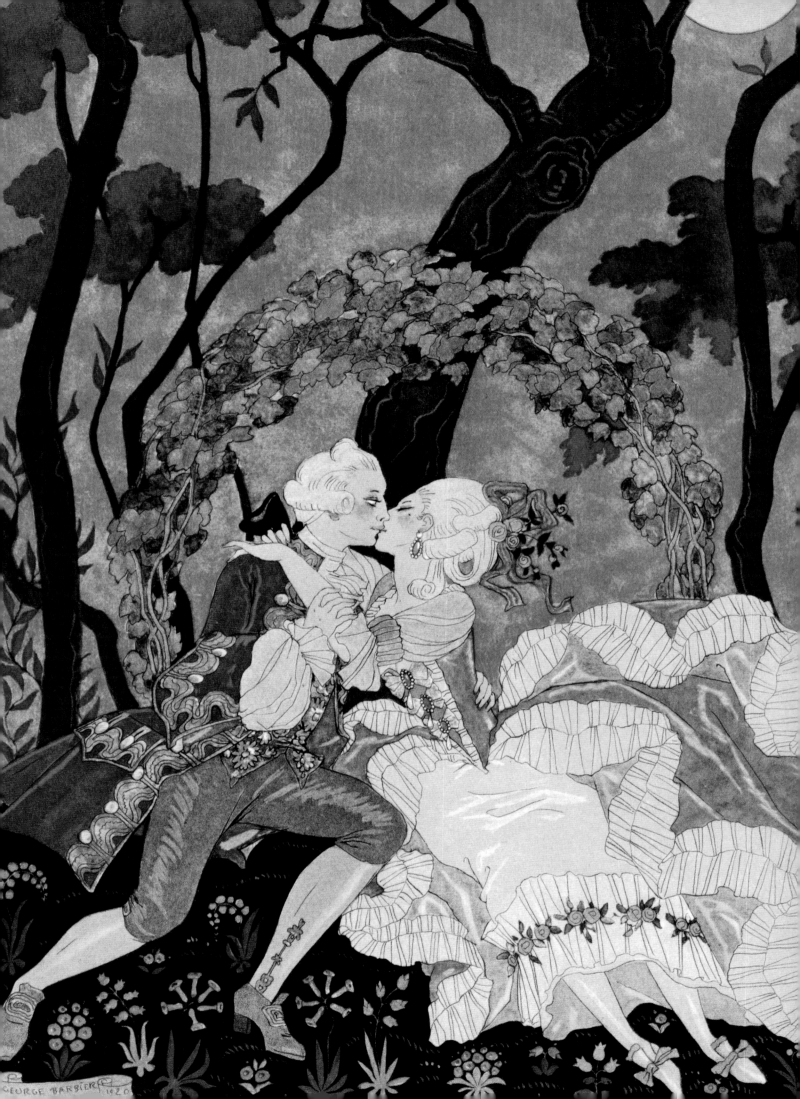

CUPIDS &
COURTESANS

"A sweet disorder in the dress
Kindles in clothes a wantonness"

Robert Herrick (1591–1674) [1]

previous pages *A scene of eighteenth-century seduction by French illustrator Georges Barbier depicts a moonlit kiss stolen from a woman of pleasure at a fête galante.*

opposite *A woman holds sway in the boudoir, a feminine sanctuary where women subtly displayed their charms, their extravagant dress a match for the sumptuousness of their surroundings.*

At the door of the boudoir a gentleman pauses. Holding his breath, he listens for the creak of stays being loosened, the rustle of a petticoat, the click, click, click of a dainty heel, feeling a frisson of excitement at the forbidden pleasures to come. He stoops and spies through a filigree keyhole....

Welcome to the boudoir, a room of aristocratic status, sensual living, and risqué connotations born in the aristocratic chateaux of eighteenth-century France, the domain of the tantalizing courtesan and the seductive setting within which she displayed her sensual wares. For in the eighteenth century carnal knowledge was allowed to thrive in this feminine sanctuary, which was elegantly furnished and temptingly private. Neither a bedchamber nor a dressing room, the boudoir was a very specific social space, which, by the mid-eighteenth century, had evolved into a luxuriously decorated sitting room within which a woman of fashion entertained potential suitors and female friends and also conducted business. Here ladies of leisure reclined, relaxed, and gossiped or pampered themselves in preparation for the more masculine world outside.

Since the seventeenth-century rule of the Sun King, Louis XIV, the French court had had a reputation for sexual, fashionable, and financial excess, with the Palace of Versailles at its Apollonian epicentre. Built in the 1660s, this gargantuan chateau housed over 2,000 aristocrats, who vied with each other to pander to the King, who was, quite literally, the centre of their universe. The stunning surroundings of the court played a key role in signifying the absolute divine right and power of the monarchy by both physically and aesthetically separating the rich from the poor. Towering curled and powdered periwigs, ermine capes, and high-heeled buckled shoes displayed a conspicuous consumption that was wholly the preserve of the wealthy aristocrat, who was marked out in his grand clothes from the shabbily dressed civilian. Jean-Baptiste Colbert, Minister to the King, remarked in 1665 that "Fashion is to France what the gold mines of Peru

below *The French court at Versailles was a place of royal rituals and sophisticated flirtation, its many rooms and secret passages the setting for assignations of the most seductive kind.*

are to Spain" [2], and this passion for courtly extravagance continued into the reign of Louis XV.

In 1725 the new King of France, Louis XV, at a youthful 15, married Maria Leszczinska (a-k-a Marie Antoinette) of Poland, his senior by seven years. The bride wore ermine and purple velvet, the groom sparkled in rich gold brocade and diamonds, and their future together boded well when, on his wedding night, the King, according to one of his ministers, "proved his tenderness seven times". [3] The results of this ardour, which continued over the next ten years, made the Queen, as she put it, *"Toujours coucher, toujours grossesse, toujours accoucher"* (Always bedded, always pregnant, always in childbirth). [4]

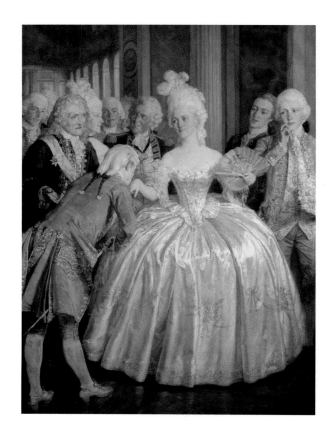

Between 1727 and 1736 Marie gave birth to ten children and, understandably, began to invent reasons to prevent her husband's nightly visits – in some instances falling to the floor in prayer until he relented and left. As a very proper and religiously pious woman, she was relieved when her confessor advised her to take a stand against such lusts of the flesh and, after one night in 1738 when Louis spent several hours in her bed trying to persuade her otherwise to no avail, her husband began openly to take a series of mistresses (a habit he had begun rather more surreptitiously in 1732).

Taking a mistress in the eighteenth century was considered an aristocrat's privilege, a normative mode of behaviour that had its own set of rules and rituals. It was an unwritten law, for instance, that the King had to have a mistress and that the mistress, in turn, had to have a husband to give a vestige of propriety to the relationship. Love was a game to be played with sophisticated dexterity, and accordingly Louis XV kept a succession of mistresses under the same roof in his vast royal palace at Versailles, which was full of secret passages and staircases.

The most favoured *maîtresse en titre* was ensconced in a suite of rooms directly above his own, and within this suite, leading directly to the bedroom, was her boudoir.

below *The morning toilette taken in the boudoir was a time to assess the business of the day and make any clandestine arrangements for an afternoon's amusement.*

Here, then, we have the boudoir as we now know it: a stage on which the fashionable courtiers were mere players, the plot a power struggle between the cynical courtesan and the narcissistic libertine. Filled with fine porcelain, gilded cherubs, and the finest damask, the boudoir was the "richly contrived environment" [5] for an eighteenth-century love affair. Used by the most powerful women within the French court, the boudoir became a secret centre of female control, where, in air heady with perfume and intrigue, the King's Favourites (his chief mistresses) schemed and plotted *les liaisons dangereuses*. It was a room of secret passions, both mysterious and impenetrable, a super-feminine hideaway that men could only glimpse voyeuristically – unless invited in, of course. In a world where few females had control over their own fates, power was a male preserve, and all women were legally, morally, and spiritually under the authority of men. There were few niches in which they could actually thrive and prosper, save the boudoir, and it was in this space that women fashioned their own seductive aesthetic.

As the first room designed specifically for women, the boudoir was regarded as trivial by male architects. This is made clear in its very name, for the word "boudoir" is derived from the French verb *bouder*, which means "to sulk". Men viewed the boudoir as the space where women "let off steam" and got over their petty grievances, and bestowing the boudoir with so flippant a moniker suggested a male perception of a rather silly female disagreeableness. This stood in stark contrast to the male equivalent, the study, where serious work was done in private – a place of masculine intellect rather than one of feminine mood swings.

For a woman, however, this private space was of the utmost importance, since a husband or lover would never dream of entering her boudoir without permission. With her secrets secure and with absolute mastery over her surroundings, a woman could explore her talents for design to create a *mise en scène*, a feminine style, for the most feminine of spaces.

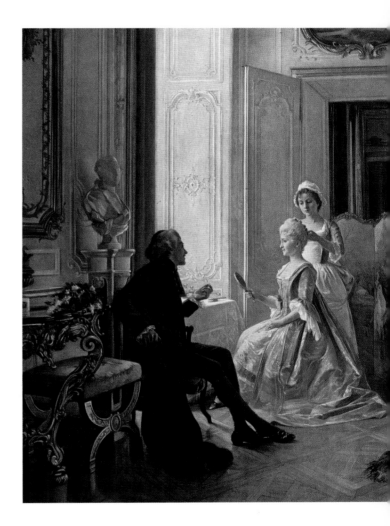

opposite *The famed boudoir of Madame de Sérilly, created by master craftsman Claude-Nicholas Ledoux in 1770–80, was a riot of cream, gold, and mirrors with painted panels that depict seductive fêtes galantes.*

below *A boudoir chair in typical rococo style, its curving lines ornately gilded and decorated with natural motifs including shells and flowers.*

An aesthetic of "informality" was created in contrast to the rigid formality of court etiquette, which meant that business of any kind could be transacted in a more subtle, underhand way using much coquetry and flirtation. Informality was created entirely through style, in particular using rococo, which took over the eighteenth century in the same way as modernism dominated the twentieth century in Europe. The term "rococo" was derived from *rocaille*, or rocks, specifically the small rock or shell formations found in grottoes. In design terms it meant a type of delicate, elegant asymmetry derived from natural forms used as a decorative device in interior design. Rococo stood in contrast to the more formal and monumental Baroque style that had dominated Europe since the sixteenth century: it seemed more relaxed and feminine, suited to intimate domestic spaces. It was an aesthetic that seemed to embody the pursuit of pleasure conducted in the boudoirs of Versailles. Horace Walpole remarked in 1740 on a visit to Paris: "Everything is white and gold, with mirrors." [6] This light, dextrous style was seen at its most accomplished in the paintings of court favourites Boucher and Fragonard.

Rococo was the perfect style of choice for the mid-eighteenth-century boudoir. In direct contrast to the magnificent splendour of other more formal rooms, such as the Salles des Gardes at Versailles – whose centrepiece was the massive royal throne of purple velvet decorated with sombre gold fleurs-de-lis – the rococo boudoir was intimate and flirtatious, full of whimsical charm and containing a dressing table, gilded mirror, and the classic boudoir *lit de repos*, or day bed. "Femininity" was encoded in forms, according to the French architect Le Camus in 1780, that were "gentle and well rounded ... governed by a simple, natural sweetness" [7]. Mirrors were essential to the look, creating a lightness and adding charm, but also fulfilled a functional need, so that "a nymph desirous of contemplating her own charms" could make sure that reflected back at her was a "regular form" rather than a "crabbed and crooked figure ... one does not expect to be vexed in such a manner in one's boudoir". [8]

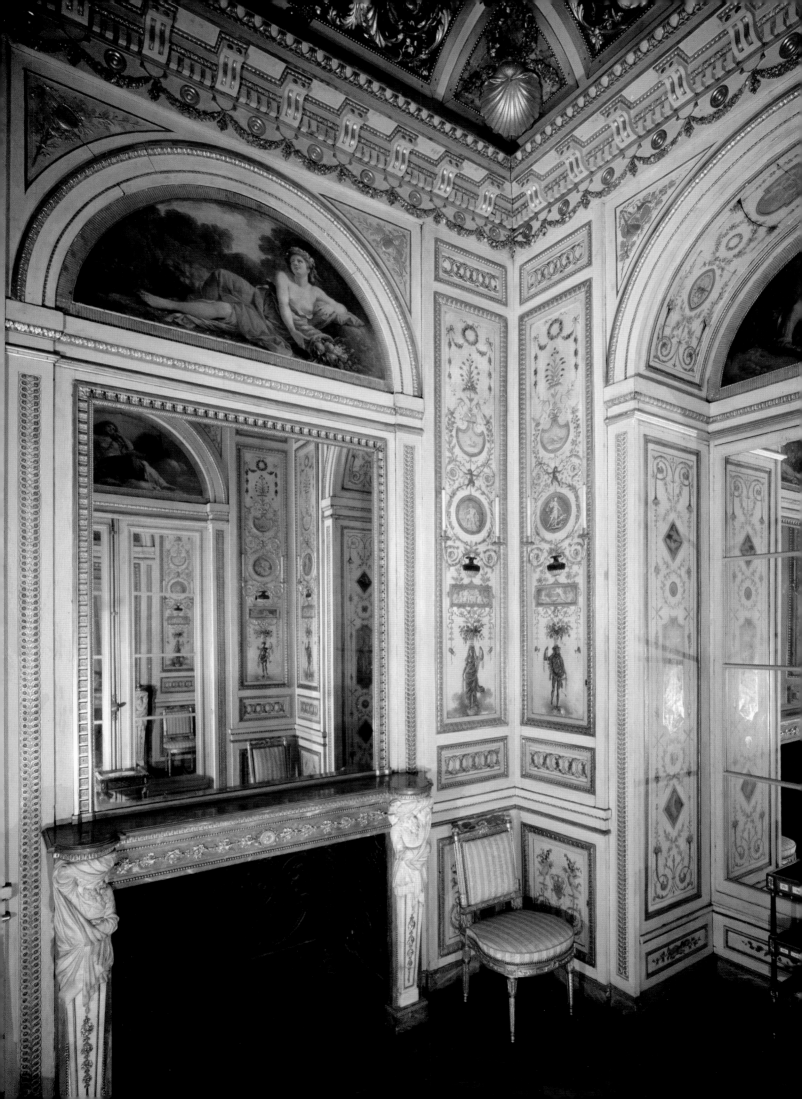

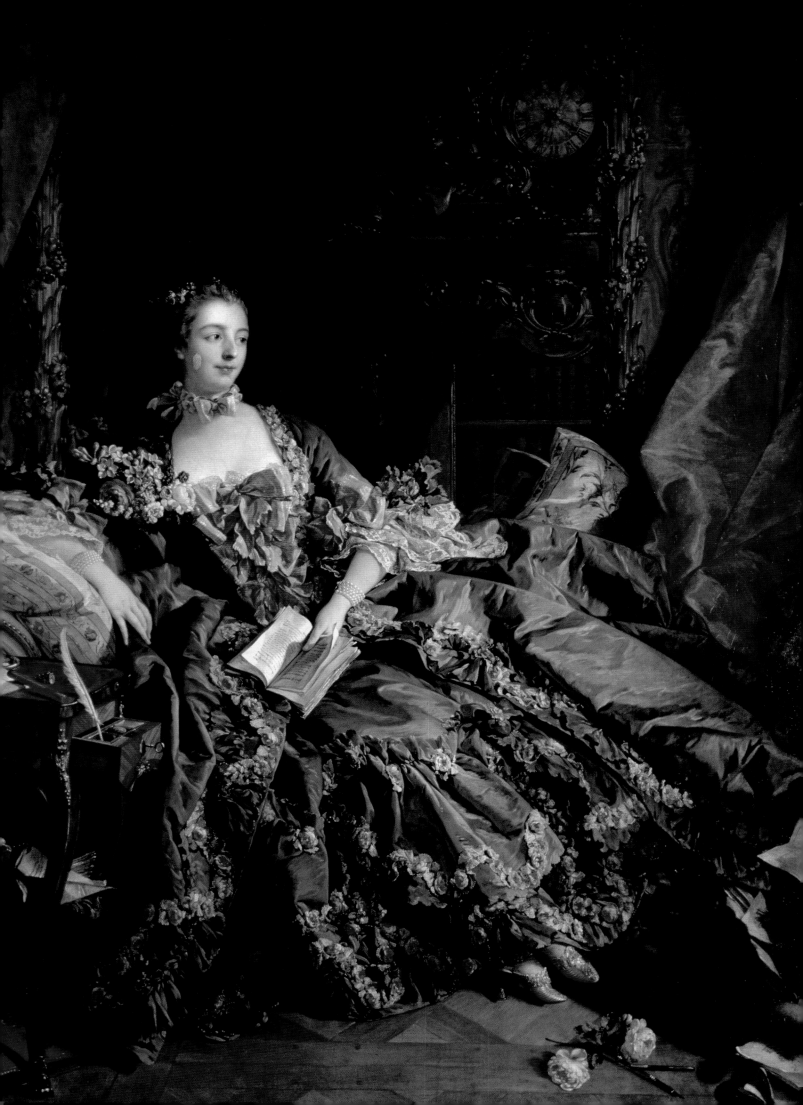

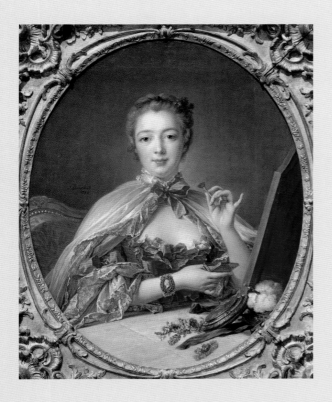

Sumptuous boudoirs were created by three key women at Versailles: two courtesans, Madame de Pompadour and Madame du Barry, mistresses in turn to Louis XV, and the legitimate Queen of France on her marriage to Louis XVI, Marie Antoinette. Madame de Pompadour came to the attention of the King in 1745. His favourite mistress, the Duchesse de Châteauroux, had recently died at 27 after contracting peritonitis, and the ladies of the court were desperately trying to catch Louis' attention so as to take her place in his affections. A contemporary account describes how:

"All the young women of Paris took to the field and ... availed themselves of every device of art and nature to attract the opposite sex. Everyone was busy ... dress-makers, hairdressers, trimmings-makers worked day and night ... never were such sales ... they bathed and perfumed themselves in readiness for any eventuality. From finery they passed to other means of attracting. Before they heard of the Favourite's death, the women of Paris enjoyed good health. Now they found themselves afflicted with terrible headaches, and most of them went to Versailles for a change of air. The chief thing was to be seen by the King and to speak to him." [9]

Madame de Pompadour was more subtle. Every time the King went out hunting, she contrived to drive past him in her phaeton and then mysteriously disappear into the forests around Versailles, eventually presenting herself to him formally at a masked ball dressed as the goddess Diana, with a crescent moon glittering on her forehead. Louis was soon entranced and from that moment she took charge. Ensconced in a suite of eight rooms above the King's apartments, she entertained in a boudoir described as "crammed to bursting point with pictures, bibelots, furniture, embroidery, cosmetics, all buried in flowers and smelling like a hothouse," [10] carrying "refinement to an extreme, especially in the everyday articles of her toilette. Powder-horns, patch boxes, rouge-pots, flasks, glove-cases, ball programmes, fans, sweet-dishes, all were of the most exquisite workmanship, in

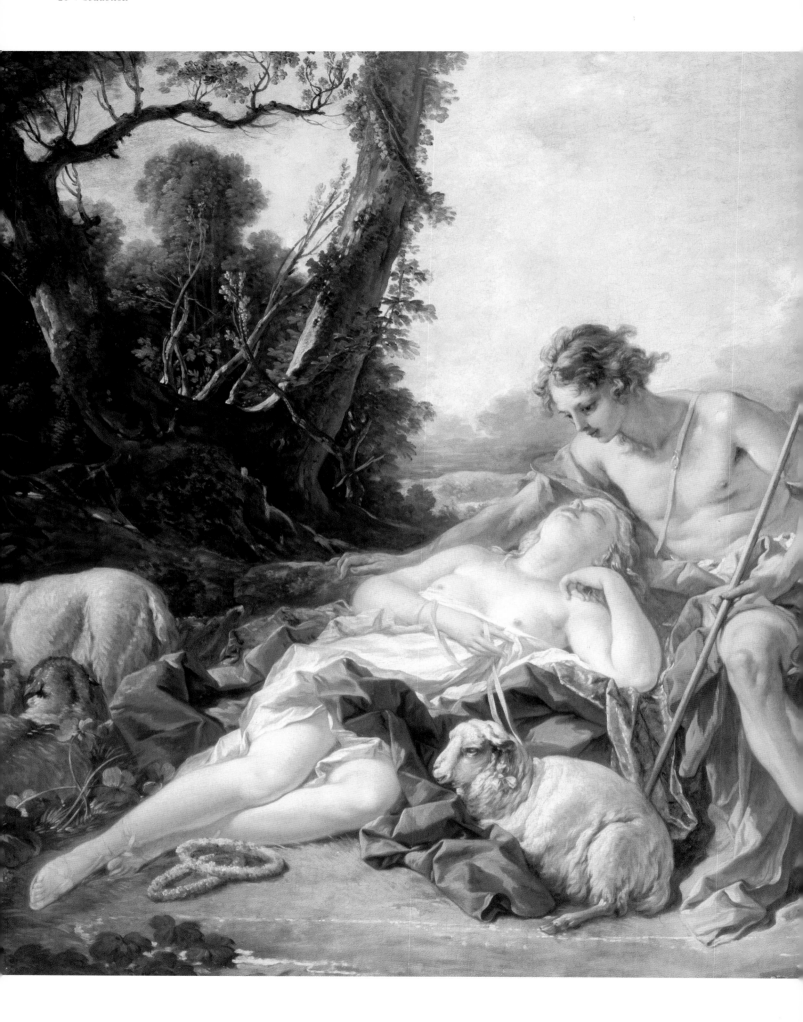

left Daphnis and Chloe, *a pastoral scene of seduction by François Boucher (1703–70) of a type used to decorate the walls of the royal boudoirs to create the required* mise en scène *for love.*

which the light and colour of gems played on surfaces of chased gold, on jasper, ivory or enamel." [11] Porcelain was her passion – chocolate cups, vases, *objets* of every sort – and she fuelled the popularity of Sèvres by filling her boudoir with its painted flowers and exquisite animals. Boucher's sensual scenes of pastoral abandonment adorned her boudoir's walls, with an emphasis on tales of seduction. It was here that she listened for the sound of the King's tread up the stairs that directly connected his bedroom to her lair, where she created a tableau of magnificence in her taffeta gowns.

De Pompadour's dresses outside the boudoir were complicated affairs, with tightly fitting bodices stiffened by stays (an early form of corsetry) and skirts that were extended laterally to each side by paniers or hoops. Skirts were also opened down the front to reveal heavily embroidered underskirts. Rich materials were the norm, embossed and brocaded, shot through with gold thread, and each court outfit was accessorized with heavy diamond necklaces. Within the confines of the boudoir, however, Madame de Pompadour changed from her formal court dress into *déshabille*, also known as *negligée*, a casually wrapped look derived from seventeenth-century portraiture, made up of layers of casually worn loose garments, described by contemporary writer Horace Walpole as "fantastic nightgowns fastened with a pin". [12] As art historian Anne Hollander explains:

"Prescribed court costume remained stiff and elaborate; but lightweight, simply spreading skirts and frothy, ruffled cuffs and caps, along with casually tumbled curtains, were elements in the new refined mode in actual life, descendants of the pictorial modes of the preceding century…. Not only were delicately coloured and softly rustling fabrics used in clothes, they also came to be hung in huge bunches in windows, heaped over screens, and draped unevenly over dressing-table mirrors." [13]

This "sweet disorder in the dress" was the key to creating sexual tension and initiating seduction before the invention

opposite *A secret assignation in the boudoir results in the woman's clothes becoming* en déshabille – *a disordered state considered deeply erotic in the eighteenth century.*

below *No underwear as we know it was worn in the eighteenth century, as this scene of seduction clearly shows. Underpants were considered extremely immodest, as they drew attention to the intimate parts of the body.*

of sexy underwear – something that would not happen for another century. Underwear itself, insofar as it existed, took the form of unisex linen shifts with no particular erotic connotations and two main functions: to protect expensive outer garments from the dirt of the body beneath, when bathing for most was an expensive and time-consuming luxury, and to add an extra layer of insulation.

As a result of their direct contact with the female genitalia, underpants, or drawers, were considered the most risqué of garments, so much so that it was considered almost more immodest to wear them than not. Thus until the mid-nineteenth century they were primarily the preserve of the common prostitute, and regarded as somewhat vulgar by any self-respecting courtesan or libertine. Casanova, the renowned eighteenth-century rake, confessed, "I have always had a horror of women in drawers, but especially black … those black drawers put black into my soul." [14]

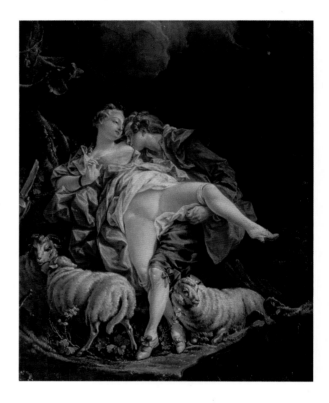

Clothes in themselves, therefore, were not considered particularly erotic. It was the art of revealing or concealing the body beneath that was paramount in creating a sexual charge – the frisson engendered by a chance glimpse of a forbidden part of the body. The poet John Logan made this clear in his *Ode to Women* of 1770:

> *At times to veil is to reveal,*
> *And to display is to conceal;*
> *Mysterious are your laws!*
> *The vision finer than the view;*
> *Her landscape Nature never drew*
> *So fair as fancy draws.* [15]

Déshabille as a form of seductive dress worn only in the boudoir is described in a scene from *Les Liaisons dangereuses* by Choderlos de Laclos, a scandalous novel of 1782. The key female character, the Marquise de Merteil, has a boudoir set within a *petite maison*, a secret hideaway for rendezvous with her lovers. Here she awaits her latest conquest, taking great care to set the appropriate scene:

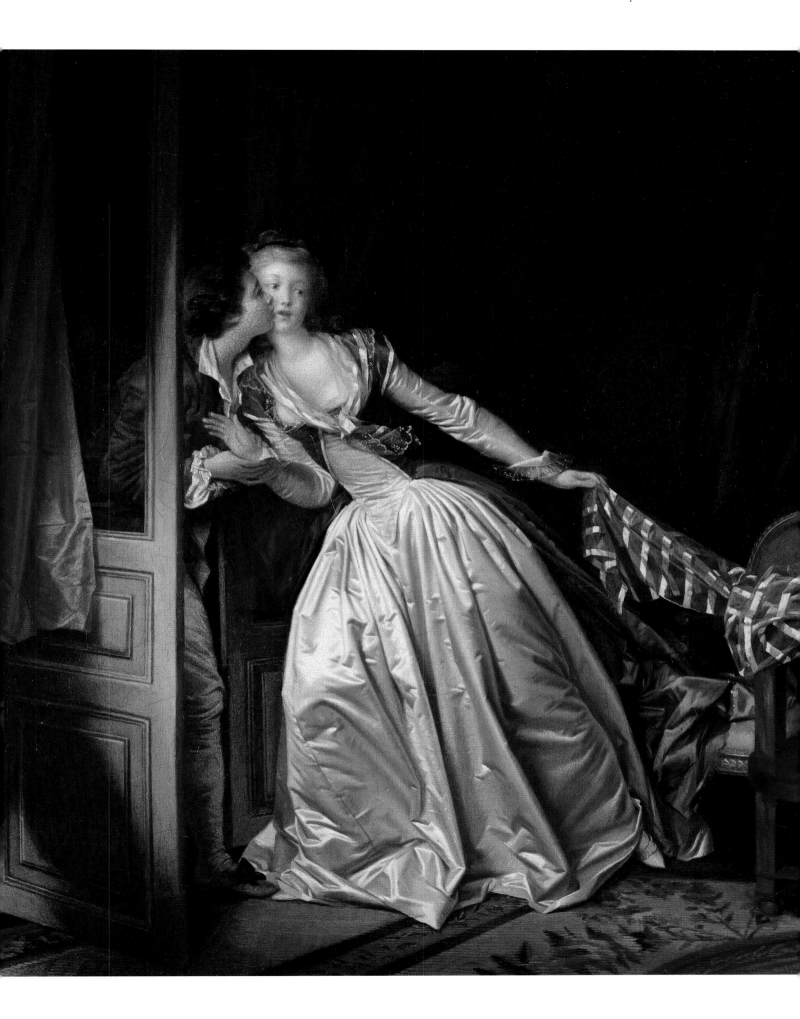

opposite *An aristocratic lady in her boudoir at her morning toilette is being prepared as an* objet de luxe *for the delectation of any gentleman callers.*

below *A coquettish courtesan allowing the viewer a glimpse of stocking in the street. A lone, gaudily dressed woman would be considered a "working girl" in an age of strict rules regarding women's social mobility.*

"I chose the most seductive dishabille. It was really delicious; it is my own invention; it lets nothing be seen and yet allows everything to be guessed at ... meanwhile my Chevalier comes to my door with his usual eagerness he sees a table laid for two and a bed made up; we then go into the boudoir, which has all its decorations displayed. There, half out of premeditation, half from sentiment, I threw my arms around him and fell at his knees. 'To prepare you for the surprise of this moment,' I said, 'I reproach myself for having troubled you with an appearance of ill-humour, with having veiled for an instant my heart from your gaze. Forgive these faults, I will expiate them by my love.' You may imagine the effect of that sentimental discourse. The happy Chevalier raised me and my pardon was sealed on the ottoman." [16]

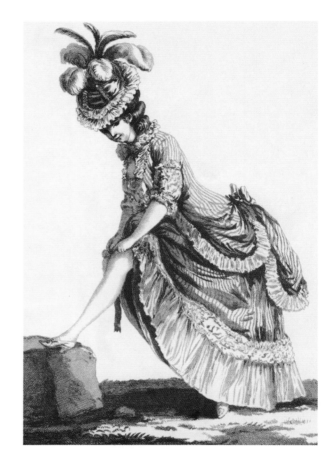

Simple muslin shifts such as these, which concealed more than they revealed, created a sexually provocative display, a state between dress and undress as a prelude to the act of love. Sensuality was conveyed through the outline of a thigh swathed in white linen or muslin, the exposure of a hint of *décolletage*, or the sway and bounce of a petticoat. Women were tantalizingly subtle, offering up their charms to the male little by little – by carelessly stepping into a carriage so that an elegant leg could be "accidentally" exposed or by causing a handkerchief that was modestly veiling a bosom to flutter to the floor, thereby exposing an exquisite *embonpoint*.

It was in such ways that Madame de Pompadour lured Louis into her boudoir, dosing herself with aphrodisiacs (which were said to have given her unsightly pimples on the nose), for ironically, despite her seductive surroundings, the King's Favourite was not fond of any form of sexual activity and found keeping up with Louis' libido exhausting. Unwilling to relinquish her powerful position, however, de Pompadour began to devise other ways of keeping him seduced, intrigued, and amused. She received titbits of gossip from her network of informants, and all the letters that entered or were sent from Versailles were sifted through for juicy information.

The sexual peccadilloes of his courtiers were laid bare for Louis' enjoyment, including who used the most "English riding coats" (condoms) and who had contracted venereal disease, and by regaling him with such sordid stories, de Pompadour helped to keep her place in the court as his pampered paramour.

By 1750, de Pompadour's morning toilette, or dressing time, in her boudoir had become the stuff of legend. An elaborate ritual of powdering and primping was undertaken by a succession of maids, during which the King's mistress conducted matters of state, dictated letters, flirted with her lover, and gossiped with friends. According to historian Gertrude Aretz:

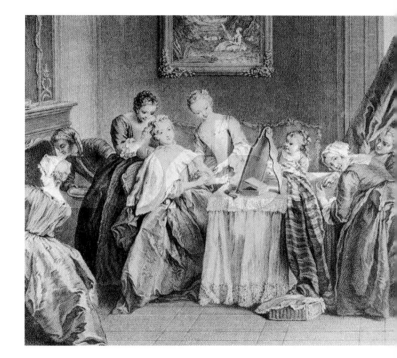

"she tried on every imaginable negligee, court dress, shoe, slipper, stocking and garter. Every physical charm was brought into play in turn. Her shoulders, her arms, her neck, her enchanting little foot, her slim leg – each physical perfection added to the desired effect. To have her hair dressed, she would sit in a cloud of fragrant lace; then with a sudden gesture, she would throw everything on one side, and swathe her limbs in some new enhancement of beauty. The eyes of the men rested in admiration, and those of the few women present in curiosity, on this capricious ruler of elegance; but every woman observed carefully all the details of her clothes in order to copy them, until at last there was scarcely a single object, not a garment, not a piece of furniture, that was not à la Pompadour." [17]

Despite her airs and graces, de Pompadour knew that her hold on the King was always tenuous – as soon as she displeased or bored Louis, she would be supplanted by a younger, more pliable, replacement. As she became more and more averse to Louis' advances, she realized that in order to keep her place as the King's confidante she needed to create sexual substitutes. Thus began her role as a procuress of young working-class girls for his amusement, taking care that none of them was shrewd enough to replace her. The girls were housed at the Parc

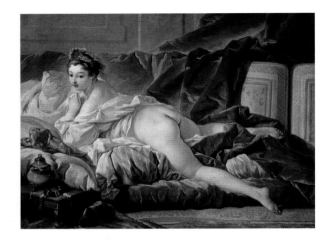

aux Cerfs, once a deer farm but by the 1750s a series of overspill apartments for the French court. One of the women who had many trysts with the King was Louise O'Murphy, who was immortalized on canvas by Boucher.

By 1764 Madame de Pompadour's health was failing. She had suffered an early menopause, had a weak heart, and was rapidly losing weight, which marred her once infamous charms. She died that year at the age of 42, brought low by pulmonary tuberculosis. Her body was moved out of Versailles by wheelbarrow, as only the dead of royal birth could remain in the palace. Louis watched her funeral cortege from his balcony and was not to take another official mistress until 1768, the same year as the death of his wife, Queen Marie Leszczinska.

Louis' new mistress was to be Madame du Barry, a woman famed for her exquisite beauty. She is described in a contemporary account as having hair that:

"was fine, long and silky, and of that *blond cendré* which, without the aid of powder, gives a sweetness and delicious harmony to the face, which was both bright and pensive. As a charming contrast, she had brown eyebrows, and long curved brown eyelashes, which set off the tender gleam of her blue eyes little Greek nose, finely chiselled, and the bent bow of a tiny mouth. ... around her that air of voluptuousness, that atmosphere of intoxication." [18]

Du Barry's first meetings with the King were planned with military efficiency. In one, she appeared before him in a diaphanous white tissue gown strewn with diamonds in the form of bouquets, garlands, and lover's knots, silk stockings embroidered with gold, and high-heeled shoes scattered with precious gemstones. She became *maîtresse en titre* and, accordingly, was given her own set of apartments in Versailles.

Her boudoir contained tiny tables inlaid with porcelain, covered with boxes of exotic sandalwood, exquisite tea sets fashioned from crystal and gold, ivory and lacquered

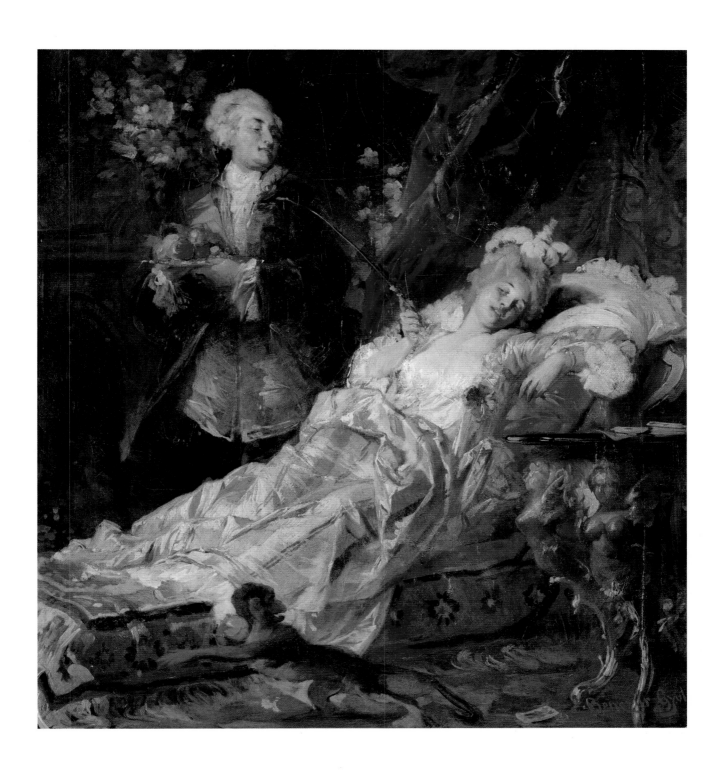

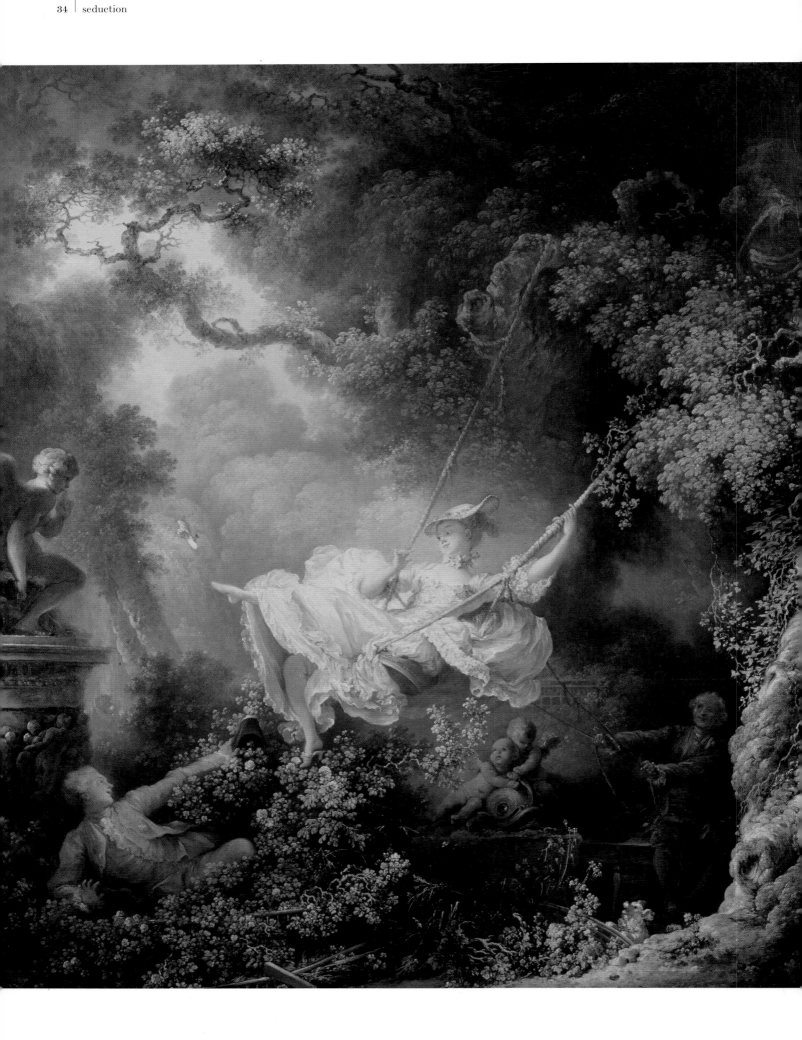

étagères, twelve large armchairs upholstered in yellow Indian silk, and masses of Sèvres. Here she could be found casually reclining on a plumped *fauteuil* wearing a dress garlanded with roses, accompanied by her white greyhound, Mirza, resplendent in a diamond collar.

Du Barry's boudoir was there to indulge the senses and was cunningly designed to foster intimacy. Paintings by her favoured artist Fragonard depicted nudes, which were, as Anne Hollander describes, "wallowing in the same silken fabrics … as those shown elsewhere", either decorating the boudoir or sported by du Barry herself in the form of a luxurious morning gown. As a result, the nude in the painting became du Barry herself, and for Hollander "the real lady's nakedness is conjured in the imagination by the surroundings she seems to share with the goddess, whose actual epiphany among the yards of taffeta is similarly made to seem more than likely".[19]

In 1770, at the king's expense of course, du Barry remodelled her bedroom: the old wooden wainscoting was gilded over as was her wooden bed, now so golden it resembled metal. Fluted columns wreathed with garlands of laurel and myrtle leaves held up a white silk canopy embroidered with the ubiquitous rococo roses. The headboards had a decoration of two love birds billing together among an array of flowers, and the carpet was woven from the whitest of Chinese silks; white silk was also draped over the room's thirteen chairs. White satinwood furniture was inlaid with porcelain versions of Watteau's *fêtes galantes* – scenes of romantic rendezvous – and a gold clock stood on the mantelpiece depicting the Three Graces with Cupid's arrow as a dial, suggesting, of course, that in this room there was always "time for love".

A typical day for du Barry began at nine in the morning, when the gilded shutters in her bedroom were thrown open by a maid, who proceeded to help the King's mistress from her lace sheets into her dressing gown and then into a bath of perfumed water. Next, dressed in a morning gown of Brussels lace trimmed with ribbons, du Barry took her morning coffee in a silver cup while sitting

opposite *Marie Antoinette in a pink satin gown with deep* décolletage, *her hair curled, powdered, and festooned with feathers. She holds a rose, the soft pale pink of its petals echoing her delicate complexion.*

at her toilette table. Here she spent the next two or three hours being approached by a succession of craftsmen and salesmen, who displayed for her perusal a mixture of expensive trinkets for sale, including diamonds, cameos, and intaglios. After making up, using a blue pomade to emphasize her veins, black to define her eyebrows and lashes, carmine for her lips, and rose pink for her nails, du Barry repaired to the boudoir to have one of many private audiences for the day (including several with the King).

Du Barry remained the King's Favourite until his death from smallpox in 1774 at the age of 64, when she was banished from the French court at Versailles by the new King and his Queen, Marie Antoinette. She continued in her role as courtesan with a succession of rich patrons, only to suffer the same fate as the new Queen – beheaded by the guillotine in the maelstrom of the Revolution.

Born in 1755, Marie Antoinette was one of the 16 children of Maria Theresa, Queen of Hungary and Bohemia, and Francis I, the Holy Roman Emperor. In 1770, at the age of 14, Marie Antoinette was married at Versailles to the 15-year-old Dauphin, Louis XVI, in order to forge a strong political alliance between France and Austria; in 1774 she was made Queen of France. Antoinette was an unpopular Queen, regarded as fanciful and frivolous and rumoured to have had several affairs, including one with Count Hans Axel Feyer, a Swedish diplomat.

Reviled for her Austrian blood, Marie Antoinette became the focus of mass uprisings against the aristocracy, which were to culminate in the Revolution of 1789. Aristocrats such as Marie Antoinette were criticized for their seemingly frivolous pursuit of pleasure – the masquerade balls, gambling, and intrigue that seemed to dominate court life repulsed a French population in times of hardship, and Marie Antoinette took the full force of their disapproval, at one point in 1787 being dubbed "Madame Deficit".

Although France was plunging into financial crisis, a kind of recklessness dominated court life, with fierce

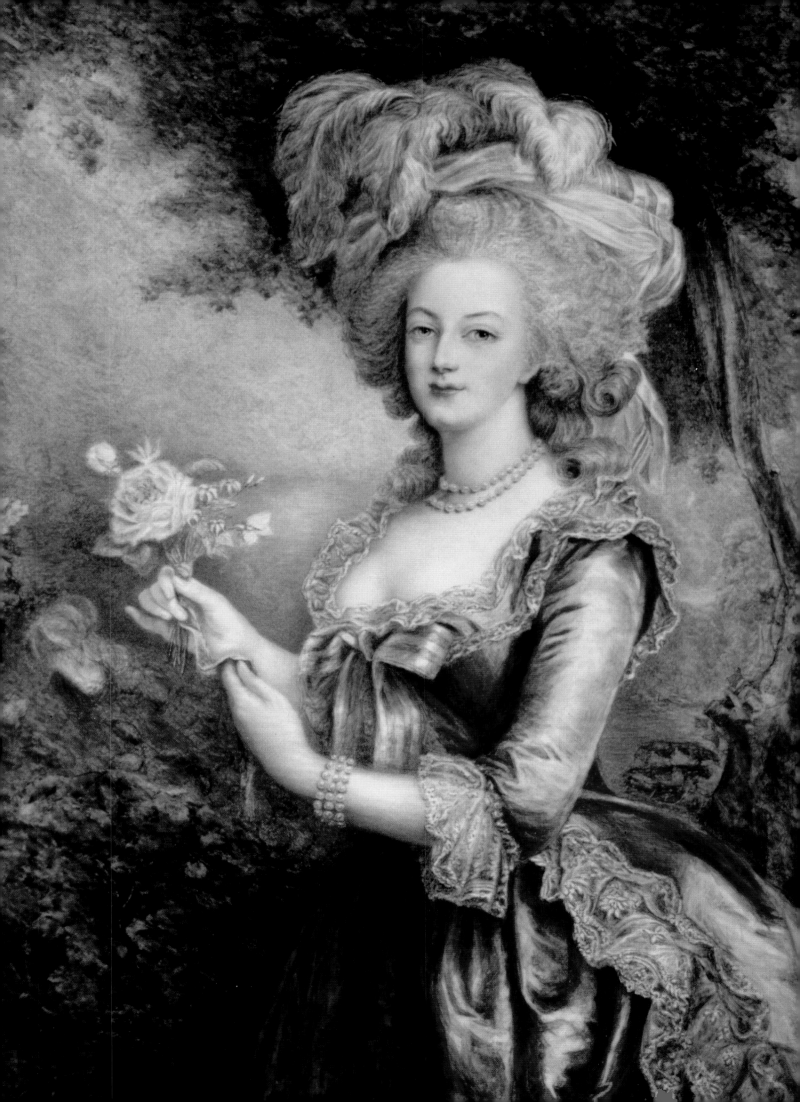

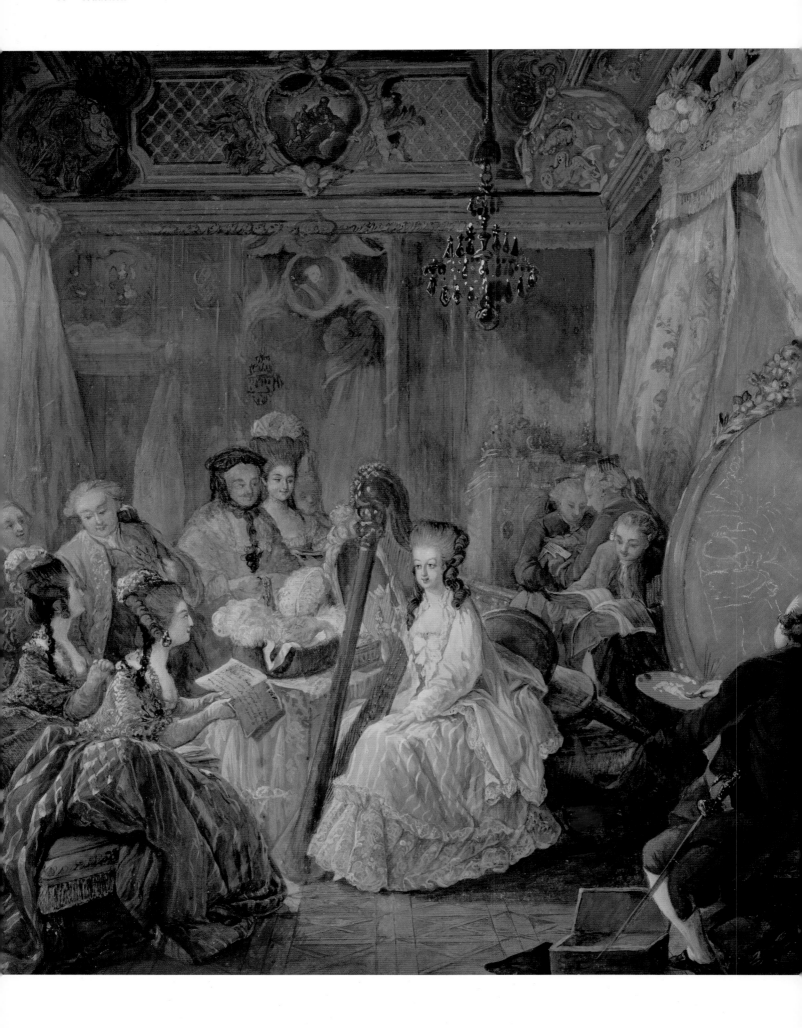

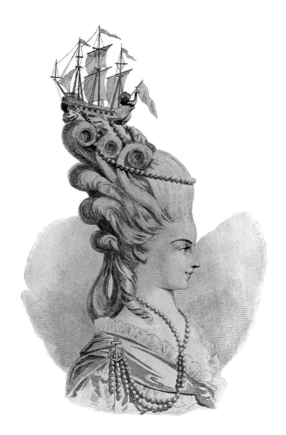

competition in fashion and leisure pursuits and the patronage of major artists for interior design schemes, sculpture, and painting. Marie Antoinette refused to compromise and had several boudoirs constructed and furnished to the highest standards of the day in her palaces and country homes across France. Her boudoir in Versailles was a riot of rich red and gold, a mark of her regal grandeur and gracious living, and a sumptuous antechamber to her state apartments.

Here, after a bath in a gigantic shell that had been rolled into her bedroom, with hair lightly powdered and studded with diamonds, in a pink satin gown, she flirted with potential lovers and gossiped with friends. For more formal state occasions, her hair was dressed into towering shapes by the court hairdresser Léonard, as high as 90cm (36in) from the roots to the top, and decorated with ribbons and feathers. Decked in lavish gowns by her couturier Rose Bertin (dubbed the Minister of Fashion), she had her cheeks lavishly rouged to indicate what Casanova called "amorous fury", [20] "an illusion of sensual excitement which promises unusual pleasure and positive orgies of love". [21] In her less formal *petits appartements* at the Trianon in the grounds of Versailles, the Queen reclined on a couch in a room where, according to one account, "the translucid mirrors on the doors were surrounded with delicately chased copper, fashioned in a design of flowering rose trees, hung with garlands and interspersed with torches and hearts pierced with arrows". [22] All around her were flowers including hyacinths, irises, and tulips: as the historian Antonia Fraser relates, "One of her ladies had special responsibility for seeing that everywhere in her apartments huge Chinese pots and small vases of crystal, Sèvres or Venetian glass were filled with flowers." [23]

It was in the 1780s that Marie Antoinette began to feel the full force of the French people's disgust for the monarchy, which was to culminate in her death by guillotine in 1793 after a long imprisonment in the Tuileries palace. Marie Antoinette had been a regular topic of scurrilous libel, a

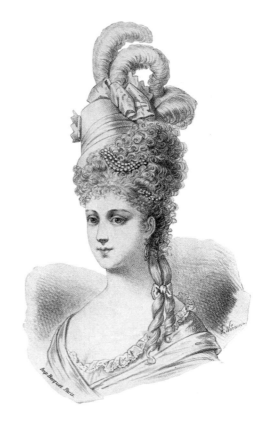

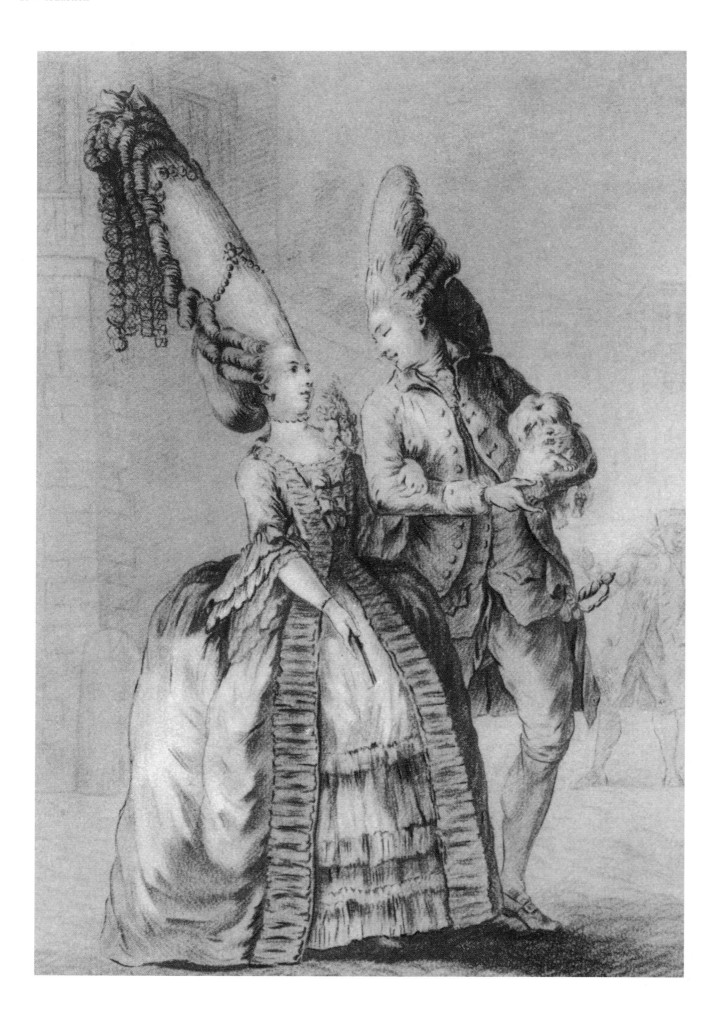

opposite *Hairstyles and court dress of 1777 exaggerated by the artist to comment on the excesses of the French court, which were to be swept aside by the Revolution and replaced by the more sober and discreet hairstyles of the next century.*

below *Norma Shearer as the lead in* Marie Antoinette *(1938), an extravagant Hollywood production with gowns by Adrian. In the film she cuts a tragic, tearful figure, in contrast with the darker representations of a decade earlier.*

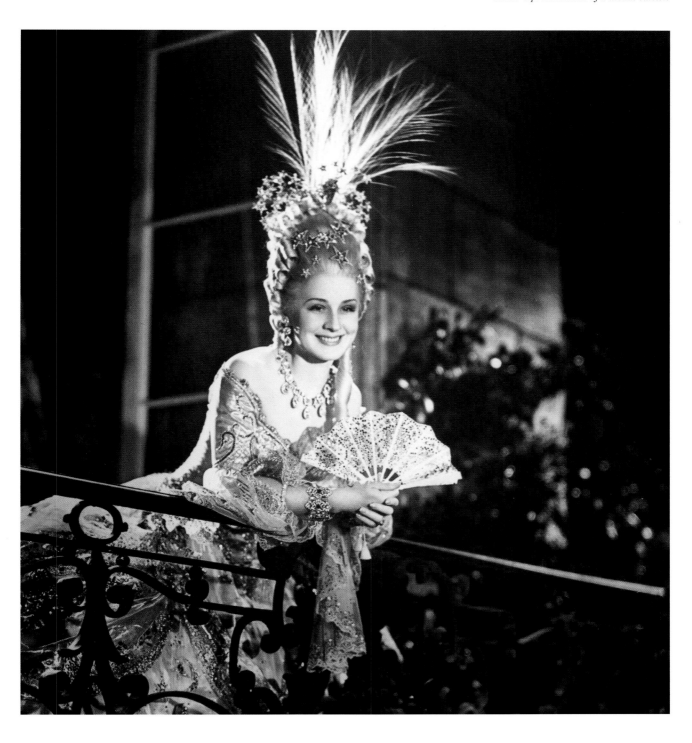

key character in early pornography, popular songs, and pamphlets, with her every movement criticized. Scenes of the Queen's wanton behaviour in the boudoir were regularly invoked, with the room entering the popular imagination as a place of unbridled lust, and in turn acting as a metaphor for the degeneracy of the aristocracy on the eve of the Revolution and Enlightenment.

Les Liaisons dangereuses (1782), for instance, purports to be a true account of a series of Machiavellian seductions orchestrated by the sexually sophisticated duo of former aristocratic lovers the Marquise de Merteuil and the Vicomte de Valmont. The narrative takes the form of a series of letters sent to and fro between the participants, a popular narrative device of the eighteenth century, and the secrets and lies contained in the various missives sent from each of the participants build up to the novel's dénouement. The boudoir is the battleground of the war between the sexes: it is here that the women think, plot, and write at a piece of furniture called, very significantly, a secretaire, a little writing desk-cum-bureau, its drawers filled with secret missives detailing flirtatious intrigues. The downfall of the deliciously corruptible Cécile Volanges occurs when this young virgin, fresh from the convent, gives the wily Valmont a key to her boudoir, so he can access her secretaire to pass on messages unbeknown to her strait-laced mother ... and by so doing allows him easy access to her bedroom.

Eighteenth-century sexuality, as popularly represented in Laclos' work, is at once bawdy and licentious, in a time of libertines, courtesans, and moll houses, but it is also subversive, dark, and dangerous. Husbands and wives are wantonly unfaithful to each other, despite their marriage vows (one popular anecdote has a husband finding a young man in his wife's bedroom and remarking "Madame, how very imprudent on your part; suppose you had been seen by anyone else"), libertines are vicious beyond all measure, while courtesans are calculating and deadly. Love is

opposite *A bedroom scene from* Les Liaisons dangereuses, *illustrated by Georges Barbier in the 1920s. The cynicism, lust, and betrayal in this eighteenth-century novel are a comment on the perceived debauchery of the French aristocracy at the time.*

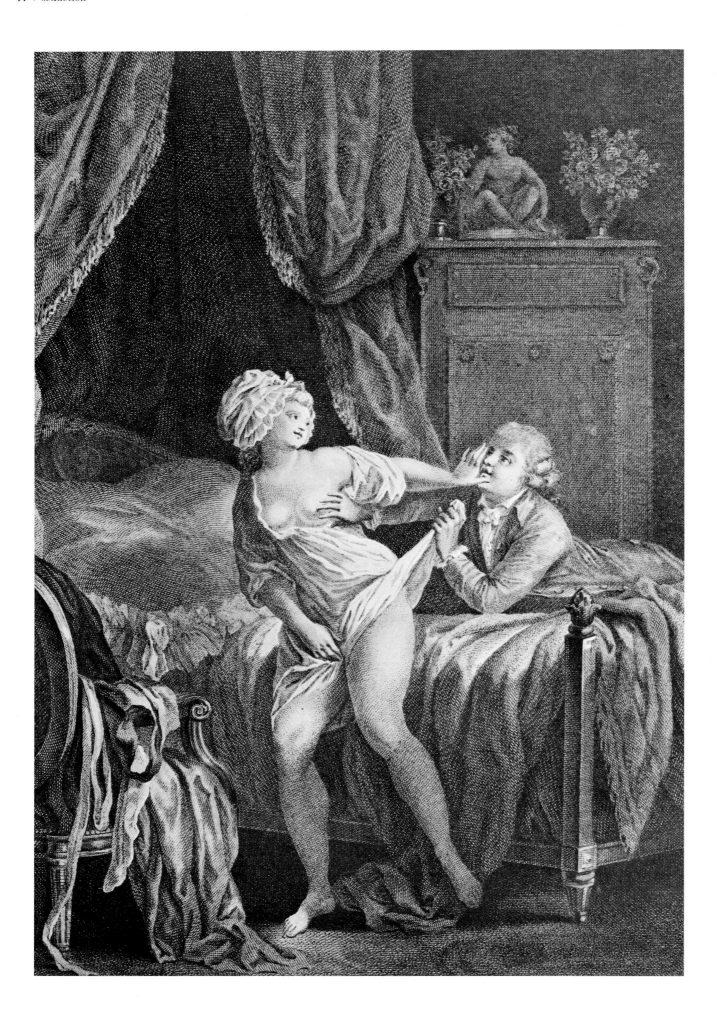

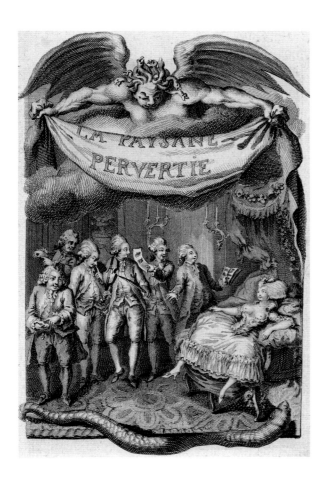

a pursuit for the idle and sexually voracious, with seduction and subsequent conquest its prize.

In late eighteenth-century narratives, boudoirs become dens of depravity populated by the debauched aristocracy who are responsible, in the readers' minds, for levying punitive taxes on the peasant classes to fund their degenerate lifestyles.

Walls are painted with erotic images "to sustain erotic activity", [24] as Restif de la Bretonne put it when describing the courtesan Ursule's boudoir in one of his many licentious novels *La Paysanne pervertie* (1784). Alternatively, they are covered in pornographic paintings with mirrors reflecting back into infinity the libidinous poses displayed on the walls. The decor of the boudoir is deliberately intended to provoke desire by providing a heady atmosphere and stimulant for lovemaking. In the novel *Le Rideau levé* (1786), attributed to the Revolutionary politician and orator Honoré Gabriel Mirabeau, the heroine enters the salon of an infamous libertine and remarks that:

"Those paintings, those sculptures, and the wines and liqueurs that we drank removed and dismissed from our minds any shadow of constraint: a voluptuous fever took hold of our senses; Bacchus and Madness were leading the dance." [25]

Other decorative devices in the fantasy boudoir conveyed secret messages of eroticism to those who entered. In *La Secte des Anandrynes: Confession de Mademoiselle Sapho* (1786), illustrated by Paul-Emile Bécat, two women enter a boudoir, and one recounts:

"Without uttering a word, filled with gratitude, I threw my arms around her neck and embraced her. 'Oh! you foolish little thing! That is not how it's done. Look at those two doves nuzzling amorously.' As she said this, she made me look up to the arch above the niche where we were, with its ornamentation of floral

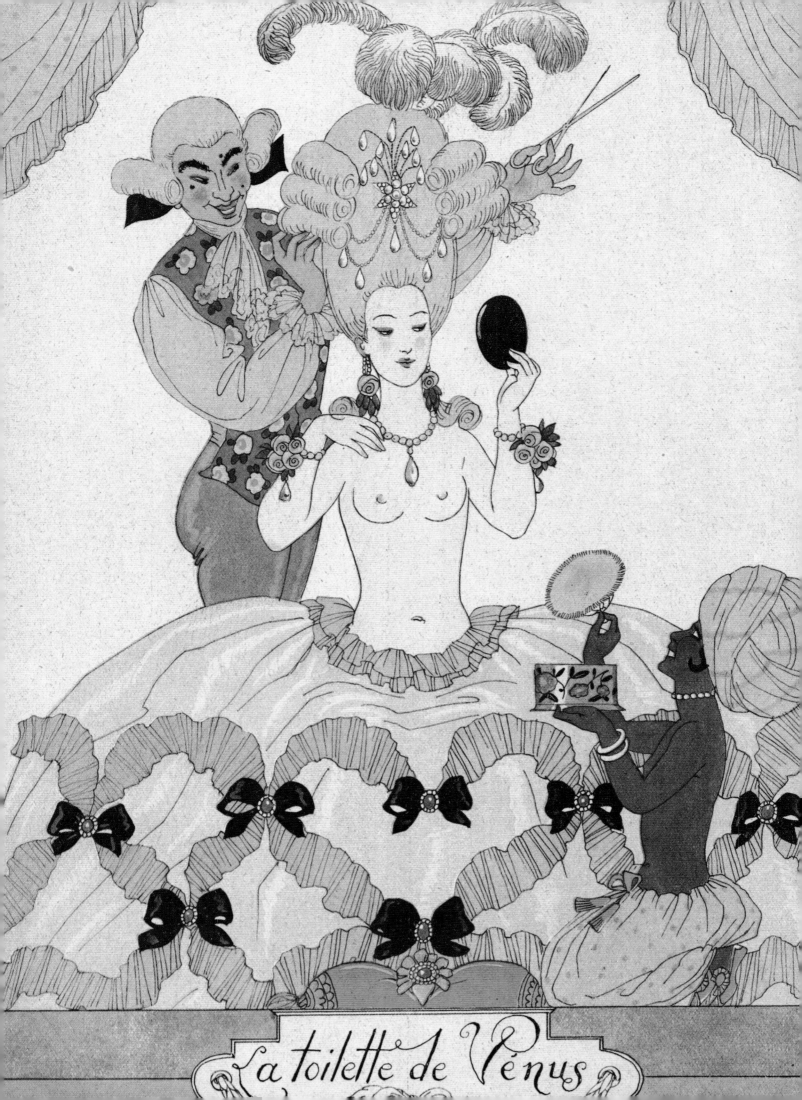

La toilette de Vénus

opposite *By the early twentieth century the cynical courtesan was a Sadeian figure of deepest depravity who appeared regularly in erotic and risqué representation.*

below *Marlene Dietrich poses as an eighteenth-century vamp, one of the many versions of the* femme fatale *popular in pre-war Hollywood and European cinema.*

sculpture. There, indeed, hung that lascivious couple, the symbol of tribadism. 'Let us follow their charming example.' And so saying, she slipped her tongue into my mouth." [26]

By the end of the eighteenth century a veritable cult had grown around this room of pleasure, and the boudoir was consistently used in fiction as a scene of illicit seduction. The aesthetic of the boudoir was now complete – a shrine to femininity, a place of leisured pampering, Venetian mirrors, gilded cherubs, and erotic pleasure, all in a rococo-inspired style. In 1932, the fashion historian Gertrude Aretz summed it up thus:

"The mere phrase *dix-huitième siècle* conjures up a vision of a veritable paradise on earth; and no matter how far such a picture may be from reality, it has imposed itself ineffaceably upon the imagination of the world. Those courtly gallants, their velvet and silk clothes bedecked with diamonds, feathers, and gold, and those ethereal ladies, in mythological costumes, in charmingly seductive negligees, in piquant dishabilles, seem to have lived solely for enjoyment and sensuality." [27]

This is made abundantly clear in the plethora of boudoir imagery that appears throughout the nineteenth and early twentieth centuries, before modernism as an international style took hold in the 1920s. The eighteenth-century courtesan, with her towering powdered hair and paniered skirts, takes the form of a voracious *femme fatale* in the work of Aubrey Beardsley and gentlemen's magazines such as *La Vie parisenne*. Perhaps, as the literary historian Nicole Reynolds suggests, this was "a cultural sign of feminine sexuality whose referent had been seemingly suppressed under the weight of Victorian conventionality". [28] This eighteenth-century *maîtresse* embodies a more decadent form of eroticism in keeping with other *fin de siècle* representations of women. The vision of a woman as seductress was assuming a far more powerful form.

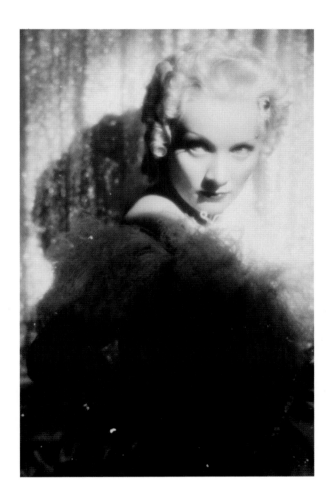

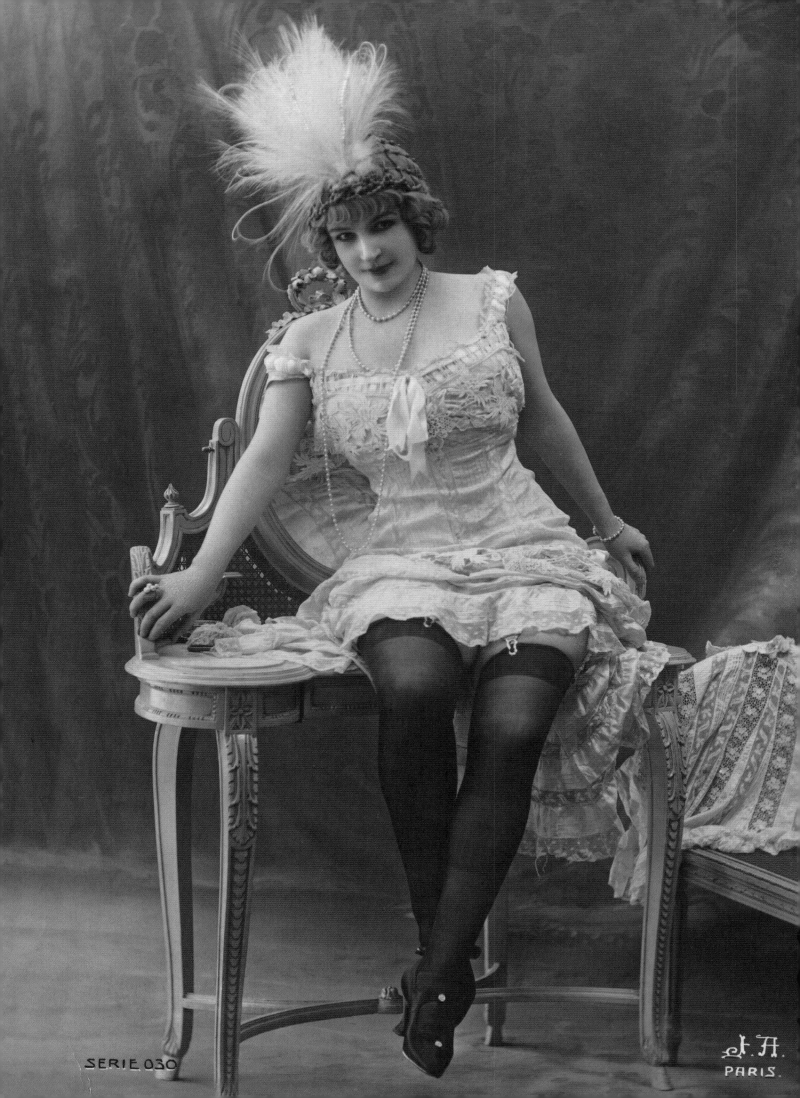

SERIE 030

PARIS.

A GLIMPSE OF STOCKING

"Your money cannot buy my love ... but it will put you in an excellent bargaining position."

<div align="right">

La Belle Otéro (1868-1965) [1]

</div>

previous pages *In this early boudoir photograph, a corseted seductress sits on a rococo revival dressing table, presenting her body as an object of delicious artifice ready to be unwrapped.*

opposite *The cancan, as performed at the Moulin Rouge, played on the open display of the petticoat and drawers – private items of underwear that were normally hidden.*

The 1890s in Paris witnessed the birth of what is now known as *la belle époque*, a decade as sparkling as champagne before the cataclysmic horrors of the First World War. Culture was in transition as people questioned sexuality, the rights of women, relationships – even love itself – as the old century due to a close. This was an era dubbed "decadent" by those who disapproved of it.

Paris was a glittering city of erotic pleasure. The Italian writer Edmondo de Amicis was overwhelmed by the *grands boulevards* where: "Windows, shops, advertisements, doors, facades, all rise, widen and become silvered, gilded and illumined. It is rivalry of magnificence … which borders on madness.. The eye finds no place upon which to rest." It appeared to be a "city of coquetry and pride … a great, opulent and sensual city, living only for pleasure and glory." [2]

The city's gaudy attractions are perhaps best expressed in its most infamous and anarchic dance: the cancan. It was performed at the Moulin Rouge, a saucy nightclub known as "The Palace of Women", which first opened its doors in the district of Montmartre in 1889. The spectacle was not one to be forgotten:

"As the band struck up, the girls would come out to the centre of the dance floor, start with a few relatively simple steps and then work up to a frenzy, spinning around like tops, turning cartwheels sometimes, and punctuating their gyrations with the famous high kick, the *port d'armes* ('shoulder arms'), when the dancer would stand on the toes of one foot, holding the other foot as high as possible with one hand. The other main feature of the *chahut* [cancan] was the *grand écart* or 'splits' when the dancer would make a spectacular finish by sitting down on the floor with both legs stretched out absolutely horizontally. It was a noisy stamping dance, it was earthy and animal, performed to a rough-and-ready clientele in an atmosphere of tobacco smoke, sweat and cheap perfume and … highly erotic." [3]

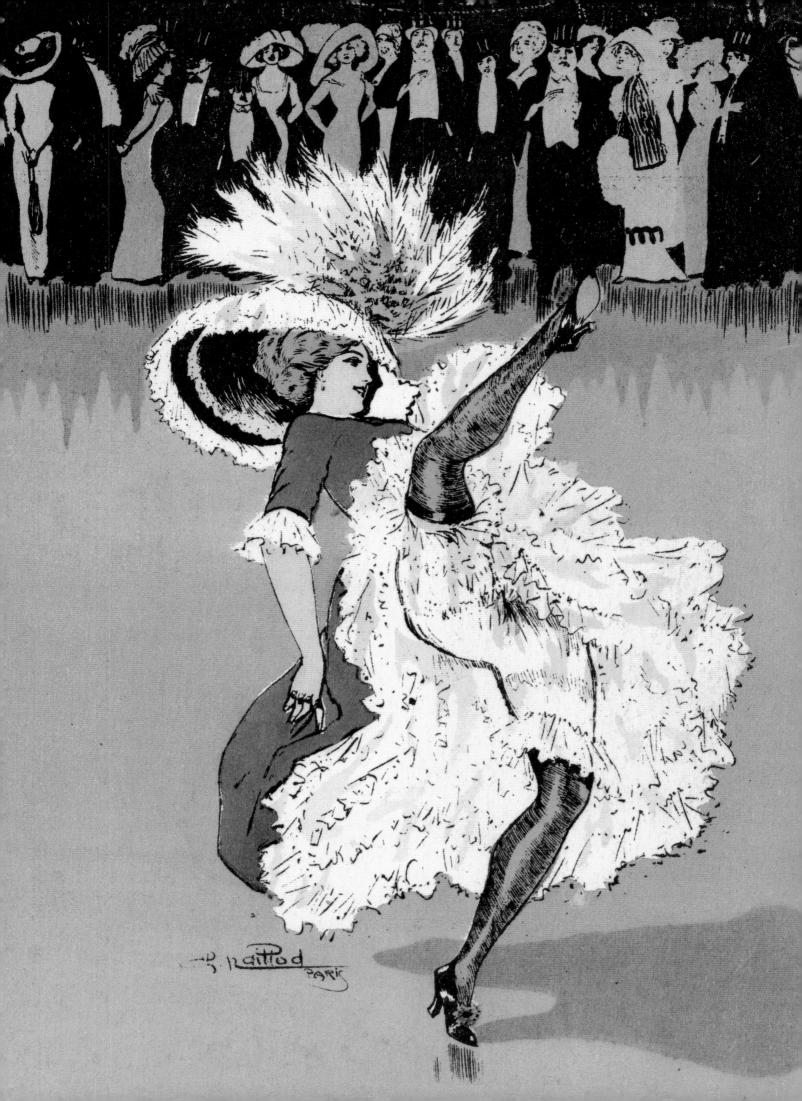

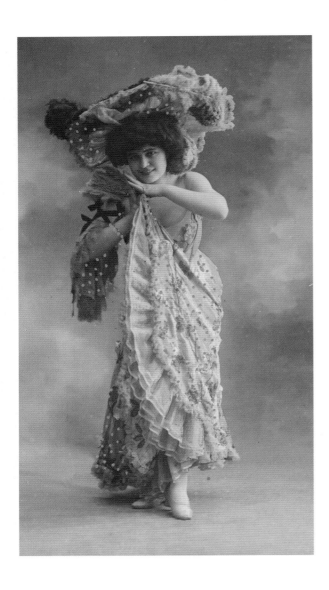

The erotic charge created by the cancan's "uncontrolled frenzy of intoxicating movement" [4] came through the chance sight of stocking tops, some bare thigh, and frilly knickers, openly displayed by dancers in an era when women were modestly clad from head to toe during their day-to-day lives. The petticoat, in particular, was considered an extremely seductive garment, and played a key role when the celebrated dancer Saharet kicked up her legs and flashed metres of thrilling frills, an erotic look that spread to everyday life amid more sophisticated women of fashion. The display of Valenciennes lace, rose chiffon, or apple-green taffeta petticoats was made rather more suggestive by a coquettish lifting of the skirts to move across a room or while alighting from a carriage, delighting any male observers.

Cascading petticoats were known as "froufrou", a word that described the rustle of taffeta when rubbed against the coarser material of the skirt. The sound was instantly intoxicating, the most evocative of sounds for the Edwardian gentleman, one of whom advised others to "take your time to listen to the music of fabrics. This music is at the heart of man's desire." [5]

Stockings also played a suggestive role, leading the eye to a finely turned ankle and up a shapely leg ... to who knew what pleasures beyond. They could be highly decorative items fashioned out of yellow silk, or violet cashmere with inserts of lace in the front, each held up with decorative garters bedecked with huge satin ribbons or clusters of lacquered fruit. Thus in Paris, as historian Cornelia Skinner describes,

"woman was an erotic queen whose very clothes rustled with innuendo. The lifting of her skirt was erotic. The act of pulling up skirt and petticoat together to just the proper height was an art. The movement could be highly seductive or comically awkward. Emile Bergerat, a well-known observer of the passing scene, used to sit out on a café terrazzo on windy days for the pleasure of watching ladies defend the honour of their legs." [6]

opposite *The dancer D'Argent of the Folies Bergères, the Parisian nightclub famed for its dancers, displays her petticoat, the most seductive garment of* la belle époque.

below *A saucy postcard of the late nineteenth century shows how the most casual daily encounters could be given a sexual frisson with the "accidental" display of a finely turned ankle and stocking top.*

"Puis-je vous être utile ??"

opposite *Courtesans were socially mobile seductresses, predatory women who displayed their charms in the most fashionable bars and cafés of Paris in search of a wealthy benefactor.*

And the established "queens of the erotic" were the courtesans of the demi-monde, including women such as La Belle Otéro, the bisexual Liane de Pougy, and Emilienne d'Alençon, collectively known to a disapproving public as *les grandes horizontales*. Lauded by their contemporaries as having no rivals in the art of seduction, or what was known as *galanterie*, and amassing enormous fortunes through their powers of bewitching men, these women refused to obey the conventional rules of heterosexual love and remained independent and in control, choosing lovers for their own pleasure in an era when women had little power outside the home. As a result, every move of *les grandes horizontales'* was documented in the gossip columns of the European press, to be avidly consumed by a curious public who, while outwardly disproving of their morals, were enchanted by such flamboyant celebrity lifestyles.

Liane de Pougy, for instance, born Anne-Marie Chassaigne in 1870, fled her abusive husband to make a life for herself on the Parisian stage. She danced nightly at the city's first music hall, the Folies Bergères, thereby gaining a legitimate, if slightly bogus, career. The high point was her L'Araignée d'Or act, which, according to the historian Andrea Stuart,

"featured her – in what was no doubt a metaphor for her profession – as a golden she-spider. She wore a costume made from a few strips of gold lace, and posed in the middle of a huge, shimmering wire web, which enmeshed her hapless male victims, all in evening dress. Off-stage her antics were no less outrageous. She was said to have publicly horse-whipped Jean Lorrain, the alleged author of the above spectacle, over some slight; and to have made one of her lovers crawl the length of the Champs-Elysées, barking, to prove his affections." [7]

De Pougy's true wealth and fame, of course, came from her day job – the rich clientele she established of both male and female lovers, including the American heiress Natalie Barney, and Romanian royalty in the form of

Prince Georges Ghika of Moldavia, whom she went on to marry when she was 39 and he was 24. After a lifetime of amorous adventures, she ended her days by joining a convent as a repentant lay sister in the Order of Saint Dominic in 1950.

La Belle Otéro, a Spanish dancer once described in the French press as "the most scandalous person since Helen of Troy", was, according to her own memoirs, both irresistible and proud of her lifestyle:

"Ever since my childhood, I have been accustomed to see the face of every man who passed me light with desire. Many women will be disgusted to hear that I have always taken this as homage. Is it so despicable to be the flower whose perfume people long to inhale, the fruit they long to taste?" [8]

Otéro was a talented performer, both in and out of bed, and renowned for her salacious fandango, a lascivious dance "of an orgiastic character" [9] according to the painter Paul Klee, which she would perform after leaping onto a table at the notorious restaurant Maxim's de Paris; it was a wild dance, so erotic that the cartoonist Sem remarked, "I feel my thighs are blushing." [10] Otéro had a list of lovers that spanned Europe and included Edward, Prince of Wales, who gave her a hunting lodge outside Paris in which to hold their clandestine meetings, the King Alfonso XIII of Spain, Kaiser Wilhelm II, and Nicholas, Czar of Russia.

She was rapacious and mercurial, amassing a fortune in jewels from her lovers, which she flaunted at every public opportunity, declaring, "no man who has an account at Cartier's can be regarded as ugly." [11] It was Cartier, in fact, who created the most extraordinary bolero for Otéro out of ten million francs' worth of precious stones, "set into a gold frame with thirty large diamonds hanging at the end like huge tears, and a pair of diamond ropes each glistening with twenty stones, secured at the centre by a large diamond clasp." [12] The value was such that it was

22e Année — N° 31 — Vendredi 31 Janvier 1902 CINQ CENTIMES LE NUMÉRO 22e Année — 12 Pluviôse an 110 — N° 31

LE RADICAL

Journal ... Littéraire

below *A group of bawdy courtesans at Maxim's, the Parisian restaurant where La Belle Otéro regularly danced on the tables in so vulgar a fashion that one diner described his thighs as "blushing" in response.*

opposite *La Belle Otéro in the pose of an exotic belly dancer, her jewels as seductive as the veiled body beneath, the glimpsed outline of her thighs daring in 1901, when the photograph was taken.*

CHEZ MAXIM'S (6 heures du matin) — AT MAXIM'S (Six O'Clock in the morning)

318

kept in a bank vault, and whenever delivered to Otéro had to travel in a reinforced carriage accompanied by two armed gendarmes.

The writer Jean Cocteau gives us a glimpse of her exaggerated personal style:

"I saw Otéro at dinner tonight. It wasn't exactly an 'under-dressed' affair. She was swathed in whalebone, silk girdles, suspenders, gaiters, gloves, corsets, halters of pearls, covered in feathers, and velvet and satin belts. Her hair was piled up. She wore false eye-lashes, and was covered in a variety of brooches, Egyptian and Japanese, and furs of ermine and sable. In truth she was harnessed rather than dressed. This bosomy soubrette, it seemed to me, had as much chance of getting out of these clothes as does an oyster from its shell. To undress her would be a costly enterprise which I could only compare to moving house with all its belongings." [13]

Otéro was a spectacle, a masterpiece of elaboration that only hinted at the body beneath. Eroticism derived from her body's packaging rather than its flesh, blood, and bone, and also from what that packaging signified: that Otéro could be bought but only by the very richest, and her magnificent jewels represented her sexual prowess.

After a lifetime of sexual bartering, two husbands, and literally hundreds of lovers, Otéro retired to Nice, where she gambled away her vast fortune at Monte Carlo's casinos, a fortune that included her own Pacific island given to her by a besotted Emperor of Japan. She eventually died, unrepentant, at the age of 97.

Women like Otéro, whose blue-black hair was offset with glittering diamonds, sparkled in private apartments or in public at Club Été or Maxim's, which was the famed haunt of the city's women of pleasure, in particular a bar in one of its many rooms dubbed The Omnibus. Every wall was covered in mirrors, thereby intensifying the flash of the *grandes horizontales'* jewelled aigrettes, and it was

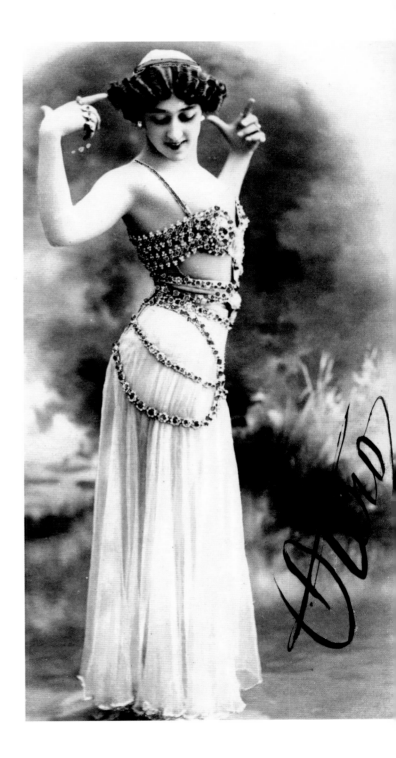

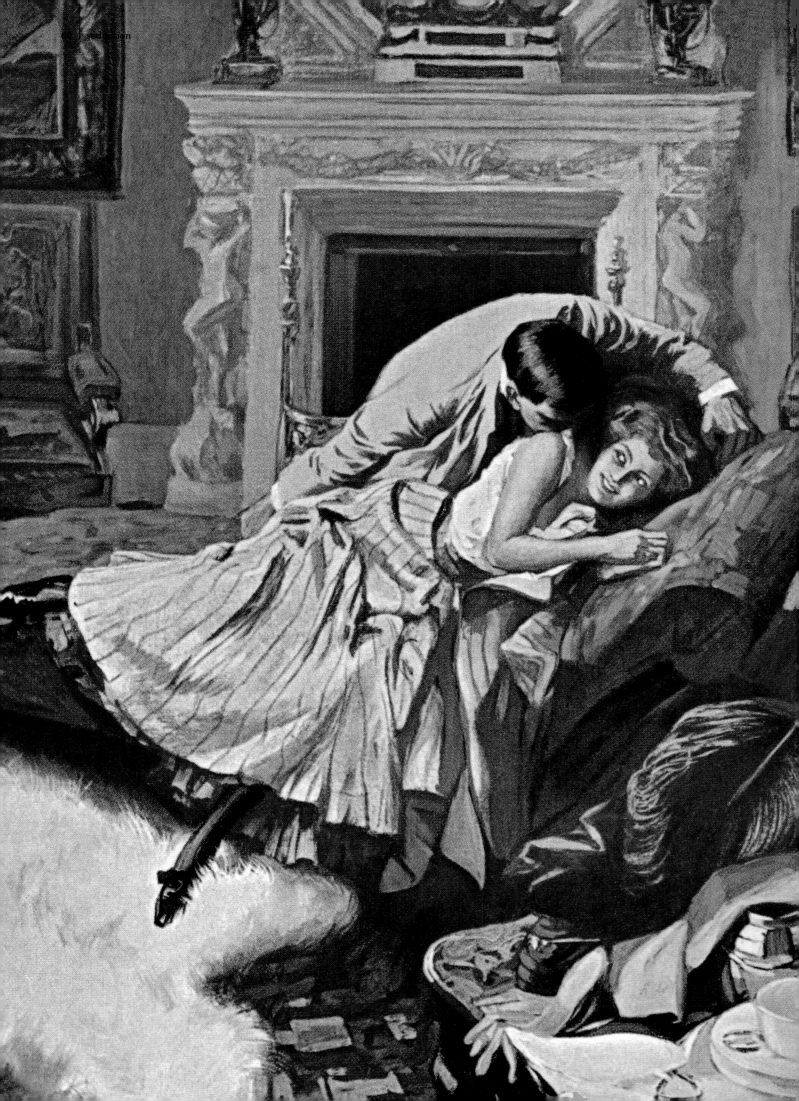

in this seductive setting that Liane de Pougy observed one of her rivals, Mimi Saint-Cyr, who was:

"waiting for twelve o'clock to strike. She had twelve glasses of kummel ready on the table. At the twelfth stroke the table was clear! What dexterity and what a capacity! I watched her with my mouth agape. Everyone crowded round to congratulate her. She wasn't very drunk, just as gay as can be, and believe it or not she danced with her usual skill. It was that evening that she made a long-lasting conquest of the little Prince of Annam." [14]

These were women who, quite clearly, broke the rules – or appeared to – for however brazen their behaviour there was a certain etiquette attached to *galanterie*, and unwritten codes to be followed. A young man was expected to enjoy a healthy love life, and so married men could have mistresses (and women could also have lovers – as long as they were discreet). However, divorce was a no-no, an occasion for social ostracism and disgrace. Secret dalliances were dubbed "four to fives", because the afternoon was the perfect time for an assignation and required military precision – coachmen had to be ordered to the required destination and then compelled to turn a blind eye to the sexual shenanigans while there. Once inside her bower of love, wherever that may be, a woman had seriously to consider how to undress and dress without the aid of her usual maid. A husband could easily realize he was being cuckolded if he found his wife's corset inexpertly laced or a gown's button left unfastened; and, such was the problem, women had to make plans well in advance. One rather cynical player had specific stipulations for meeting her lover:

"Figure out, chérie, how many times a day I am obliged to change. I get out of my negligee to take a bath … that's one. I take off my street suit for my fittings, at the couturière, that's two. I change my afternoon calling frock, which is three, for my dinner gown, number four, and every other night there's a late ball which makes a fifth change … and my nightgown makes an exhausting

below *Showgirl Camille Clifford epitomized the Gibson Girl, an ideal of femininity created by illustrator Charles Dana Gibson. Her figure swathed in fur, she poses as an* objet de luxe.

opposite *A fashion plate from* L'Art et la Mode *of the late nineteenth century depicts a modern Eve, the original seductress, her dress displaying her body as forbidden fruit.*

sixth. And so I told my handsome friend 'If you want me to undress a seventh time, I must have a maid to help me. And that's not all! I warn you that I don't know how to do up my own hair so I must have a coiffeur, preferably from Lenthéric, to arrange it.' At which the charming wretch assured me that he wouldn't dream of disarranging a single strand, to which I countered, wasn't that as much up to me as it was to him and wasn't he taking for granted my immobility?" [15]

Relationships had rules, especially those with *grandes horizontales* who subscribed to "contracts without passion" [16] with the men who could afford to keep them in the luxury they demanded. In return they were sexually available and stimulating company, and also displayed to the city's elite that the man who paid the bills could afford such an expensive luxury and was thus credit-worthy, a success in business, and a man to do business with. In return, the kept woman distracted herself by spending money on fripperies and making herself look fabulous for an evening at the latest fashionable cabaret. As Octave Uzanne commented:

"The men of the world who form a liaison ... with a *horizontale* ... keep a woman as they keep a yacht, a stud, or a sporting estate, and they require of her everything that can augment the reputation of their fortune and improve their chic in those circles where one is observed and esteemed according to the scale on which one lives. Thus, they are more susceptible to the toilettes of their fair friend than even to her beauty or youth What they want of her is neither love nor sensual pleasure, but the consecration of their celebrity as viveurs." [17]

Above all else the *grande horizontale* had to look good, and to create exactly the right impression she was prepared to spend a king's ransom – and often did precisely that. The extravagant spending was boundless, as Aretz describes:

"a positive fury of extravagance, an orgy of spending, seemed to possess them all. Everything was subordinated

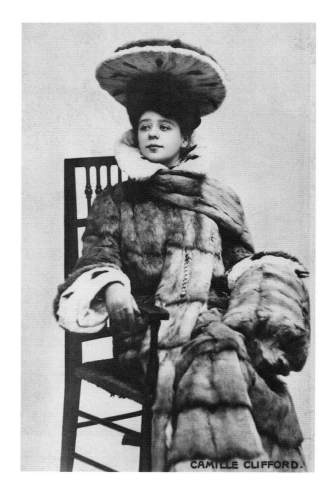

CAMILLE CLIFFORD.

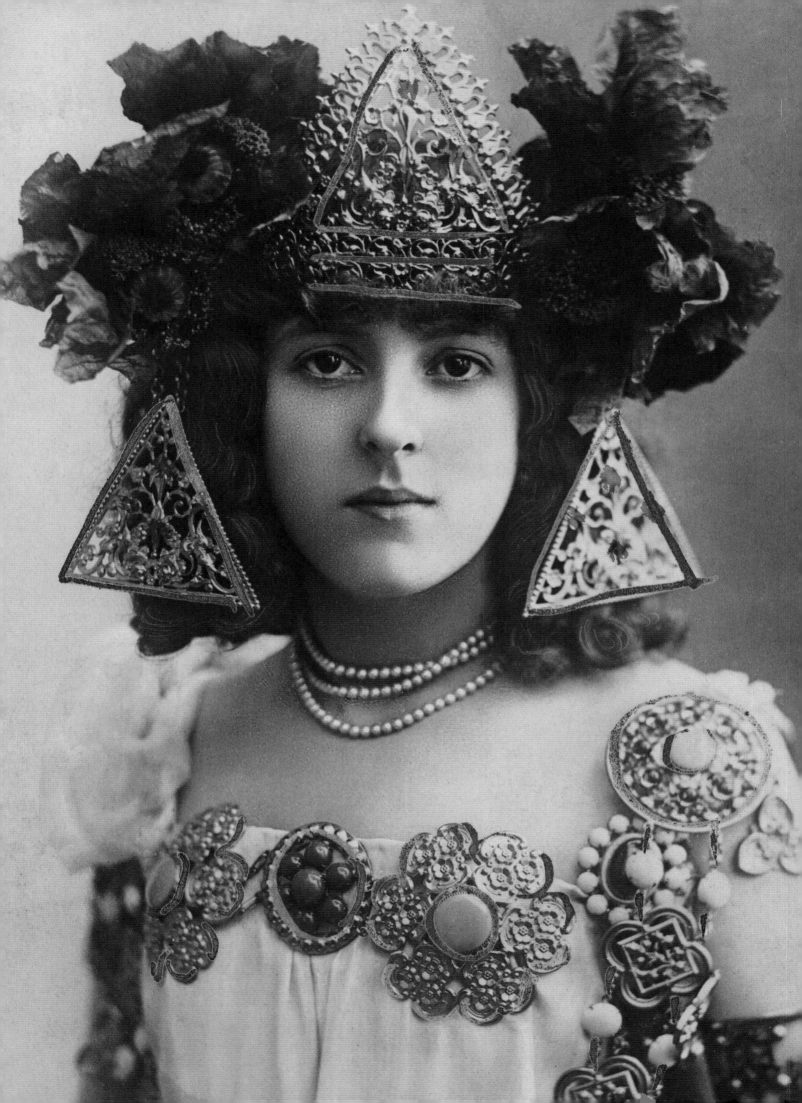

opposite *Emilienne d'Alençon performed at the Folies Bergères with a troupe of trained rabbits. A famous courtesan, she wears the costume of an Art Nouveau-inspired Salome.*

to the purposes of ostentation, and even the less reputable places of amusement were filled with women in dresses of silk brocade, dresses of corded silk covered in gold or silver sequins, little coats, called casaquins, trimmed with rich embroidery, expensive shawls, Arabian burnouses with diamond buckles, gold-embroidered tartalin, lace with fringes of real gold, not to mention the jewels, medallions, brooches, pendants, and necklaces of Oriental pearls." [18]

La Belle Otéro, by stalking to her special table with her face powdered and rouged and eyes rimmed with kohl, her hat bedecked with feathers and birds of paradise, trailing chinchilla and clouds of ylang-ylang, her bare shoulders lit by the iridescent glow of the Lalique glass roof, was proclaiming the taste and deep pockets of her latest paramour, making him the envy of fashionable Paris. Emilienne d'Alençon was another prize for a wealthy man, with her "enormous golden eyes, the finest and most brilliant complexion. A proud little mouth, a tip-tilted nose you could eat, (and) an oval face." [19] D'Alençon was renowned for entertaining dressed in pink taffeta and lace with her pet rabbits dyed to match, or dressing up as a naval officer in shorts, "her little curly head dyed red with henna to visit scandalous bars patronized by inverts [homosexuals]". [20] According to her great rival (and sometime lover, according to gossip) Liane de Pougy, "she carries on with her fantastic and vicious little life, pays no heed to nature or to the Creator, enjoys herself according to her whim" and, most importantly, "could be beastly!" [21]

"For instance, she said to me: 'I know you're going to be at this big dinner tonight. Don't dress, I shall be wearing just a coat and skirt and a blouse and one row of pearls. You do the same, so that we'll be alike.' So at eight o'clock there I am in my simple little suit and one row of pearls – and at nine o'clock in sweeps my Emilienne resplendent in sumptuous white and gold brocade, dripping with diamonds, pearls and rubies, no hat, her curls full of sparkling jewels. 'Oh dear – am I late?', with a delicious little pretence at absent-mindedness! One

opposite *A boudoir photograph, the name given to an erotic image for gentlemen collectors, shows a seductive nude who uses a veil to both conceal and reveal her curves.*

careless, hardly teasing glance at me , and she doesn't speak to me for the rest of the evening." [22]

Les grandes horizontales certainly knew how to set the stage for seduction with their "lurid glamour". [23] De Pougy describes in her diaries receiving guests "like the Queen of Sheba, reclining in a mass of mauve and blue chiffon, lace, scent, cushions and silk with an Italian greyhound lying at my side. We sipped beverages from China, nibbled sweetmeats from the South and pastries from the Ile de France." [24] And men of the highest rank succumbed: Prince Henri Dolmans gave Pougy a white poodle "washed, combed and tied with sky-blue ribbon, accompanied by these words in a letter: 'I belong to Liane de Pougy. I want to live for her.'" At first she "was enchanted" but then had to think twice as "the animal went for people's throats!". [25]

Exoticism was used to heighten this rampant seduction and provided a mania for what was dubbed Orientalism in the early years of the twentieth century, after the stunning success of the Ballets Russes production of *Schéhérazade* in 1910 and the theatrical fashion designs of Paul Poiret. Women sinned on tiger skins in rooms heady with incense, swathed in silks and velvet, or played the part of Art Nouveau *femmes fatales*. This sinuous, snake-hipped style infiltrated European and American design at the turn of the century, and popularized the notion of the decadent woman being a harbinger of death to the men enraptured by her mesmerizing yet fatal beauty. This was a very different representation of femininity from the one that had dominated most of the nineteenth century. Women were supposed to be domesticated keepers of hearth and home – yet the *femme fatale* was mysterious and dangerous, a woman who lured men to their doom with her sexual magnetism.

The *femme fatale* was an ancient stereotype of femininity, stretching back to Eve and her forbidden fruit in the Garden of Eden, but it gained what the historian Valerie Steele calls:

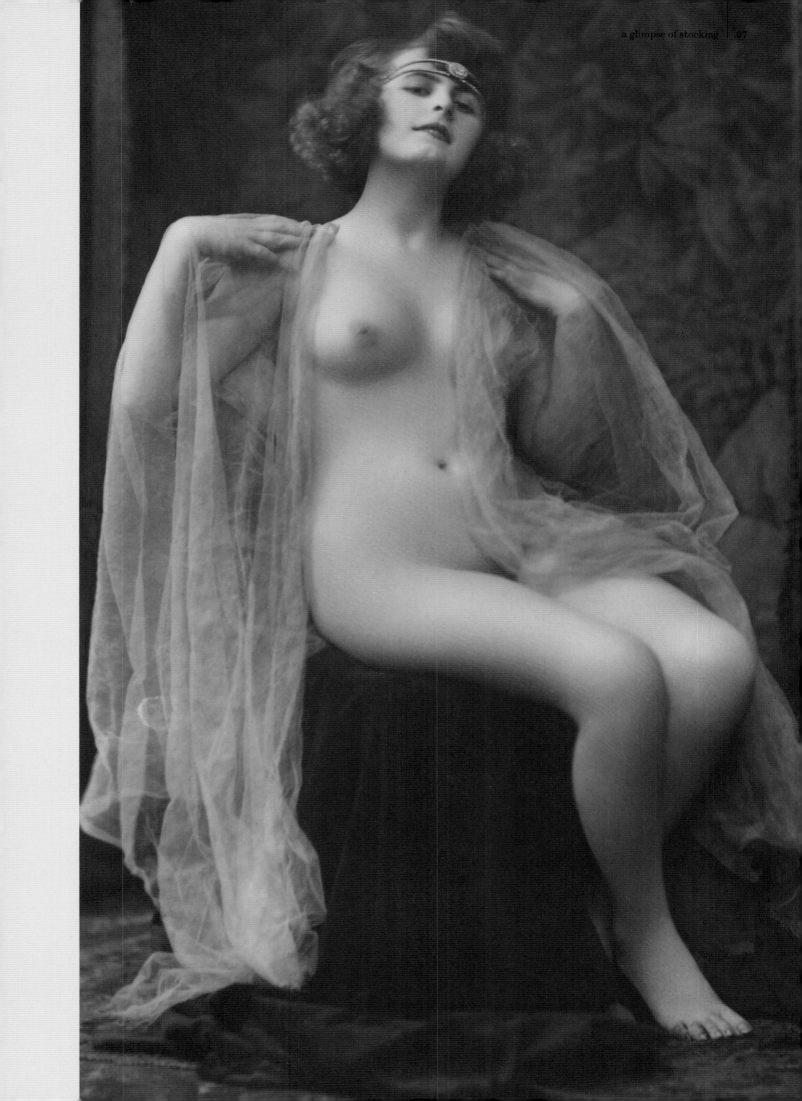

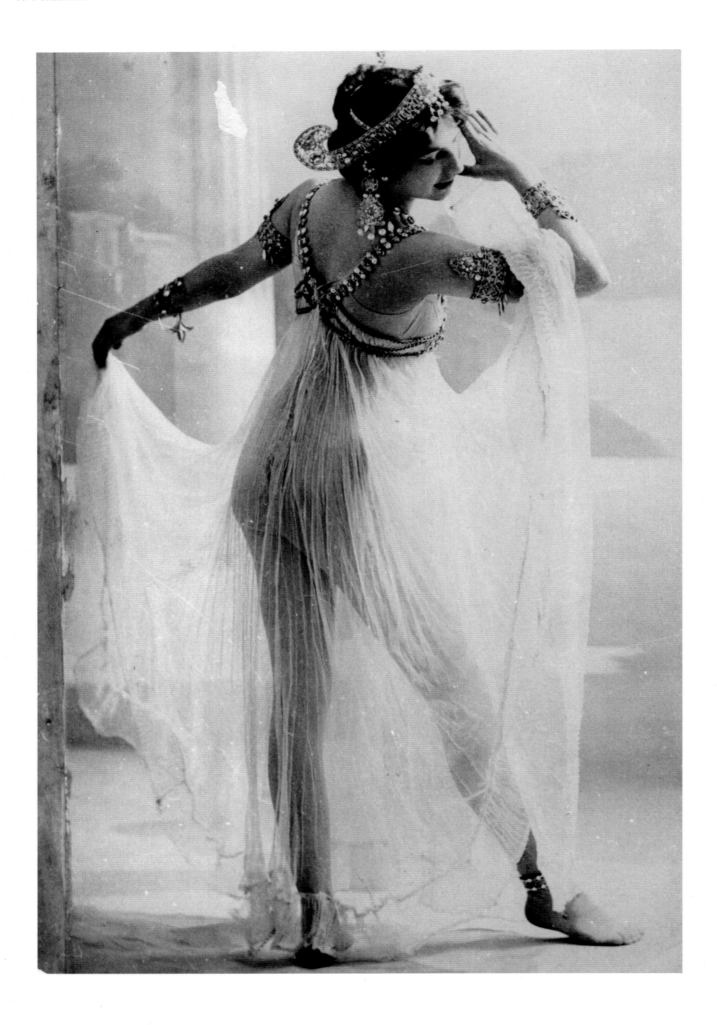

opposite *Mata Hari was an exotic Orientalist dancer of Dutch descent who posed as a princess from Java while pursuing a double life as a courtesan and spy. She was executed by firing squad in 1917.*

below *A voluptuous modern beauty of the early 1900s models an embroidered open-worked camisole covering a corset, with lavishly embroidered stockings held up by beribboned garters, the ensemble finished with high Louis heels.*

"new currency at the end of the nineteenth century, when the position of modern women aroused particular anxiety. Behind the image of the *femme fatale*, the irresistibly attractive woman who leads men to destruction, lurked the specter of the fashionable Parisienne. Far from being a frivolous figure, she embodied the metamorphoses of the modern woman and the destructive power of fashion to obliterate distinctions between different types of women." [26]

Seductive fashion was no longer for the aristocrat who could afford the privilege – it could be bought by women who had the cash at their disposal, no matter where it had come from. And women such as the *grandes horizontales*, who had no more rules to break, could look as lavish as possible because, of course, in the public's eyes they were already vulgar. As a result, by becoming an international celebrity, a "showgirl" such as Gaby Deslys, one of the most famous (and rich) beauties of the *belle époque*, could parade in gowns that were blatantly erotic and inspire legions of more "respectable" women to do the same, albeit in rather tamer versions.

Within the boudoir a more overt sensuality than had been allowed for most of the nineteenth century began to creep in. A wealth of feminine style was available, from chinoiserie through rococo revival to domestic Gothic, as long as it created the right sexually charged ambience. The celebrated American author Edith Wharton gave advice on boudoir etiquette in one of the first popular books on interior decoration written for an American audience. In *The Decoration of Houses*, co-authored with the architect Ogden Codman in 1898, she castigated typical Victorian domestic style – all overstuffed furniture and rooms crammed with "jardinières of artificial plants, wobbly velvet covered tables littered with geegaws and festoons of lace on mantelpieces". [27] For the modern boudoir she felt that pretty chintzes and cotton covering a simple day bed were more apt. A similar aesthetic had been broached in 1878 by Lady Barker in *The Bedroom and Boudoir*, who recommended a subtly ornamental treatment with "conscientiousness of every

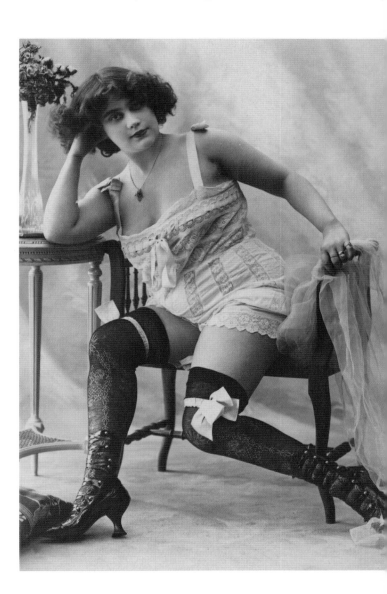

below *An "orgiastic negligee" from a risqué gentleman's magazine*, La Vie Parisienne *c.1900s. Lingerie design was changing underwear from fantasy to functional by the early twentieth century, thanks in the main to the English designer Lucile.*

opposite *A French boudoir scene of frilly femininity in rococo revival style. Mme Blanchard wears an informal tea gown – a style of dress related to the* déshabillé *aesthetic of the eighteenth century.*

detail" and an emphasis on "prettiness" with soft tints of grey and "tender sea shell pink" [28] with lashings of fluted white muslin.

Providing the crowning glory of the *fin de siècle* boudoir was the seductress bedecked in a gorgeous tea gown – an item of luxurious yet informal dress invented in the 1870s, to be worn privately when "entertaining" friends at five o'clock tea. The tea gown was a little scandalous because it was devised to be worn while relaxed and thus without corsets, which by the end of the nineteenth century were compressing the body into a pronounced S, or what was known as the "swan shape", with the bust thrust forward and the bottom out behind, with suspenders attached to hold up stockings. Covered in the frothiest of lace, a sash delineating the waist and with pretty puff sleeves, the tea gown was the direct descendant of the *déshabille* beloved of the *maîtresse en titre* in the eighteenth century.

Other new intimate items of lingerie were emerging, as one fashion writer put it in 1907, to be "utilized only in the house, from the *robe de chambre* in rather thick material … or the more lightweight peignoir … to the elegant *robe d'interieur*", [29] "diaphanous robes, a product of our age, and calculated so splendidly to show off the grace of the modern woman". [30] Dressing for sensual pleasure was a fairly new concept for many women, and designers and female consumers responded with enthusiasm to the new styles, soft fabrics, and intricate devices embroidered on highly feminine undergarments. Octave Uzanne noted how:

"The lingerie shops have grasped in a wonderful way that it is impossible to devise trimmings sufficiently fantastic or silks sufficiently transparent. To invent enough filmy, flimsy materials in delicate, dainty colours. Lace from Valenciennes, guipures from Ireland, enchanting laces from Mechlin, Chantilly, and Alençon, and *point de Venise* are used to deck the fashionable beauty." [31]

And Emile Zola wrote of lingerie displays that looked "as though a group of pretty girls had undressed, layer by

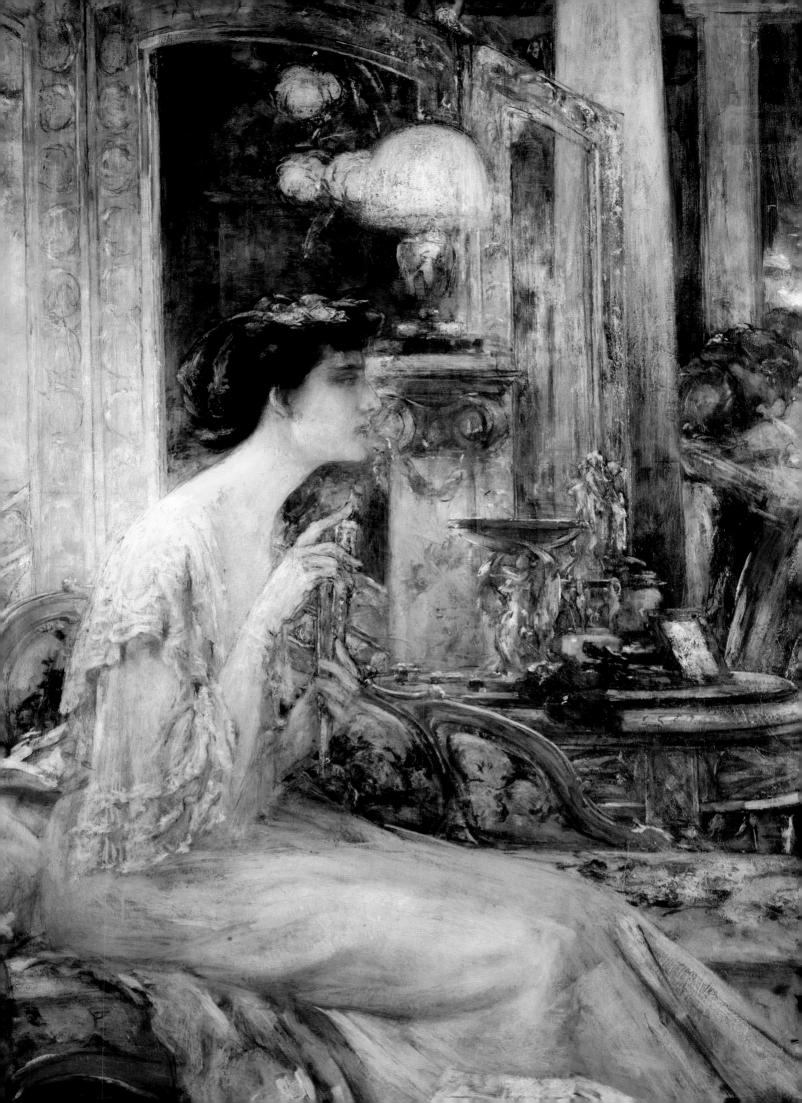

layer, down to the satin nudity of their skin". [32] The pioneer of lingerie design was London-based Lucile, who introduced a staid public to delicately fashioned camisoles, peignoirs, and petticoats of lace, chiffon, and crêpe de Chine, evoking all manner of lustful feelings in men. In 1890 Lucy Wallace, soon to become the eponymous Lucile, set herself up as a dressmaker in Old Burlington Street, London. She wanted to create beautiful lingerie to be worn under her stunning outerwear, or what she named her "Gowns of Emotion" – eveningwear designed to inspire a passionate response. Models walked out onto a miniature stage through olive chiffon curtains in dresses with names such as Give Me Your Heart, The Sighing Sounds of Lips Unsatisfied, which was described as "a soft, gray chiffon veiling an under-dress of short pink and violet taffeta", [33] Red Mouth of a Venomous Flower, and the rather wistful When Passion's Thrall is O'er. With such stunning outerwear, Lucile felt that underwear had to live up to pretty high expectations. She particularly hated:

"the thought of my creations being worn over the ugly nun's veiling or linen-cum-Swiss embroidery which was all that the really virtuous woman ... permitted herself. I vowed to change all that, and made plans for the day of chiffons and laces, of boudoir caps and transparent nightdresses. I was so sorry for the poor husbands who had to see their wives looking so unattractive at night ... So I started making underclothes as delicate as cobwebs, and half the women of London flocked to see them, though they had not the courage to buy them at first Those saucy velvet bows on the shoulder might surely be the weapons of the woman 'who was not quite nice'? but slowly one by one they slunk into the shop in a rather shame-faced way and departed carrying an inconspicuous parcel, which contained a crêpe-de-chine or a chiffon petticoat." [34]

Pioneers such as Lucile helped the acceptability of luscious underwear to gain momentum, as did the new notion that the expression of a healthy love life within marriage was beneficial. This new notion was discreetly

left *A crocheted boudoir cap of the early 1900s, to be worn as an informal head covering while relaxing at home.*

below *As the fashion for lingerie spread, increasing numbers of women realized that underwear could be a form of erotic dress that played its part in seduction.*

opposite *The Edwardian hourglass silhouette was dependent on an under structure – a tight-fitting corset over which clothes were moulded. This seductive advertisement of the 1900s describes it as a garment of seduction, as opposed to one of physical restriction.*

championed, as a generation attempted to differentiate itself from the Victorians by acknowledging that women had sexual desires that did not necessarily relate to the pursuit of reproduction. The boudoir became the place for a woman to please her man – but only within the sanctity of marriage. By 1902, a female fashion journalist felt brave enough to risk stating that "Lovely lingerie" did not belong "only to the fast ... dainty undergarments are not necessarily a sign of depravity. The most virtuous of us are now allowed to possess pretty undergarments, without being looked upon as suspicious characters." [35]

Sensuality now had its place in the home and was expressed in boudoir paintings, furniture, gowns, and lingerie – all conjuring the appropriately erotic state – although interior designer and society *grande dame* Elsie de Wolf snapped "Nothing more ridiculous has ever happened than the vogue of the so-called 'boudoir cap.'" [36]

De Wolf had other rather direct views regarding the boudoir, feeling that by 1914 a woman of elegance could push the erotic boundaries a little further. Although the boudoir "should always be a small room, because in no other way can you gain a sense of intimacy," you may still "have all the luxury and elegance you like, you may stick to white paint and simple chintzes, or you may indulge your passion for pale-coloured silks and lace frills ... you have a right to express your sense of luxury and comfort." [37] However, a woman should be ever-vigilant and beware misunderstanding the inherent meanings in items of furniture: "for instance, the chaise-longue may be used in the boudoir, but in the drawing room it would be a violation of good taste because the suggestion of intimacy is too evident." [38] In her own boudoir, De Wolf had an aquarium on a teak stand full of "gorgeous fan-tailed goldfish," [39] and Wee Toi, her little Chinese dog, was housed in a Chinese lacquer box with a "canopy top and little gold bells. It was once the shrine of some little Chinese god I suppose." [40] She reclined on the chaise longue while having her hair styled, with her feet swathed in a *couvre-pieds* (literally a cover for the feet), as she

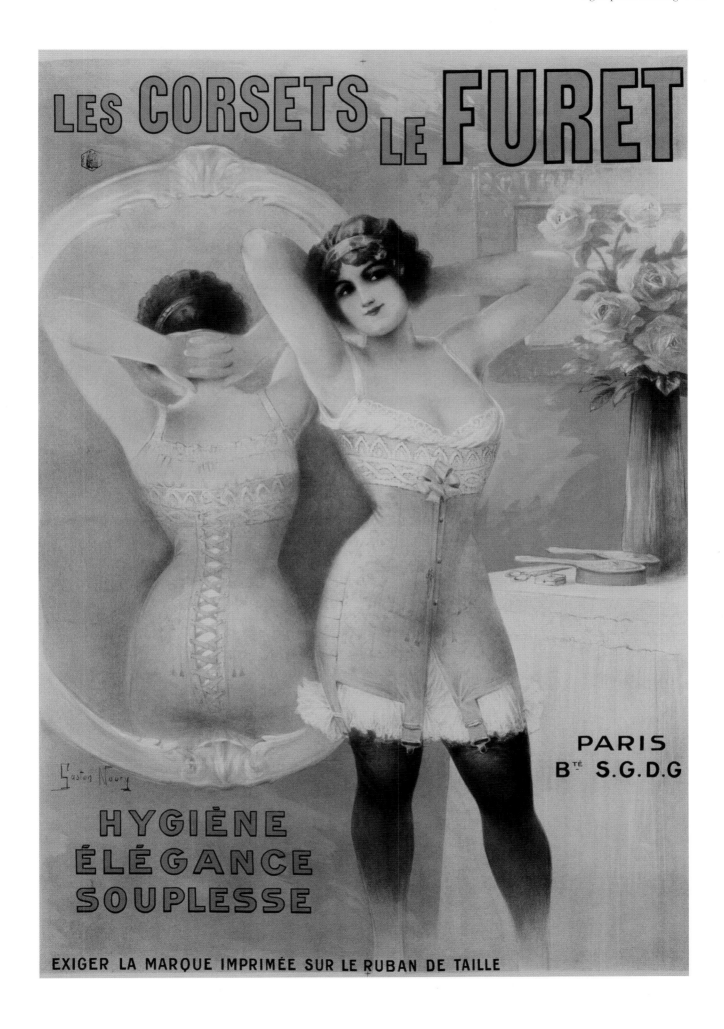

described it, "a sort of glorified and diminutive coverlet, made of the palest of pink silk, lined with the soft long-haired white fur known as mountain Tibet, and interlined with down. The coverlet is bordered with a puffing of French lace, and the top of it is encrusted with little flowers made of tiny French picot ribbons, and quillings of the narrowest of lace." [41]

In the first decade of the twentieth century the Edwardian lady now entered her boudoir, threw off her corset, donned a tea gown or richly embroidered kimono (a symbol of educated good taste thanls to the mid-nineteenth-century Aesthetic Movement), and relaxed in *déshabille*. Her style, although now respectable, had originated with the *maîtresse en titre* of eighteenth-century Versailles and the sexual underbelly of late nineteenth-century Paris. Fashion had breached the boundaries that separated the monde and the demi-monde. As the historian Kate Hickman onserves of the *grandes horizontales*, or royal courtesans:

"Like saucy sprites, they had an inconvenient habit of leaping out of the Pandora's Box to which they had been relegated. But that was not all. Although courtesans were unequivocally morally reprehensible in the eyes of decent women, it did not take any great leap of the imagination to see that the independence and sexual expression they claimed were things of which ordinary women, for the most part, could not even dream." [42]

With the advent of modernism, however, this was to change, as the development of the fashion and beauty business, the rise of the Hollywood star, and the increasing sexual awareness of women made the tools of seduction more readily available to those who had the savoir-faire to use them in the pursuit of love. Women were asserting their sexual presence.

Nights in White Satin

"Needle, needle, dip and dart,
Thrusting up and down,
Where's the man could ease a heart
Like a satin gown?"

Dorothy Parker (1893-1967) [1]

previous pages *Louise Brooks, with her raven black bob and white satin gown, typifies the new sleek chic of the 1920s, which was very different from the fussy styles of the previous decade.*

opposite *The clean lines of Art Deco were expressed in interior design, fashion, and the lithe silhouette of the flapper – a woman who painted her face, smoked, and seduced potential lovers.*

Modernist aesthetics changed the style of seduction in the 1920s, as streamlining, geometry, and Cubist-inspired forms entered the vocabulary of designers across the world in the form of Art Deco. The seductive boudoirs of the *grandes horizontales*, with their heavy drapes, heady perfumes, and Orientalism, were ignored in favour of black lacquered furniture, glass, chrome, and mirroring applied to every surface, in particular the ubiquitous dressing table, which was needed to hold powder puffs, lipsticks, and Lalique perfume bottles.

The fashionable body shape for women followed the same clean lines, all svelte serpentine slimness, Cubism made flesh, and the antithesis of the soft white pampered body of the 1890s. Women cast aside the overstuffed splendour of Edwardian costume, preferring a more minimalist fashion that showed a newly tanned and worked-out body fresh from the tennis court or ski slope. With no discernible waist, and breasts pressed flat, women presented a new *sportif* silhouette of youth and modernity.

Aldous Huxley described the new style of woman in his novel *Antic Hay* of 1923. She was "fairly tall but seemed taller than she actually was, by reason of her remarkable slenderness. Not that she looked disagreeably thin, far from it. It was a rounded slenderness. The Complete Man decided to consider her as tubular – flexible and tubular, like a section of a boa constrictor." [2]

Women seemed satiated with all things traditionally feminine after the carnage of the Great War. Hips and full breasts were out of fashion, becoming what historian Gertrude Aretz called "monuments of a former feminine beauty". [3] The writer and New York socialite Zelda Fitzgerald also noted the change. As women became more socially mobile, with their lips painted carmine, eyebrows arched, and a brilliantine kiss curl against their cheeks, – they were the epitome of urban modernism in a newly streamlined world:

"On all the corners around the Plaza hotel, girls in short squirrel coats and long flowing skirts and hats like babies' velvet bathtubs waited for the changing traffic to be suctioned up by the revolving doors of the fashionable grill. Under the scalloped portico of the Ritz, girls in short ermine coats and fluffy, swirling dresses and hats the size of manholes passed from the nickel glitter of traffic to the crystal glitter of the lobby. In front of the Lorraine and the St Regis, and swarming about the mad hatter doorman under the warm orange lights of the Biltmore façade were hundreds of girls with Marcel waves, with coloured shoes and orchids, girls with pretty faces, dangling powder boxes and bracelets and lank young men from their wrists – all on their way to tea." [4]

A new world order was in the process of creation in which gender construction was under review, as was exemplified by the hard-drinking flapper, a cigarette case in her hand, a powder compact in her purse, and sex on her mind – if the popular press were to be believed. Her lone appearance on the city streets in highly fashionable dress, which drew appreciative gazes from men whether in New York, London, or Paris, was at first confusing – wasn't this the domain of the *grandes horizontales*? And did this mean that flappers were just a modern incarnation of the cynical courtesan?

The outcry against the "hard-boiled" flapper was in part due to this cultural confusion based on accepted sexual stereotypes. Women, increasingly visible in their short skirts, cloche hats, and painted faces, had outlaw status, and also seemed to be the embodiment of male fears of women moving away from their traditional role as wife and mother. This was a modern seductress, "dangerously sexual beneath a façade of artificial charms", [5] as fashion historian Rebecca Arnold put it, and she could provoke extreme reactions. President Murphy of the University of Florida warned that "the low-cut gowns, the rolled hose and short skirts are born of the Devil and his angels, and are carrying the present and future generations to chaos and destruction." [6]

In 1922, Ellen Welles Page "came out" as a flapper for *Outlook* magazine in the United States with an article entitled "A Flapper's Appeal to Parents", asking older Americans not to judge young people by their appearance:

"I wear bobbed hair, the badge of flapperhood. I powder my nose. I wear fringed skirts and bright-colored sweaters.... I adore to dance. I spend a large amount of time in automobiles. I attend hops and proms; and ballgames and crew races, and other affairs at men's colleges We are the Younger Generation. The war tore away our spiritual foundations and challenged our Faith. We are struggling to regain our equilibrium. The times have made us older and more experienced than you were at our age." [7]

Part of this experience was sexual experience, and since sex was far less taboo by the 1920s, it was ready for more open discussion. Marriage was no longer seen as the only morally sanctioned outlet of sexuality, and female desire was being recognized as no longer just the province of the highly paid woman of pleasure.

A key change was the eroticization of leisure time for both men and women, in the form of dance halls, the movies, dating, and petting parties. Before the First World War, eligible young men would call on young women and be allowed to meet in the company of her parents before becoming betrothed. Now the rules had changed and the idea of dating began to take root. Single men and women were allowed together on their own at night, with even a little discreet loving in a car at the end of the evening occurring. Petting parties were another licence for sexual intimacy, although they meant that women had to become even more sophisticated in the art of sexual management: how to be naughty and how to be nice, how far to go before being considered fast and how much to yield for fear of being considered a prude.

Women could also take delight in reading popular novels with a scandalous content. In 1922, *La Garçonne* by Victor Marguerite flaunted a heroine who rails against the

opposite *The etiquette of sexual relationships began to change in the 1920s, when the concept of dating without chaperones was introduced. Couples had a little longer to be left alone.*

below *The bobbed and painted flapper was a brazen figure in the minds of worried moralists. In this artist's fantasy, her transparent gown stands as a symbol of declining morality.*

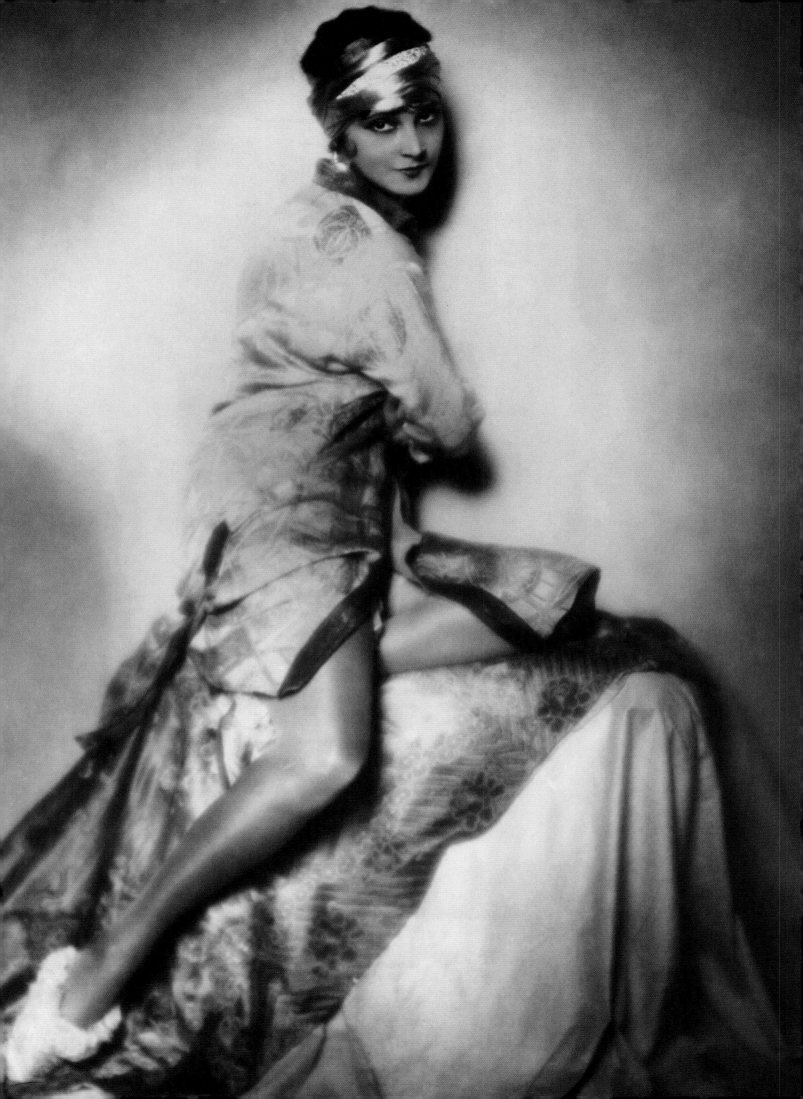

opposite *Until the 1920s, women tended their long lustrous hair, dressing it in a variety of complicated styles. The flapper reacted against this hidebound notion by sporting crops, bobs, cloches, and turbans.*

conventions of French society after the end of an unhappy love affair with her cheating fiancé and chooses the path of free love. The English equivalent, *The Green Hat* by Michael Arlen (1924), featured Iris Storm, loosely based on socialite Nancy Cunard, a woman with "a pagan body and a Chislehurst mind", [8] her mouth painted with purple, her head bedecked with a green cloche hat that figures in the book as the prime symbol of her sexual Bohemianism. Storm's hat became such a fad in Europe that green felt hats were displayed in shop windows alongside a photograph of the author. Evelyn Waugh gave a nod to Iris in his novel *Brideshead Revisited* (1945) in which one of the principal characters "like most women wore a green felt hat pulled down over her eyes with a diamond arrow in it". [9]

Iris Storm, a woman who "indulges her intolerable little lusts" [10] while wearing "369 white ermines (as if) ... wrapped in cloth of soft snow", [11] is an outcast condemned by polite society after the suicide of her first husband, rumoured to have thrown himself out of a hotel window after a surfeit of champagne on their wedding night. Powdering her face dead white using a black onyx box with her name initialled in diamonds, Iris Storm, wielding a cigarette (a rebellious act for women in the 1920s), "inhaled her smoke with a faint hiss, and her teeth were ... very smart and sharp. These were imperious dangerous teeth" [12] – her teeth as feral as her raw sexuality. Her hair is bobbed: "it was like a boy's hair swept back from the forehead ... the tawny cornstalks danced their formal dance on the one cheek I could see, and the tip of a pierced ear played beneath them, like a mouse in a cornfield." [13]

The new bobbed haircut was the focus of much disdain in the 1920s, a living, growing embodiment of a frighteningly new femininity expressed in a comprehensive movement away from the constricting, uncomfortable styles of the Edwardian era, in particular the cascades of flowing hair that had been a key instrument in man's seduction. A woman unleashing her

opposite *By the 1920s, long hair was impractical and quite simply unfashionable, yet the sleekly bobbed flapper was still at ease in the sumptuous interior of the boudoir.*

below *The modernist lines of Louise Brooks' black bob exemplified the new woman of the 1920s, who was exchanging the moribund sexual codes of pre-war culture for a new era of seduction.*

hair for the private delectation of her husband had been a scene of sexual temptation throughout the nineteenth century, but modernism changed all that. As early as 1911, the celebrity crimper Antoine de Paris recognized that change was afoot. As he explained it:

"a bell rang inside my head. The time had come for women to have their hair cut short. This new automobile in which women sat open to the winds, these new women with careers, this busy life. And these changing clothes, which demanded small, neat heads, not enormous masses of hair." [14]

One of his first shorter haircuts was for the French actress Eve Lavillière, but it was too avant-garde – out of kilter with prewar style. It was to be in the early 1920s that bobbed hair really began to catch on, perfectly complementing the garçonne look of fashion designers Coco Chanel and Elsa Schiaparelli. The neat chic exemplified in their designs was part of an aesthetic revolution whose functional lines could be seen in a *Le Corbusier* chaise longue, a Manhattan skyscraper, and actress Louise Brooks' haircut. A perfectly symmetrical bob of shiny black, Brooks' hair became a symbol of women's liberation from the moral strictures of the early twentieth century.

The bob, according to the conservative press, was a symptom of declining morality, and many deplored this new look, harking back to a time when men were men and women were women, or so it seemed through a glow of post-war nostalgia. One woman wrote:

"I feel infinite pity for the man, be he husband or lover, who is deprived of the incomparable pleasure of watching the woman he loves unloose her lovely hair in hours of intimacy, unloose it for him alone! I pity the men who no longer know what it means to see a beautiful and beloved head lying on a pillow amid a wealth of loosened hair, the men who have no conception of how entrancing a woman can be when she hides her face under the thick abundance of hair and peeps out with a roguish smile What

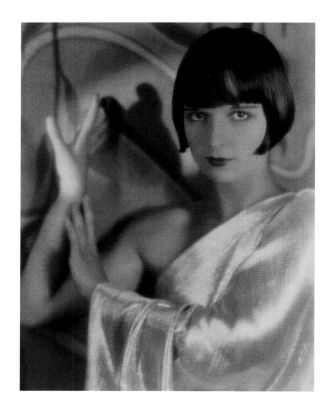

LES BAS
DE GASTINEAU
6 RUE DU FAUBOURG SAINT-HONORÉ

opposite *The shortened skirt of the flapper created a new erogenous zone – the knee. This stocking advertisement makes clear the sexual lure of this new look.*

right *The new curveless body that had become fashionable by the mid-1920s was offset by legs becoming the focus of erotic interest.*

below *New items of lingerie began to be invented in the 1920s, including French knickers and teddies – a combination of knickers and chemise.*

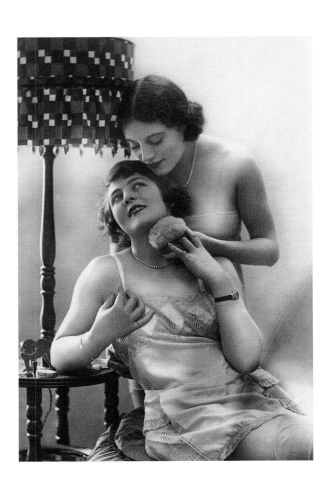

longing, envious looks followed the happy man who accompanied a woman with a fine head of hair, and who would probably in the next few minutes be running his hands through that wealth of loosened tresses! Nowadays? Why should one envy a man nowadays who is taking home a lady with a shaved neck?' [15]

It seemed that some kind of seductive mystery had gone. Women appeared to be laying bare their bodies in public, sporting shorter skirts, bared necks, and, horror of horrors, armpits, which had to be shaved of exposed and unwanted body hair. However, men's gaze was prepared to shift, and new erogenous zones were invented, in particular a woman's knees, which some rouged for extra erotic effect.

Lingerie changed its appearance to accommodate the new fashion silhouette, as the body began to take over from clothing as the principle means of seduction, causing New York journalist Bruce Blixen to comment in 1925:

"Flapper Jane isn't wearing much this summer. If you'd like to know exactly, it is: one dress, one step-in, two stockings, two shoes…. The corset is as dead as the dodo's grandfather; no feeble publicity pipings by the manufacturers, or calling it a 'clasp around' will enable it, as Jane says, to 'do a Lazarus.' The petticoat is even more defunct…."

Blixen saw it related to the fact that: 'Women have resolved that they are just as good as men, and intend to be treated so. They clearly mean that in the great game of sexual selection they shall no longer be forced to play the role, simulated or real, of helpless quarry. If they want to wear their heads shaven, as a symbol of defiance against the former fate which for three millennia forced them to dress their heavy locks according to male decrees, they will have their way." [16]

Corsets didn't entirely disappear, however: they were merely remodelled in tough elastic to flatten the hips and buttocks. Increasingly, though, women's bodies were less

opposite *A 1920s showgirl reclines on a chaise longue in a classic pose of seduction, earning the admiration of a group of stage door Johnnies.*

below *Corsets didn't entirely disappear in this decade but were re-worked into girdles: rubberized and elasticated undergarments that streamlined the body into the latest fashionable shape.*

and less dependent on underclothes to give them structure; instead, the body beautiful was all about denial – the denial of appetite – and the promotion of exercise. As *Vogue* commented in 1922: "The pursuit of slimness is one of the chief labours of the modern woman." [17] Exercise could also take the form of dancing the Charleston, tango, or Black Bottom. Jazz was seen as particularly modern and erotic, so much so that many of the older generation feared its syncopated melodies – the *Ladies' Home Journal* believed it led to "the blatant disregard of even the elementary rules of civilisation". [18]

The big departure in underwear was the adoption of the new bra invented by New York debutante Mary Phelps Jacob, under the pseudonym Caresse Crosby, in 1913. Modelled out of two handkerchiefs and a length of ribbon, this was the first piece of underwear for women that gave support while leaving the midriff free. Petticoats were practically defunct and had been overtaken by cami-knickers, loosely cut out of silk or rayon and famously worn by Florenz Ziegfeld's chorus girls. Ziegfeld had a glint in his eye as he informed his girls that the loose cut of their knickers would continually caress the insides of their thighs as they were dancing and thus keep them in a state of erotic arousal.

Less ostentatious fashion meant democracy – more women could afford this new look. The celebrated American writer Dorothy Parker described girls who:

"painted their lips and their nails, they darkened their lashes and lightened their hair, and scent seemed to shimmer from them. They wore thin, bright dresses, tight over their breasts and high on their legs, and tilted slippers, fancifully strapped. They looked conspicuous and cheap and charming. Now as they walked across Fifth Avenue with their skirts swirled by the hot wind, they received audible admiration. Young men grouped lethargically about news-stands awarded them murmurs, exclamations, even – the ultimate tribute – whistles. Annabel and Midge passed without the condescension of

"H&W" HOOKLESS *Fastened* CORSETTE

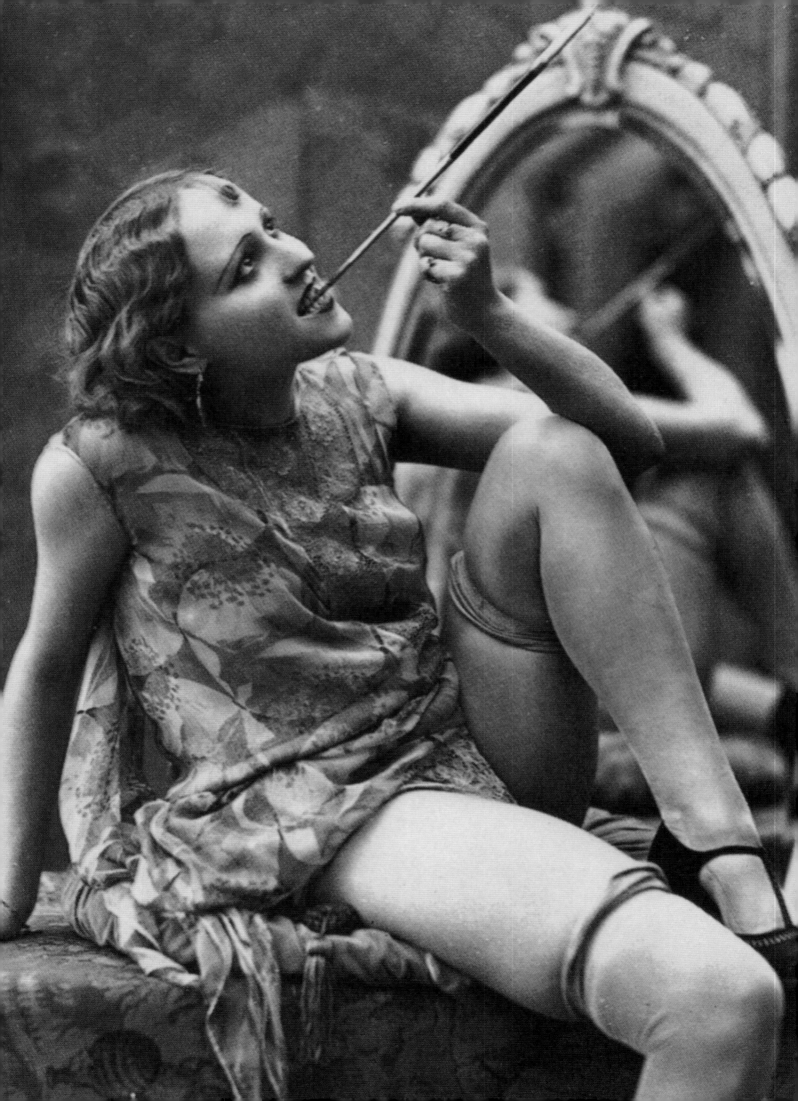

opposite *A boudoir photograph shows a 1920s "tootsie", rapaciously seductive, fuelled by bathtub gin (a homemade spirit) and nicotine – at least according to the conservative press.*

below *In a scene of boudoir seduction, Hollywood star Clara Bow, the "It Girl", bewitches with her proverbial "bedroom eyes" in this photograph of 1929.*

hurrying their pace; they held their heads higher and set off their feet with exquisite precision, as if they stepped over the necks of peasants." [19]

The new glamour was given a further push in international popularity with the birth of modern cinema. Film stars were the new celebrities, and news of their Hollywood lifestyles was avidly consumed by the public through the medium of the movie magazine. Clara Bow, the "It Girl", was the embodiment of the American "tootsie", "as new as the night's batch of bathtub gin, as shiny as the firehouse-red roadster just driven from the showroom floor. Effervescent, giddy, with rolled-down hose to show her bee's knees, the new-collegiate heroine drank, smoked, made love in cars and was as happy-snappy as bubble gum" [20] – a look very different from the vamps and *femmes fatales* of the previous decade.

Clara Bow gained fame as the protégée of the English novelist Elinor Glyn, who had scored a hit in 1907 with *Three Weeks*, a love story of "sin on a tiger skin" featuring an older married woman and a young English aristocrat. Her books on sexual etiquette, such as *This Passion Called Love*, sold millions. Her advice to the lovelorn included such gems as: "a wife ... should be elusive, mysterious, unpredictable so that her husband's hunting instincts would never be lulled to sleep, later to be reawakened by some new quarry." [21]

By the 1920s she was a writer and adviser in Hollywood at Paramount and Metro-Goldwyn-Meyer, where she advised stars on how to seduce on screen. One of her most famous clients was Rudolph Valentino, whom she persuaded to kiss the palm rather than the back of a woman's hand as a form of seductive introduction. But she achieved perhaps her most long-standing publicity with an article she penned in 1927 for American *Cosmopolitan* magazine, entitled "It". According to Madame Glyn, as she liked to be called, having "It" meant you possessed an indefinable quality of animal magnetism that meant that both men and women were hopelessly drawn to you – no matter what

opposite *Clara Bow established the archetype of the flapper in American film, and her screen image appeared to reflect her private life, as stories abounded of her wild parties and numerous lovers.*

you looked like. As she put it, "beauty was unnecessary". Glyn then duly pronounced Clara Bow as having "It", and Bow became the "It Girl".

Clara Bow was the archetypal New York flapper on film, a role that she extended to her off-screen life with wild parties featuring drugs, Latin gigolos, and, it was alleged, the entire University of Southern California football team. She romanced her co-stars including Gary Cooper (rumoured to be the most well-endowed man in Hollywood), and her seven dogs were dyed red to match her hair. Bow's appeal to both men and women came from the seemingly ordinary roles she played – manicurist, waitress, salesgirl in a department store – with which many women could identify. Her scenes also usually took place in settings that provided her with a stream of men to flirt with – if she were a salesgirl, for instance, it was usually in the lingerie department, or she could be found eyeing up men as a hat check girl in a nightclub. Her seduction techniques were similarly urban and thus "modern", as film critic Alexander Walker describes:

"She never went in for the long, premeditated embrace, but would pat a guy on the cheek, chuck him under the chin, fix his tie, brush an invisible speck off his lapel, or ferry a kiss from her lips to his on her finger-tips. For the really big moments, she would leap bodily on to the fellow's lap as if playing leap-frog. She has only to spot an unattached male 100 yards away and she starts freshening her make-up, patting her hair and giving her dress half a dozen more nips and tucks that in the course of a film took on an almost fetishist feeling." [22]

Zooming around in her red Kissel convertible, Bow was one of many stars who were earning vast wages and lived lives of magnificent luxury and excess. Rudolph Valentino's sexploits took place in a black marble and black leather bedroom, Pola Negri had a Roman plunge pool in her living room, and Gloria Swanson had a Lancia limo upholstered in leopard skin.

opposite *Jean Harlow reclines in a white satin peignoir trimmed with marabou. When the film* Platinum Blonde *was released in 1931, sales of peroxide in the United States soared as women raced to copy her look.*

Jean Harlow was the epitome of this new Hollywood glamour, her publicity releases and public appearances emphasizing her sexuality. It was rumoured that she always slept in the nude in her Hollywood bed, which was a replica of the scallop shell in Botticelli's *Birth of Venus*, "and that at least twenty men, determined to be faithful in mind and body to Harlow, had undergone castration to make them useless to all other women". [23] At one press conference, prior to which Harlow rubbed ice cubes over her nipples to make them stand out, a reporter asked:

"'Jean, would you advise a young woman to take a lover instead of a husband?' She replied, 'I'd advise her to take what she can get – and to keep on shopping.' 'Why do you think audiences like you, Miss Harlow?' 'The men like me because I don't wear a brassiere. And women like me because I don't look like the kind of girl who would steal a husband. At least not for long.' 'But would you steal a husband, Miss Harlow?' 'Wouldn't that be like shopping in a second hand store?' 'Are you wearing a brassiere now, Miss Harlow?' 'That sounds like a nearsighted question.'" [24]

The emphasis on Harlow's lack of underwear was as a result of her trademark bias-cut satin gowns, designed by famed Hollywood designer Adrian. This look had been imported from Paris, after the Hays Code of the early 1930s forbad "indecent or undue exposure" in film with a ban on the naked body – indeed even cleavage was taboo. The fashionable body was by this time moving from one of skinny geometry to a rounder voluptuousness, away from what one beauty book of 1929 dubbed "excessive thinness to pleasing roundness" – which was a relief for many. As one famous fashion creator said, "It's about time, for I'm tired of trying to fit beautiful silks and satins to a rack of skin and bones!" [25]

Adrian's erotic designs were based on the work of Parisian couturière Madeleine Vionnet, who specialized in gowns cut in the round that clung to the curves of a woman's body – the complete antithesis of the androgynous 1920s flapper look – using silk, satin, and crêpe de Chine, which

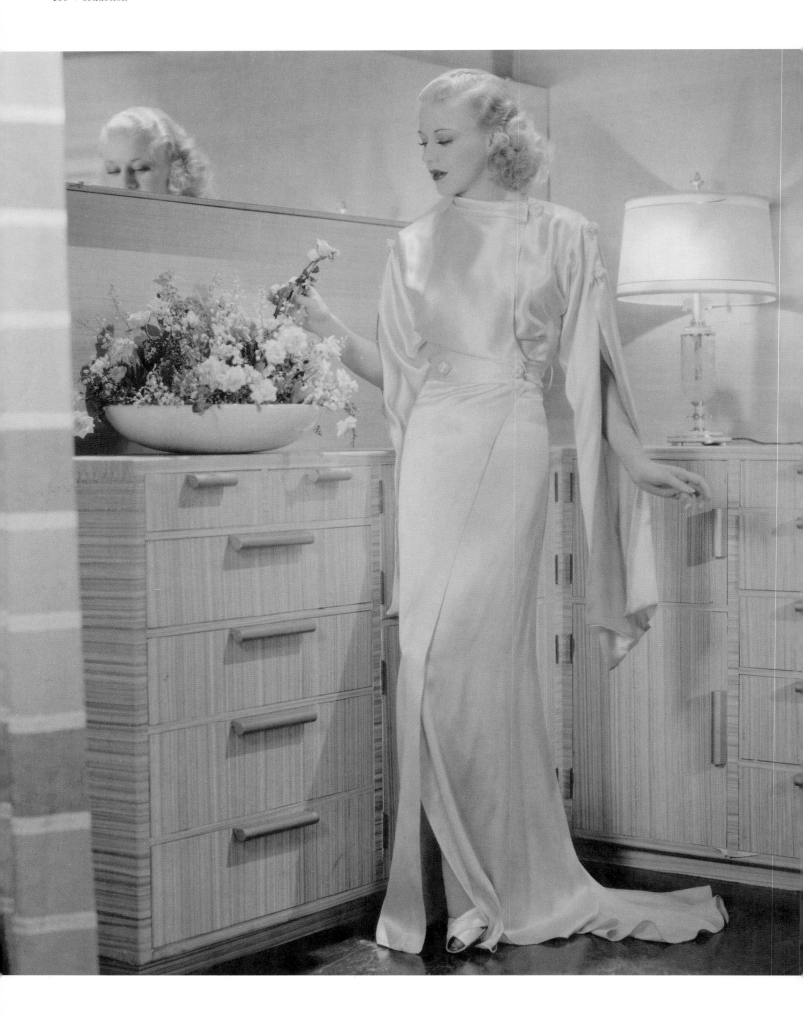

evoked the skin of the body beneath. Dresses that clung so tightly to the body's contours needed specialized underwear, which Vionnet designed, also cut on the bias, in flesh-coloured silk (though the bravest of wearers wore none at all), and the first nipple to be shown in American *Vogue* was through Vionnet lingerie in 1932.

Jean Harlow preferred nudity under her Adrian gowns and, so it was rumoured, had to bleach her pubic hair as a result so that it didn't show through the delicate fabric. In one of her most famous scenes in *Hell's Angels* (1930), she utters the line: "Would you be shocked if I put on something more comfortable?" (now more colloquially known as "I'll just slip into something more comfortable") and walks towards the bedroom door, allowing her white fur wrap to slip down her shoulders. By so doing she seductively shows off a low-cut gown that reveals a bare back without a scrap of structure to support her curves. As film critic Parker Tyler put it in his seminal survey of sex bombs in film, *The Awful Fate of the Sex Goddess* (1969), "Nothing seems to exist between her and her filmy dresses but a little perspiration." [26]

A key feature of Harlow's image was her peroxide blonde hair of an incandescent white, as she posed in a lavish boudoir swathed in fur and in a white satin gown complete with diamond clips. It was her hair that had drawn the attention of Arthur Landau, who became her agent after seeing her on a sound stage at Culver City Studios: it was a completely different look from the pre-war model of beauty, which had been dark haired. Bright white and obviously artificial (although Harlow said it was bleached naturally by the sun), it was the beginning of Hollywood's love affair with blondness that still continues today. As Walker puts it, "Men were attracted by her beacon of hair with its promise of fun, women dyed their own hair in imitation and waited for the hoydenish allure to collect around them." [27] It certainly worked as an image – after the release of her film *Platinum Blonde* (1931), which capitalized on her magnesium blondeness, sales of peroxide in the United States went up by 35 per cent.

opposite *Jean Harlow embodied the 1930s notion of blondes having more fun. Her whiter-than-white hair was emphasized in publicity photographs by incandescent white satin and the palest of furs.*

below *Carole Lombard, known as the Profane Angel in Hollywood for her seductive beauty mixed with a bawdy sense of humour, was married to Clark Gable. She was killed in a plane crash in 1941.*

Blondes were having more fun and gentlemen really did prefer them – in Chicago dance halls one observer noted that men "spent more freely on blondes and red-heads than on brunettes". [28]

The juxtaposition of white hair with white satin, the most seductive fabric in 1930s Hollywood, with its glossed surface and slippery texture, led to an artificially constructed glamour that had nothing to do with naturalness becoming *de rigueur*. The English writer Rebecca West wrote of one woman's longing for glamour, as embodied in the white satin gown – she longed for the feel of the fabric against her skin … she longed for:

"thick white satin, light made solid for a woman's wearing when she wants to think of nothing but pure light …. It should be simply made, for light takes simple forms, the path of the moon on the water is quite straight, the lightning through the cloud traces a pattern simpler than a branch. It was lovely that there were artists who attended to such things, who would make her a dress for tonight." [29]

Harlow's hair and white satin, fur and blazing diamonds were particularly suited to the starkness of black and white film, which, as the historian Anne Hollander puts it, "drained colour out of elegance". It actually transformed the look of fashion, as white gold and platinum became the most modern metals used in Art Deco jewellery, and "draped lamé and sequinned satin offered rivulets of light to the eye as they flowed and slithered over the shifting flanks and thighs of Garbo, Dietrich, Harlow and Lombard".

Hollander believes that "these visions were built on the newly powerful sensuality of colourless texture in motion in which American dreams were now being acted out. For women's clothes, sequins, marabou, white net, and black lace developed a fresh intensity of sexual meaning in a world of colourless fantasy." [30]

White was the colour of 1930s seduction. Syrie Maugham,

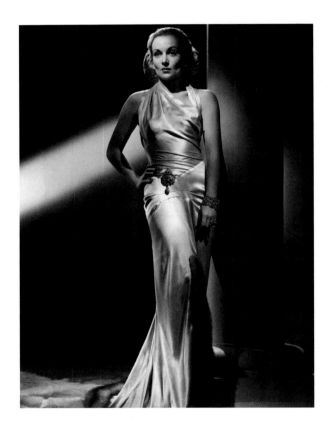

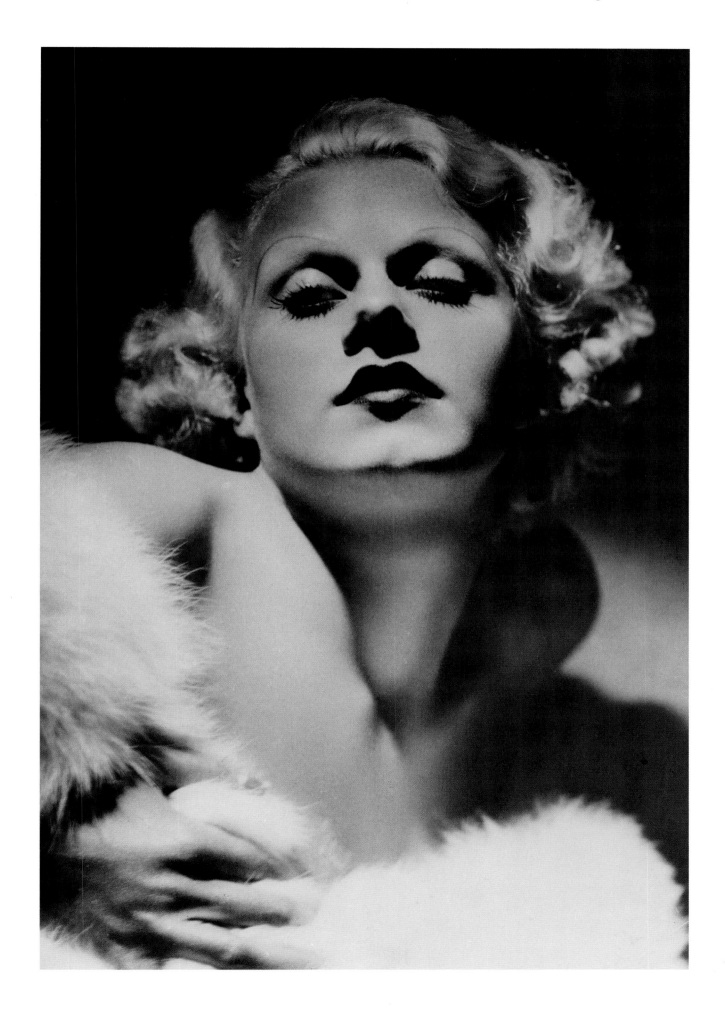

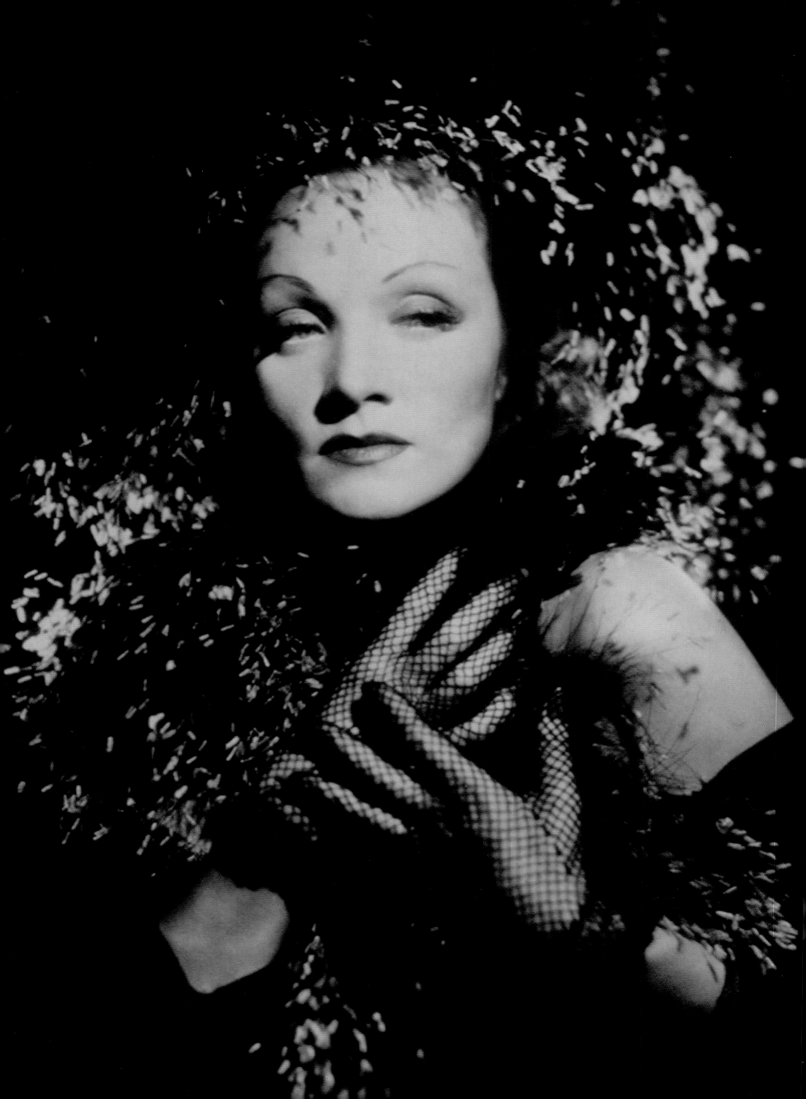

wife of author Somerset Maugham and a celebrated interior designer of the 1930s, had an entirely white house with white walls, white satin curtains, white velvet lampshades, and white lilies in white vases, and her mania for minimalism created a vogue for white sheepskin rugs, huge white sofas, and paint effects on antique furniture. Cecil Beaton talked of Louis Quinze antiques being bleached, painted white, and having all the gilding silvered to look like chrome, turning "Mayfair drawing rooms ... [into] albino stage sets", [31] and this particular brand of English modernity is satirized in Evelyn Waugh's *Decline and Fall* (1928). In this caustic novel, brittle socialite Margot Beste-Chetwynde, drugged up to the eyeballs on morphine and cocktails, demolishes an untouched medieval country pile and has built in its stead a modernist monstrosity with pillared colonnades of black glass, aluminium balustrades, and glass flooring. The coolness of the interior matches Beste-Chetwynde's lack of passion when it comes to love.

In Hollywood, stars like Marlene Dietrich, a woman who evoked memories of the demi-monde and a smoke-filled Berlin cabaret, Greta Garbo and Carole Lombard became fashion leaders, showing a Depression-hit America that the boudoir was the ultimate place of escape. Slinking across highly polished floors, with marabou mules on their feet and dressed in lace peignoirs, female stars took over from the upper classes or demi-monde as the arbiters of style, as recognized by German writer Curt Moreck in 1929:

"America's fashion-leading class, so far as luxury in dress is concerned, is not to be sought in the exclusive upper stratum of the plutocracy, but in the chosen beauties of the film world ... whose tastes are similar in tendency to the luxurious *demimonde* of the Old World. Film stars are the mannequins who launch the new fashions and give them popularity. Even in earlier periods, the stage, with its often extremely subtle undressing scenes, was the appropriate shop window in which the elegance of intimate garments aroused the enthusiasm of women in the audience and exercised its erotic stimulation in men. The old idea that what was under the

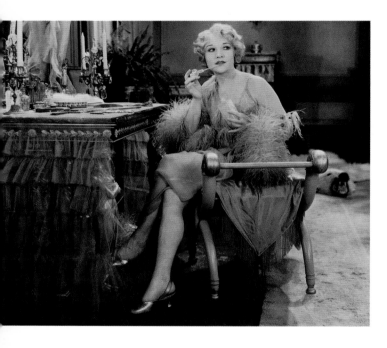

dress would not be seen, and therefore need not be of the same delicacy and fineness as the over-dress, is no longer held by any modern woman. Nowadays, whether she be adventuress or lady, harlot or respectable woman, she must be clothed to the skin so that she has no reason to fear any curious glances. The elegant woman will blush more readily at being seen by intrusive eyes in unfashionable lingerie than entirely naked The woman of today expresses her joy in her body by clothing it in the most delicate materials, filmy stuffs which surround it like the caress of a lover and touch the skin as lightly as a breath." [32]

As the 1930s progressed, women across the whole social spectrum were able to buy into this new glamour, with the newly burgeoning beauty industries and increasing availability of mass-produced fashion, and they began to develop a real sense of their own identity as consumers. Advertisers and manufacturers such as Max Factor seduced women with brand names and slogans, and women used these new tools, in turn, to seduce men. Magazines and beauty books gave advice on the new glamorous looks emanating from the silver screen, and promoted products that still hold sway in the market today, including such staples as Maybelline mascara and Revlon nail varnish.

The notion of portability was another important development in cosmetic use, hence the invention of the powder compact and lipstick cartridge, which had new lives as beautifully made lifestyle accessories designed to be brandished with a flourish in front of friends and potential lovers. The powder compact was an important prop of women's public performance, as beauty historian Kathy Peiss writes, which "drew attention to fabrication of appearance" (these were no natural beauties):

"as they put on a feminine face, these women briefly claimed a public space, stopping the action, in a sense, by making a spectacle of themselves, making up spotlighted the self in a gesture at once forceful and feminine, as a tale told of aviator Ruth Elder suggests. Crossing the Atlantic, Elder was plagued with trouble in flight and

SÉDUCTION

Directeur littéraire : MAURICE ROSTAND.

3 MARS 1934. (2ᵉ ANNÉE) Nᵒ **18.**

2f·**50**

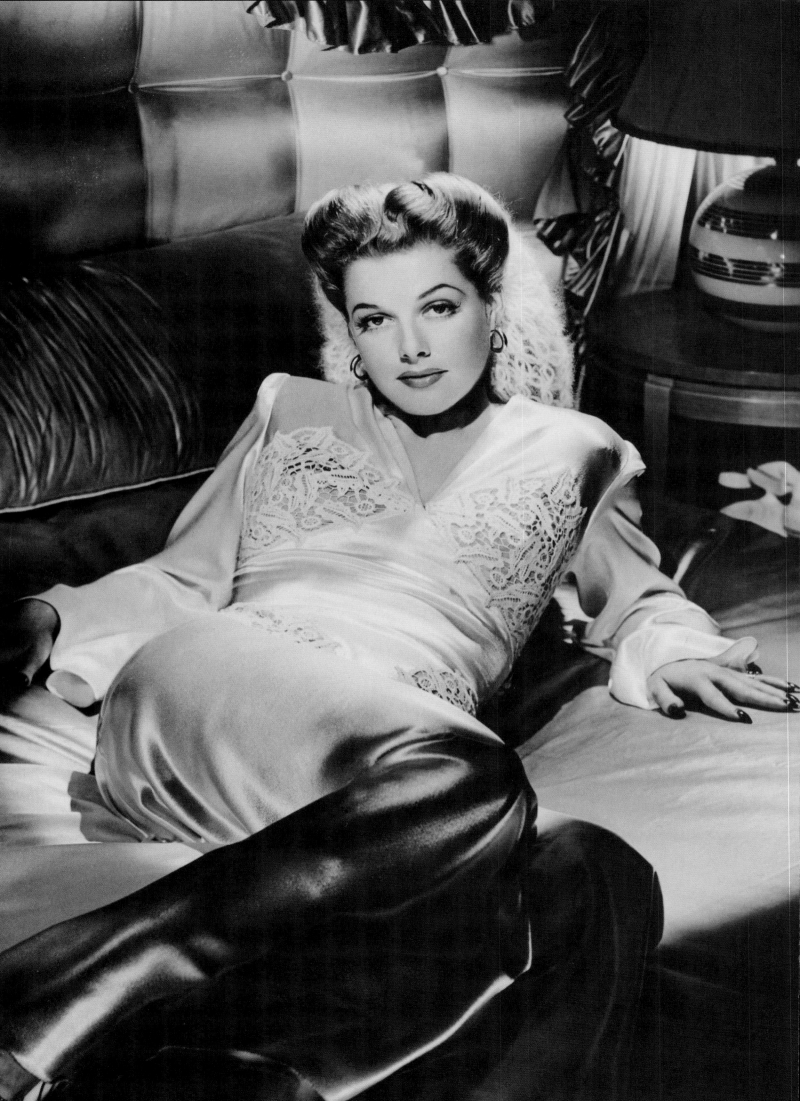

opposite *In 1944, actress Ann Sheridan reclines invitingly on a padded boudoir bed, dressed in the ubiquitous satin negligee, with her hair carefully rolled and her fingernails painted.*

below *A 1930s pin-up takes the aesthetic of the* belle époque *boudoir photograph and adds the modern accoutrements of French knickers and fluffy mules.*

required rescue; when she stepped off the plane, her first act was to powder her nose." [33]

Bleached blondes in full make-up and flash clothes were a public part of the new culture of consumption, no longer branded tarts but now women on display. Advertising and films made this clear – the streets were a stage now and a woman always had to look her best for any potential close-ups, performing even at moments of the utmost intimacy: dressing and undressing in the boudoir, for instance, or moving to accept a lover's embrace. Women were continually being appraised and appraising themselves, as they checked their image in the glass windows of the urban shopping arcades – the new cathedrals of consumption. Beauty writer Virginia Lee made this clear: "The woman in the home, the woman in business, in society, must make up for the part she is to play in life," and Armand advertisements concurred: "The great moments of your life are 'close-ups'." [34]

Fashion and make-up were weapons in the war of the sexes, used to create a glamorous identity in a modern world, and the part of their lives over which women had the utmost control. American *Vogue* of 1933 was emphatic on the importance of glamour, cautioning that when a woman "begins to regard her appearance in her own mind as a fixed, unalterable quantity – that same moment, some vital, shining part of her is extinguished forever." [35]

Appearance could be manipulative and seductive (make-up was quite literally war paint), but significantly for women it was an expression of their true identities, not a false mask to disguise a better body beneath. Dorothy Parker saw red nail varnish as a marker of a sexual carnivore when noting a girl "in a happy calm, inspect(ing) finger-nails of so thick and glistening red that it seemed as if she but recently had completed tearing an ox apart with her naked hands". [36] And glamour could be heroic: in the 1931 film *Dishonoured*, Marlene Dietrich as Agent X-27 faces a firing quad. As the drums roll and the men take up arms, she makes the sign of the cross, lifts her veil and … applies her lipstick.

PRETTY IN
PINK

*"A woman should be pink and
cuddly for her man."*

Jayne Mansfield (1933-1967) [1]

previous pages *Jayne Mansfield had an IQ of 163, breasts measuring 117cm (46 in), and an insatiable lust for publicity, making her one of the most successful film stars of the 1950s.*

opposite *Blonde bombshell Diana Dors, born Diana Fluck in Swindon in 1931, poses in a gondola wearing a mink bikini for a publicity stunt at the 1955 Venice Film Festival.*

Think Pink! Leisure and pleasure were key to lifestyle marketing in the 1950s, because an economic boom in the United States, followed closely by Europe, meant that people had more money and the inclination to spend it on objects of desire and frivolity. Journalist Vance Packard recognized this in his book *The Status Seekers* of 1959, a best-selling exposé of the class system in America and how it was being renegotiated:

"With the general diffusion of wealth, there has been a crumbling of visible class lines now that such one-time upper-class symbols as limousines, power boats and mink coats are available to a variety of people." [2]

The new post-war wealth was displayed through the domestic, with His and Hers bathrooms, push-button curtains, air-conditioned dog houses, and maitre d' kitchens; and in "a time not very far away," promised one newspaper supplement in 1956 "your home will be a push button miracle" where "electronic 'maids' will cook and clean by magic". [3]

The lifestyle to match was that of the Hollywood film star who lived in pastel pleasure in Bel Air, with its "glossy bars and perpetual, merciless sunshine beating down amongst the lush palm trees". [4] Stars such as Rock Hudson, Doris Day, and Elizabeth Taylor lived in luxurious split-level ranch-style bungalows or faux Mediterranean villas filled with all the latest mod cons. In England, Britain's answer to Marilyn Monroe, Diana Dors, drove a powder-blue Delahaye with a crystal steering wheel and solid gold fittings. Dors, a British sex goddess and as such, according to Parker Tyler, a "sanctified, superhuman symbol of bedroom pleasure", [5] was a platinum blonde with an hourglass figure that she showed to effect in 1955 at the Venice Film Festival, where she posed in a mink bikini while being propelled in a gondola.

Pink was the key shade of the decade, used to colour fashion, interiors, cars, refrigerators, and the fantasy

opposite *The emphasis on the colour pink for 1950s furniture and fashion evoked a high femininity, originally displayed at the eighteenth-century French court.*

1950s boudoir, which was all leopard-skin throws and powder-puff pink – a place to drink champagne from a stiletto heel wearing a Baby Doll nightie with matching puff panties, as popularized by Carol Baker in the 1956 film *Baby Doll*. Pink was the colour of seduction, a colour associated with femininity since the beginning of the twentieth century, when it became the norm to dress baby boys in blue and girls in pink. By the 1950s, the gendering of the colour was complete, with a variety of shades available such as fuchsia, "shocking", rose, and salmon. As the design historian Penny Sparke remarks:

"Linked with the idea of female childhood, it [pink] represented the emphasis on distinctive gendering that underpinned 1950s society, ensuring that women were women and men were men. Gendering had to start at an early age and parents were the key role models. The use of pink in the home emphasised the essential femininity of girls and women and showed daughters that their mothers both understood this and wished them to recognise the distinctiveness of their gender as well …. by surrounding themselves with it women could constantly re-affirm their unambiguously gendered selves." [6]

Pink was also the colour of sensuality, evoking naked flesh, and had been since the eighteenth century. By using pink in the 1950s for their interiors, fashion, and lingerie, women were making an important link with the high femininity of the past, evoking the boudoirs of the great French mistresses, in particular Madame de Pompadour and the court of Versailles. Rococo motifs crept into the 1950s bedroom, with the use of white and gilt on dressing tables and boudoir chairs, and the revival of the chandelier as a leitmotif of Hollywood glamour, as Sparke reflects:

"Re-emerging in the 1950s interior on the surfaces of radios and refrigerators, these evocative colours recalled the feminine taste, craftsmanship and luxury that were part of that historical moment, reconfirming in the process the essential femininity of the domestic sphere." [7]

However, as she points out, there was an etiquette in its usage: "according to one British adviser, there were dangers in using a particular shade of pink in certain situations. It is probably the association of pink with underclothes that makes it less desirable for use in its lighter shades for net curtains." [8]

Hollywood pink was paramount, seen at its most extreme in the trappings of American star Jayne Mansfield, who lived in the Pink Palace on Sunset Boulevard and who advised that "a woman should be pink and cuddly for her man". According to her friend and fellow blonde bombshell Diana Dors:

"Jayne Mansfield had a 'thing' about the colour pink – her house in Hollywood was pink, so was her swimming pool. Autographs would be signed with a pink pen and a little pink heart drawn over the 'I' in Mansfield instead of a dot. On one occasion she actually got her hairdresser to shape and colour her pubic hair into a pink heart – that was probably the only part of the Mansfield anatomy the public never saw in photographs!" [9]

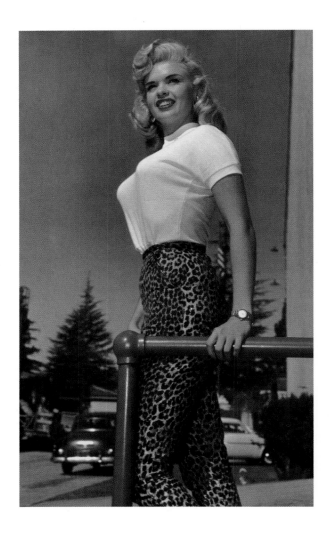

Ensconced in her Pink Mink living room, idly chatting on her pink rhinestone phone after her bi-weekly bath in pink champagne, Mansfield, with her magnificent *embonpoint* and passion for pet chihuahuas, epitomized the look of the Sweater Girl, a glamour girl much beloved of the 1950s whose vital statistics were boosted by a whirlpool-stitched bra underneath the tightest of sweaters. On a visit to Camp Pendleton to entertain the troops, Marilyn Monroe, wearing a figure-hugging cashmere sweater, was praised as "the most beautiful sweater girl" ever seen at the base. She turned to the audience and quipped a sly *double entendre*: "You fellows down there are always whistling at sweater girls. I don't get all the fuss. Take away the sweaters and what have you got?" [10]

The 1950s was a decade obsessed with breasts, and women made the most of their assets – as Jayne Mansfield put it,

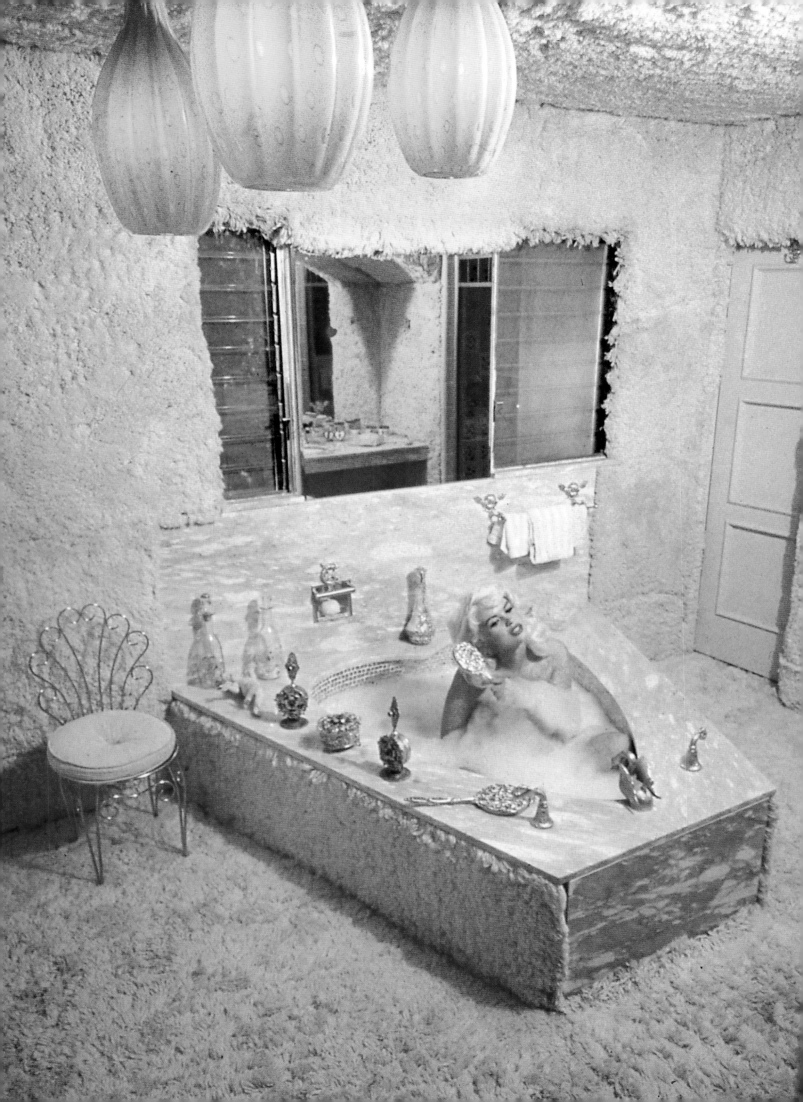

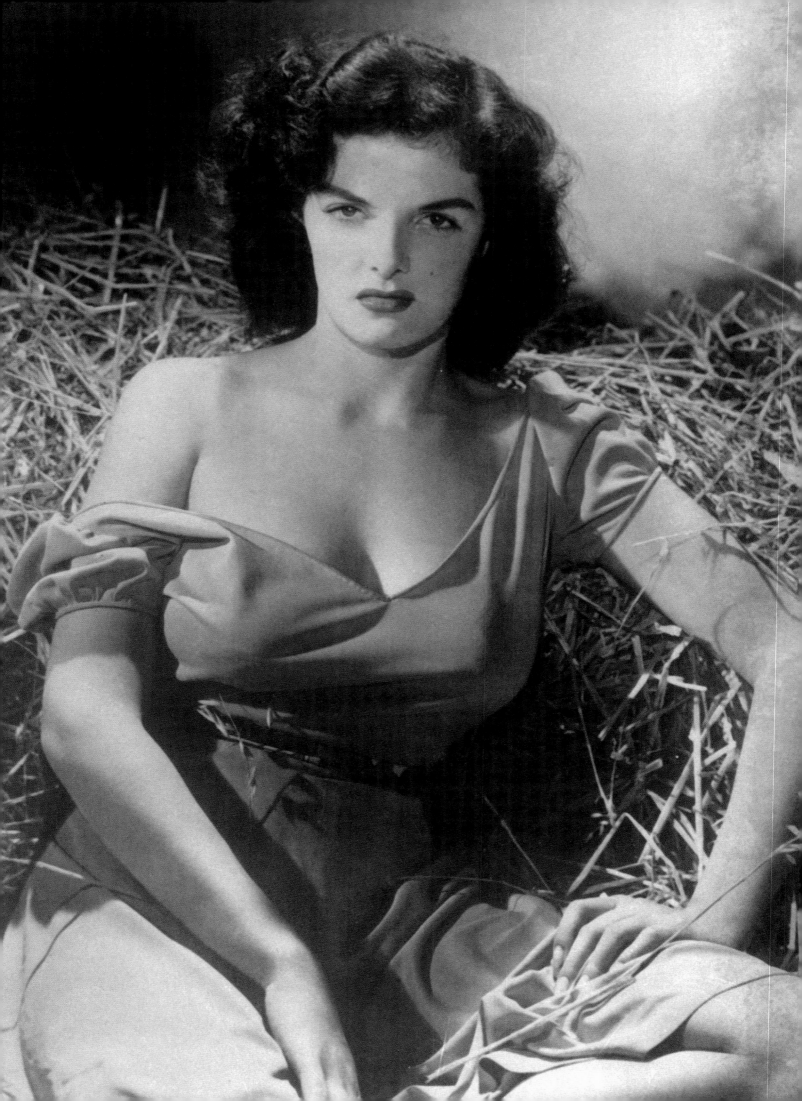

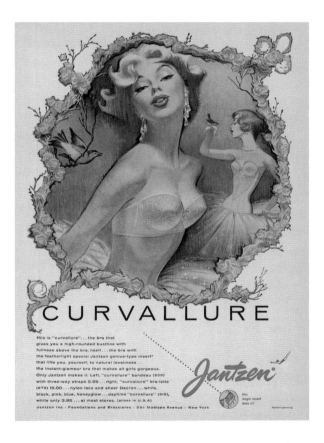

"A forty-one inch bust and a lot of perseverance will get you more than a cup of coffee – a lot more." [11] The cleavage became a defining emblem of the post-war years, so much so that the writer Peter Lewis observes:

"The bust, bosom or cleavage was in the Fifties the apotheosis of erogenous zones. The breasts were the apples of all eyes. Never in this century had so much respect been paid to mammary development. The very concentration on female breasts seemed to swell them with pride to melon-like proportion – or disproportion, for they would flatten and disappear just as mysteriously ten years later. Whole careers were built on breasts." [12]

And if you hadn't the luck to be born with big breasts, the inflatable bra was there to help, among other breast-related inventions. Bras had become masterpieces of engineering, as a result of the aircraft designer and billionaire Howard Hughes, whose cantilevered bra design was created especially for the actress Jane Russell when she appeared in the 1943 western *The Outlaw,* playing the sultry Rio. During filming, she complained that the bras she was forced to wear didn't give enough support and caused embarrassing jiggling in all of her action scenes. The producer Howard Hughes solved the problem by using aerodynamic principles to create the first engineered brassiere that gave both support and uplift – the route to a cleavage of Grand Canyon proportions – and a look that caused Hughes to remark: "there are two good reasons why men go to see her. Those are enough." [13] Hughes had miscalculated the shock of Russell's cleavage, though, and her appearance in the film was rated too suggestive for American tastes: the film was banned until 1950. (Finally, at the long-awaited premiere, in a pivotal scene when Jane leans over a wounded Billy the Kid, a voice in the audience was heard to shout, "Bombs Away!!")

Breasts were also moulded into points by cone-shaped Triumph bras, the choice of stars such as Marilyn Monroe and Brigitte Bardot, and it was in the 1950s that Frederick's of Hollywood, inventors of the first push-up

opposite *A range of late 1950s underwear featuring the girdle, the post-war equivalent of the corset, which flattened the tummy and prevented "jiggle".*

below *The classic Whirlpool bra of the 1950s. The circular stitching gave the coveted torpedo shape to every budding starlet's* embonpoint.

bra, began their reign as leaders in libidinous lingerie. The company was begun by ex-GI Frederick Mellinger in 1946. During the war he had whiled the time away by asking his fellow soldiers to describe the sexiest fantasy underwear they could think of their girl back home wearing. Their ideas provided the basis for a range of styles that he developed on his return, the most successful being the Hollywood Profile, which was designed to recreate the curvaceous bodies of stars such as Marilyn Monroe and Jayne Mansfield. One push-up bra, evocatively entitled Rising Star, was designed to make you "come in looking like a Chevy and leave looking like like a Cadillac". [14]

As breasts became the focus of the fashionable silhouette, so the shape of underwear changed to accommodate the newly voluptuous figure. The elasticated corset, or girdle, was remodelled by Christian Dior using ideas developed by Marcel Rochas in 1945. Dior's new waspie, or waist cincher, was a mini-corset that pulled in the waist to create the perfect hourglass figure that went on to dominate feminine fashions, and the wearing of a full corset disappeared to be replaced by a more youthful combination of bra and pantie girdle. All women wore underwear as a matter of etiquette, including girdles, whatever their shape. One beauty writer advised:

"Your figure will dictate the type of girdle which is best for you. However, don't think you need none at all because you are very young or very slim. A girdle less figure is seldom seductive, and many girls whose rounded tummies and bouncing hips are unhappily revealed by a close-fitting dress seem rather immodest. Most men are embarrassed by feminine exposure in public; and a hint of your charms is far more enchanting than a flaunting show of them." [15]

Eschewing a girdle was considered rather risqué in the 1950s and could make a woman the talk of the town, although careers could be helped by it. Marilyn Monroe, for instance, was infamous for her lack of undergarments, confiding to columnist Earl Wilson in 1952 that she wore "nothing, but nothing at all – no panties, slips, girdles or

FROM THE

American *Dreamform*

RANGE

opposite *Marilyn Monroe arrives in London in 1956 with her husband playwright Arthur Miller to begin filming* The Prince and the Showgirl *with Laurence Olivier. As usual, she is wearing no underwear.*

below *Monroe poses at the 1953* Photoplay *dinner, where she won two awards. Her skintight gold lamé gown by Travilla caused a sensation.*

bras", as she liked to feel "unhampered". [16] Monroe also went on to cause a scandal in 1953 at the annual dinner of *Photoplay* magazine, held at the Beverly Hills Hotel, having been selected as the best new star of that year. She made a stunning entrance wearing a one-piece gold lamé gown designed by Travilla, floor-length and with a plunging décolletage, which was deliberately made one size too small and so tight she could wear no underwear underneath. She had to be quite literally sewn into it. Even the designer begged her not to wear the gown, because he felt she was too fat for it, but after two sessions of colonic irrigation, Monroe made her entrance in the dress that columnist Florabel Muir described as looking "as if it had been painted on". [17] She made every other female star there appear dull by contrast. Maurice Zolotov remembers:

"Marilyn hove into view – two hours late. Because [...] her dress was tight around her knees, she walked with mincing steps which emphasized the rotation of her hips. Her curves shimmered in the golden dress. Slowly she walked down the room to the head table. Dining was suspended. Breaths were drawn in, gasps of horror, and admiration, filled the room. For a long moment conversation halted. Then she sat down. The conversation resumed in a lower key, and the topic was Marilyn Monroe." [18]

Director Billy Wilder capitalized on Marilyn's habit of wearing nothing under her clothes in the film *Some Like It Hot* (1959), when she makes her entrance undulating down the station platform. He described her coming in:

"with her two balconies sticking out ... and she always seems surprised that her body is kicking up such an excitement. It's instinctive. Of course, she helps it along by never wearing a girdle or a brassiere in a scene. Never. That's why she looks fat around the tummy. I, for one, say more power to her without a girdle. Who can get enough of Marilyn Monroe? So we're back to the women of Rubens! Is that bad?" [19]

opposite *Kim Novak, the daughter of a Slavic railway worker, embarked on a career as a model and beauty queen when touring America as Miss Deepfreeze in the early 1950s. She was given a contract with Columbia Pictures, who saw her as a rival to Marilyn Monroe.*

Women embraced a new Kodachrome-coloured glamour that was part-Christian Dior, part-Hollywood, part-*Playboy* magazine, and perfectly suited to the new fan magazines that showed endless glossy spreads of stars at home and abroad, at premieres and at cocktail parties. The public was obsessed with the lifestyles of the rich and famous in Hollywood, especially the icons of femininity, "whose beauty [they thought] could be replicated through the purchase of particular commodities", [20] and film studios were happy because it gave their films publicity and boosted box-office receipts. As Diana Dors wrote:

"When I was a child, my one ambition was to go to Hollywood. To me it was the Mecca, the ultimate, and the only life I wished for. All through my childhood those endless magical nights spent at the cinema with my mother, the fantasy and excitement connected with film stars themselves, filled me with longing and a burning determination to some day become one of them. I wrote in a school essay, at a very early age, that I was going to be a film star and live in a big house with a cream coloured swimming pool." [21]

Women mulled over the colourful images of their favourite stars and copied their looks to the best of their ability and their purses. Hair was bleached to peroxide white as blondeness enjoyed a second surge of popularity with stars such as Grace Kelly, Kim Novak, and Marilyn Monroe, whom many, herself included, saw as the reincarnation of Jean Harlow. In the 1950s, the mythology of blondes having more fun was secure, and beauty writer Lois Wyse was adamant on the subject: "Without blonde, a woman can just be another pretty face, and pretty faces are a dime a dozen. Brunettes wear boots all year round: blondes wear strappy sandals." [22] Clairol home-dying kits were launched with the phrase, "If I only have one life to live, let me live it as a blonde", and bleaching and dyeing the hair became commonplace, even respectable – no longer just for fast girls and "arty" types. In 1954, beauty writer Betty Page declared, "It is no longer in doubtful taste to change the colour of your hair." [23]

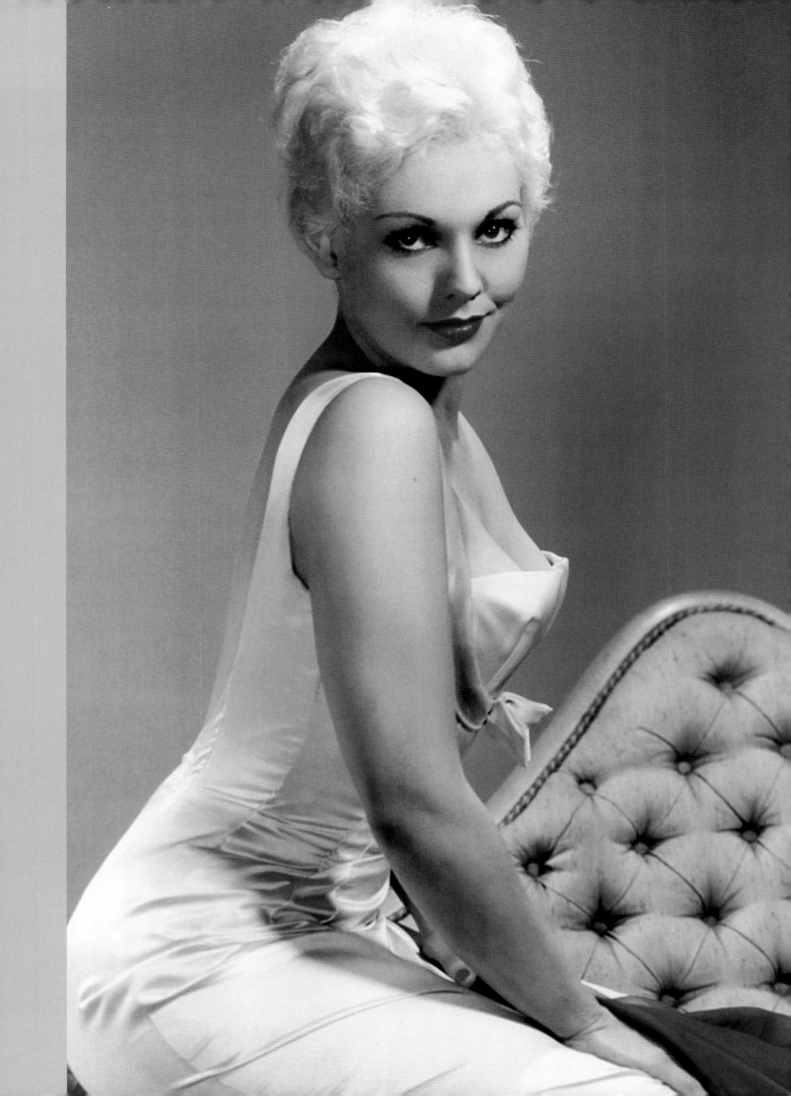

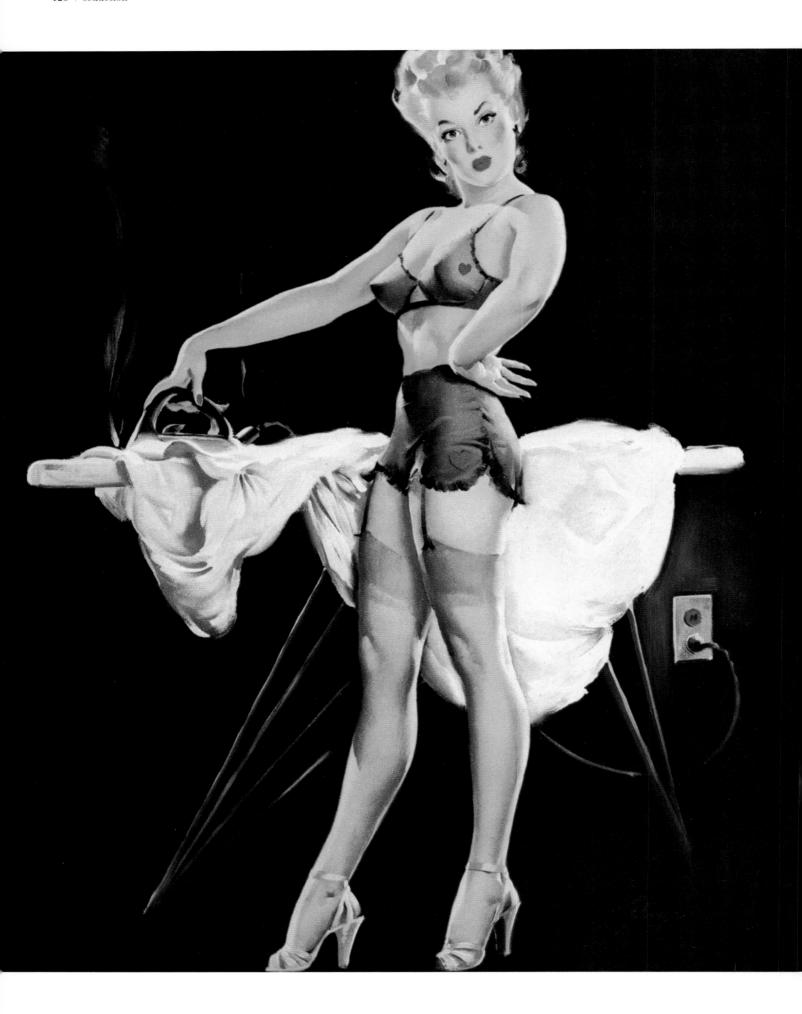

opposite *A cheesecake pin-up from the 1950s shows overtly sexy glamour in a domestic setting. Women were exhorted to fulfil their husbands' fantasies of glamorous seduction as part of a healthy married life.*

below *Books of etiquette and advice to the housewife suggested that a woman's role was as a film star in the home, with every room a stage set upon which to project her image as a seductress.*

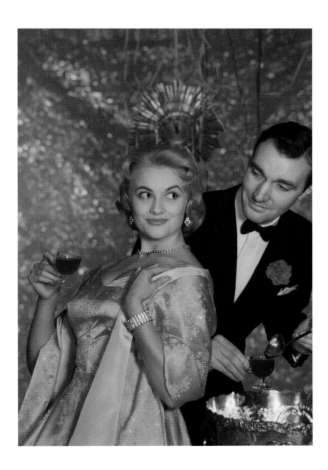

Women could be film stars in the privacy of their own home, whose rooms became stages wherein they could fulfil their fantasies of glamour and seduction. Beauty writer Veronica Dengel devoted a whole section of her book *Can I Hold my Beauty?* to "Your Home is a Stage". In the "Kitchen Scene" a woman had to make sure she served her husband's breakfast "attractively and pleasantly With a fresh face, tidy hair. And put a smile on with that lipstick. Remember that is the picture he must take with him to the office and think about all day." [24] And in the all-important "Bedroom Scene", a woman could seduce her man by means of the most mundane of daily tasks, such as brushing her hair:

"You can make a lovely picture in your bedroom if you sit in the soft light and wear a becoming negligee. Brush thoroughly, but gracefully, keeping each movement consciously beautiful. Perhaps you will need a little private practice, but when you are fairly proficient, try the effect on your husband. Watch an actress next time she is shown brushing her hair. The frequency with which this bit is injected into pictures about married life proves it is a calculated effect for creating glamour." [25]

"Slipping into something more comfortable" meant a *mise en scène* culled from any number of seductions seen on celluloid, and women turned to elaborate artifice to get their wicked way. As popular magazines such as *Glamour: Film Fashion and Beauty* established the importance of cinematic imagery, the bedroom became a woman's stage set (even if only in imagination) bedecked with crystal chandeliers and tiger-skin rugs, within which the woman reigned supreme, mixing dry martinis for a besotted suitor. Here she could, according to the pulp novel *Bizarre Harem*, lay waste to a man's senses by slowly stripping down to her saucy unmentionables in front of him:

"her slim fingers unfastened the lacy white blouse. She took that off slowly, putting it on a hanger next to her jacket. Still moving slowly, she opened the zipper at the

opposite *In this 1950s boudoir shot, a peroxide blonde poses on a tiger skin – a place "on which to sin" since the Edwardian era.*

below *Allure should be created at all times. Even the simple act of undressing at night could be turned into a tantalizing tease between husband and wife.*

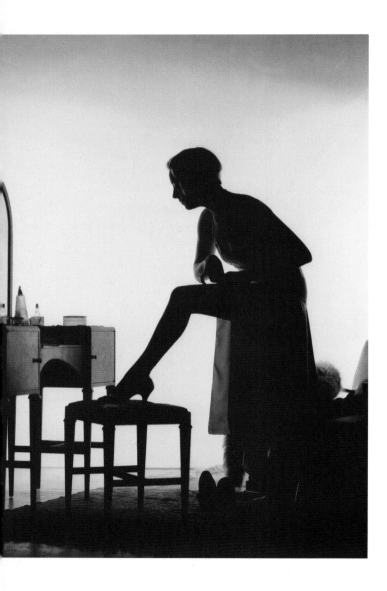

side of her skirt and slid it down. She stepped out of it as gracefully as if she had been practicing her strip-tease for months, and put it on another hanger in the closet. When she turned and faced him again, she smiled and raised the lace edged hem of her slip and reached for her garters, teasing him with brief glimpses of her bare skin as she unfastened them and peeled the nylon stockings off first one leg and then the other. As she took the stockings off she stepped out of her spike heeled shoes, and then put her bare feet back into them again as she tossed the stocking over the back of the chair." [26]

As domestic space became more and more at a premium, the boudoir, once the height of decadence with an aesthetic that led seamlessly to the bedroom, began to disappear. Now the bedroom and boudoir were combined into one, with a blond-wood dressing table and matching quilted boudoir chair as the focal point of the room, as women celebrated their new-found femininity after the rigours of war. The boudoir remained in the public conscience, but now as a fantasy, primarily a set design used as a background to a sexy shot of the latest bosomy starlet. The boudoir shot became steadily established as a rite of passage for women in Hollywood and a popular subject for cheesecake imagery in pulp publishing, featuring the likes of Bettie Page and Lilli Saint Cyr. Props included Merry Widow corsets, seamed stockings and suspenders, and a pair of killer heels, as women became more subtly aggressive in their feminine lair, with eyes smoky black with eyeliner, and lips a crimson slash of lipstick – a vital element of seduction. The use of lipstick, particularly red lipstick, was tapping into primal sexual habits, according to anthropologist Desmond Morris, who noted that:

"during erotic arousal, lips become swollen, much redder and more protuberant. The change they undergo mimics closely the alterations that are taking place on the other labia – of the female genitals …. It also explains why women have for thousands of years painted their lips red to make themselves more visually exciting." [27]

opposite *Dorian Leigh was the signature
model of Revlon's Fire and Ice
campaign throughout the 1950s, a
figure of overt glamour whom many
women emulated.*

This visual excitement, of course, is taken a step further with the sexually loaded application of red lipstick in a phallic-shaped holder, an act that by the 1950s was perfectly acceptable when done in public. Gala of London had shades of Red Sequin and Heavenly Pink; Elizabeth Arden had Surprise with "the come-hither of pink" and "the persuasiveness of rose", which claimed to transform women into "softly glowing" beauties. *Vogue* magazine even introduced a lipstick colour for each season, and by 1958 Max Factor made the following declaration: "A woman who doesn't wear lipstick feels undressed in public. Unless she works on a farm." [28]

One of the most successful lipstick shades was Revlon's Fire and Ice, introduced to American women in 1952 with the words: "for you who love to flirt with fire ... who dare to skate upon thin ice A lush and passionate scarlet ... like flaming diamonds dancing on the moon!" The Fire and Ice woman, model Dorian Leigh, was a figure of overt glamour, copying a look normally seen in the pages of men's magazines such as *Esquire* but now being appropriated by women in their everyday lives. With her lips parted and moist, wearing a come-hither expression, the Revlon model asked women, "Are you ready for Fire and Ice? Do you dance with your shoes off? Do you sometimes feel that other women resent you? Do sables excite you, even on other women? Would you streak your hair platinum without consulting your husband? Do you close your eyes when you're kissed?" This was the new femininity of the 1950s – all glamour, red lipstick, and bouffant hair – a woman who, according to Revlon, "only went out at night". By the mid-1950s it was estimated that 98 per cent of all college girls used lipstick, and its use had become a rite of passage from girl to woman – one cosmetics company, Tussy, aimed a cosmetics range directly at little girls with its Budding Beauty Glamour set. Writer Susan Brownmiller remembers:

"By the time I was old enough to identify my femininity with a Revlon colour chart in the 1950s, lipstick was a redoubtable emblem of the American way of life. While

the poor Soviet woman had to make do, we heard, with only one shade – a muddy yellowish brown produced by the State – we in the free world were codifying our sexual mores, guilt-ridden and trophy-oriented, according to the bright-red smear. A girl of thirteen who put on lipstick after school was fast and headed for trouble. A girl of fourteen who wore too much lipstick was boy-crazy. Lipstick on a cigarette butt was the sign of a dangerous, sophisticated woman. Boys who came home from a date without lipstick on their handkerchiefs hadn't been able to score. Lipstick on a shirt collar was evidence of a straying husband." [29]

All this glamour had its dark side, however, in an aspect of celebrity culture that found expression in 1952, when a new breed of fan magazine appeared that was less hagiographic and more inclined to reveal what actually went on behind the bedroom doors of the latest starlets. *Confidential* magazine was a scandal sheet, a forerunner of the *National Enquirer*, which specialized in the insalubrious goings on of Hollywood stars, first published in New York with the motto "Tells the Facts and Names the Names". The publisher Robert Harrison recognized that the American public increasingly craved any kind of celebrity gossip, and if that gossip were spicy, then so much the better. As he put it: "Americans like to read about things which they are afraid to do themselves." [30] The circulation figures proved that he was right: at its height *Confidential* magazine sold four million copies per issue. One story that particularly thrilled the public concerned blonde film star Lana Turner, one of the most successful and glamorous actresses of the 1950s, who one day in 1958 phoned the police and summoned them to her colonial-style Hollywood mansion:

"Lana was in tears; her daughter Cheryl Crane was near hysteria. Policeman Geisler then saw the cause – the object harshly jarring with the pretty pinkness of Lana's boudoir: the bloodied corpse of Johnny Stompanato, alias Johnny Valentine, former body guard of gangster Mickey Cohen, notorious gigolo, Lana's latest lover." [31]

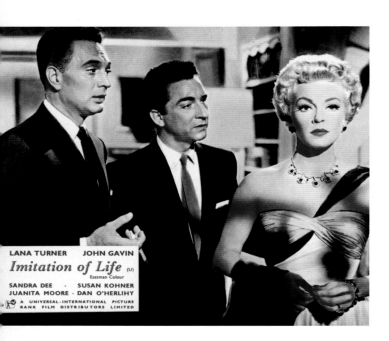

LANA TURNER JOHN GAVIN
Imitation of Life (U)
Eastman Colour

SANDRA DEE · SUSAN KOHNER
JUANITA MOORE · DAN O'HERLIHY

A UNIVERSAL-INTERNATIONAL PICTURE
RANK FILM DISTRIBUTORS LIMITED

Lana Turner had been squired around Beverley Hills by a number of prominent men, including Frank Sinatra, Howard Hughes, and actor Tyrone Power, having broken up with her latest ex-husband, actor Lex Barker, famous for his portrayal of Tarzan, King of the Jungle. She was supposed to have said: "I find men terribly exciting, and any girl who says she doesn't is an anaemic old maid, a streetwalker or a saint." [32] According to the later trial, Stompanato had threatened Turner with physical violence after she had refused to pay off his gambling debts. As a result, Turner's teenage daughter had run into the kitchen, grabbed a butcher's knife, and stabbed him. Both women were released after the verdict of justifiable homicide was reached, and Turner went on to have the biggest box-office success of her career in Douglas Sirk's glossy melodrama *Imitation of Life* (1959).

Glamour had its dark side, and as peccadilloes were exposed so the bottle-blonde's lustre began to tarnish. Jayne Mansfield's Sweater Girl image, once the height of allure, became a target of ridicule, particularly in the more grittily realistic kitchen-sink novels of the late 1950s and early '60s. In Lynne Reid Banks' *The L-shaped Room* (1960), the lead character comes across the latest blonde starlet:

"She came at last, swathed in mink …. The photographers reluctantly put their glasses down and picked up their cameras as the PRO, his hands daintily plucking at the collar of the mink, prepared to unveil the famous figure. When every camera was in place, he whisked the coat away.

It really was the most extraordinary outfit I've ever seen. The celebrated bust, looking like two dunce's caps applied to her chest, was encased in a puce halter-neck sweater which left all but essentials bare. Her sizable bottom and not-too-marvellous legs were thinly coated with tight yellow silk jeans ending just below the knee; her bare feet were thrust into pink mules with diamond spike heels. She also wore a diamond brooch at her waist, the size of a buckler.

opposite *Lana Turner played über-blonde actress Lora Meredrith in Douglas Sirk's melodrama* Imitation of Life *(1959), one of the first films to explore the cultural divide between black and white in America.*

below *Turner with ex-husband Stephen Crane in the courtroom during the murder trial of their daughter Cheryl Crane, who had stabbed Turner's ex-boyfriend, gangster Johnny Stompanato.*

LANCER BOOKS 73-414 60¢

MARTIN COLLYER

↑ **UP IN VALERIE'S ROOM**

SUBURBAN WIFE-- CITY MISTRESS

opposite *The 1950s* femme fatale *had turned into a ferocious figure of unbridled lust by the end of the decade, a woman at once feared by men and reviled by feminists.*

For a second there was an unbelieving silence – then a chorus of whistles and concerted pops and tinkles as every flashbulb in the room went off." [33]

Hollywood pink was now downright vulgar, associated with an overblown sexuality that was ill at ease with the "white heat of new technology" and the flat-chested androgyny that was beginning to filter into fashion in the early 1960s. The image of the frivolous, fluffy, and oversexed blonde clad in taffeta, net, and lace belonged to a different era, and mink coats were the preserve of Cruella de Vil, introduced via Walt Disney and *One Hundred and One Dalmations* in 1961 – a woman who slept between ermine sheets and craved the first full-length coat made of dog skins. By 1963, feminist Betty Friedan was arguing that a woman with a sexual fantasy life in the 1950s, a woman who saw herself as a seductress supreme, was in fact suffering a delusion, using her "aggressive energies" in "an insatiable sexual search" that could never be satiated because it was largely the product of cultural fantasy, what she dubbed "the feminine mystique". She wrote:

"Instead of fulfilling the promise of infinite orgiastic bliss, sex in the America of the 'feminine mystique' is becoming a strangely joyless national compulsion, if not a contemptuous mockery. The sex-glutted novels become increasingly explicit and increasingly dull; the sex kick of the women's magazines has a sickly sadness; the endless flow of manuals describing new sex techniques hints at an endless lack of excitement. This sexual boredom is betrayed by the ever-growing size of the Hollywood starlet's breasts." [34]

Women were using sex to seduce, get, and keep their man, and their sexual power was, according to Friedan, making men feel entrapped and revulsed. In her book, she used an account of a male student stopped from studying by the attentions of his voracious girlfriend:

"She was bending down the corner of a page and he wanted to tell her to stop; the little mechanical action

opposite *The seductress was no longer a powerful figure by the 1960s. Seen as a reject of a bygone era when women had only the power of their sexuality to gain admittance to high society, her image was rejected in favour of one of androgynous egalitarianism.*

irritated him out of all proportion, and he wondered if he was so tense because they hadn't made love for four days …. 'I bet she needs it now,' he thought, 'that's why she's so quivery, close to tears, and maybe that's why I loused up the exam'. …he slammed his books closed and began to stack them together. Eleanor looked up and he saw terror in her eyes …. 'Look, I'm going to walk you back now,' he said… 'I've got to get something done tonight' …. He remembered that he had a long walk back, but as he bent hurriedly to kiss her she slipped her arms around him and he had to pull back hard in order to get away. She let go at last, and no longer smiling she whispered: 'Hal, don't go.' He hesitated. 'Please don't go, please….' She strained up to kiss him and when she opened her mouth he felt tricked, for if he put his tongue between her lips he would not be able to leave. He kissed her, beginning half-consciously to forget that he should go … he pulled her against him, hearing her moan with pain and excitation. Then he drew back and said, his voice already laboured: 'Isn't there anywhere we can go?' …. She was looking around eagerly and hopefully and he wondered again, how much of her desire was passion and how much grasping: girls used sex to get a hold on you, he knew – it was so easy for them to pretend to be excited." [35]

The seductive woman was being reworked by Friedan and the burgeoning feminist movement as a hysterical victim of her sex, who should be out earning her own living and partaking of the experiences the world had to offer, rather than as a powerful *femme fatale* who knowingly sashayed her way into a man's heart (and wallet) with her erotic wiles. Women should be foregoing feminine fashions designed to physically restrict the body into seductive shapes for the delectation of the male gaze. Women should no longer be objectified and their power should be re-invested in their brains rather than their breasts. It would take a few decades before the seductress retrieved her negligee and fluttered her eyelashes again.

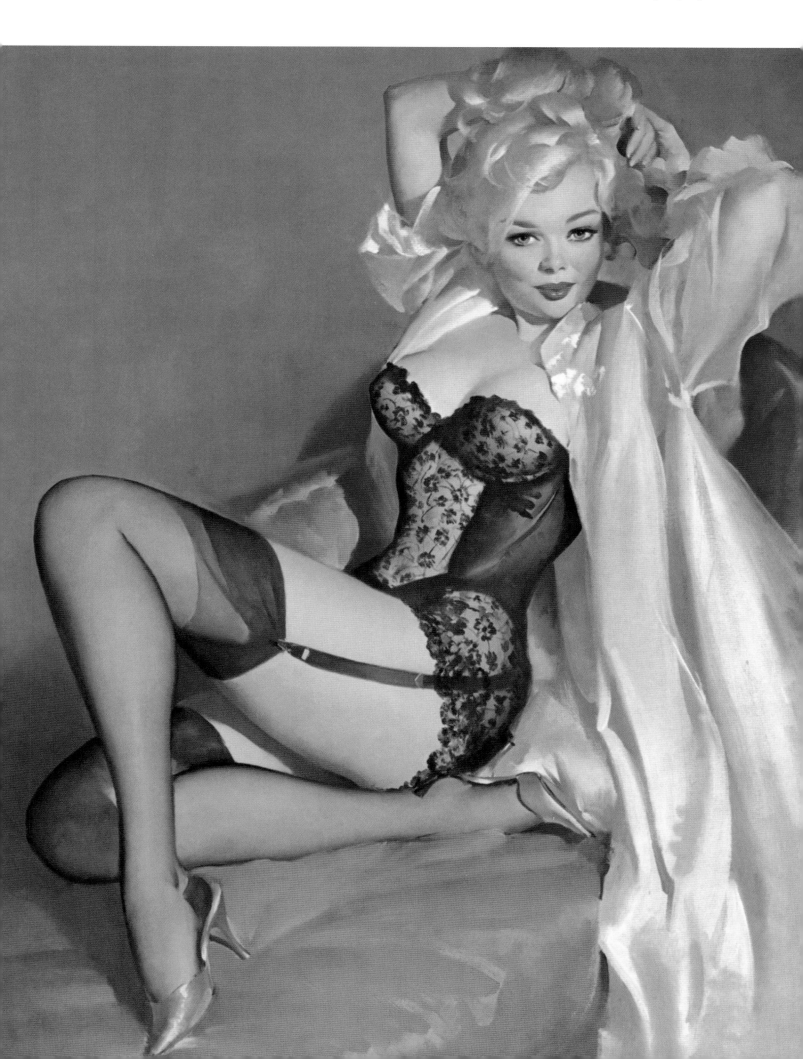

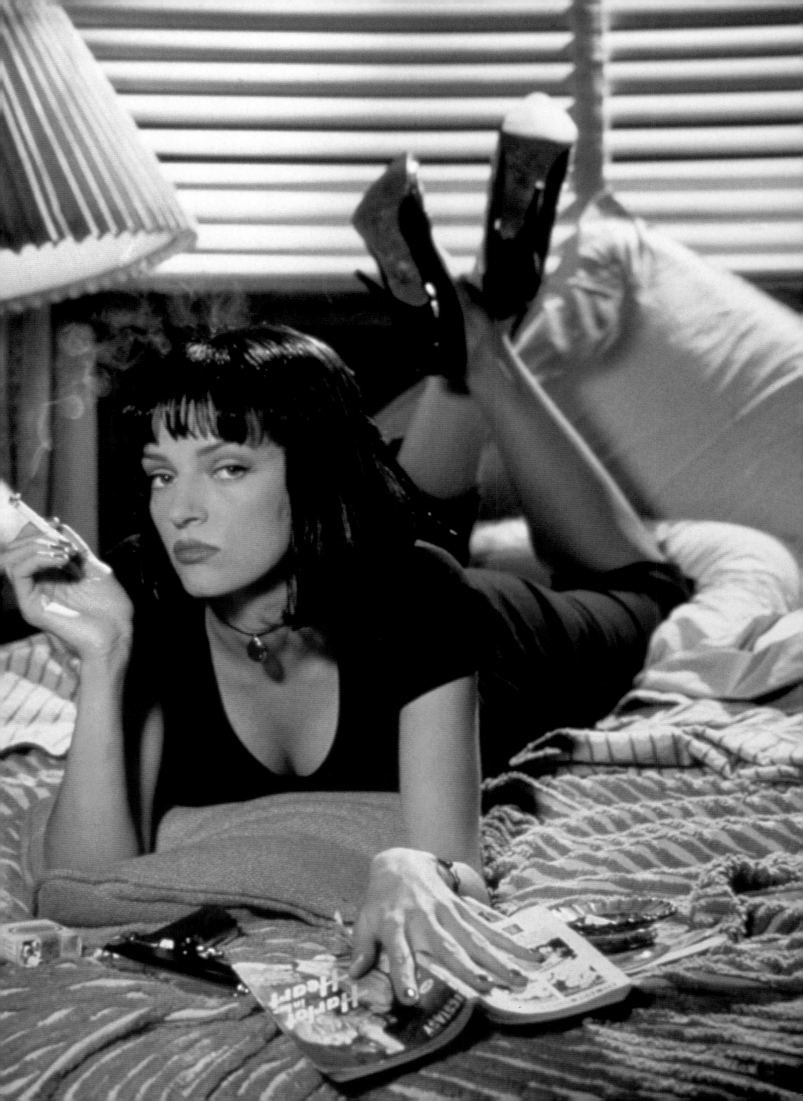

KISS & TELL

"Women who pay their own rent

don't need to be nice."

Vogue, *1995* [1]

previous pages *Uma Thurman as Mia Wallace in* Pulp Fiction *(1994) was a* film noir *seductress reincarnated. Her coal-black bob and Rouge Noir Chanel nail polish became a much-copied high street trend.*

opposite *The Lolita syndrome infiltrated fashion in the mid-1960s, with models such as Twiggy displaying an adult body that was underdeveloped and child-like, vastly different from the hourglass figure of 1950s fashion.*

In the twenty-first century, the seductress has been retrieved from the dustbin of history after decades in a theoretical, if not fashionable, wilderness. The 1960s saw a reaction to the structured silhouette of the 1950s, with the androgynous pre-adolescent body of model Twiggy becoming the fashionable ideal. Dress no longer followed the womanly curves of a body but, in the words of fashion historian and 1960s specialist Marnie Fogg, "became a futuristic carapace that didn't recognise the body at all. Even mini skirts were less about seduction than about freedom and liberation, and the invention of tights meant that legs were encased in wool or nylon that completely sealed them off from men's attentions. It wasn't at all a seductive time." [2]

It could be argued that the skinny androgynous look did simultaneously have slightly more uncomfortable, yet seductive, associations with the schoolgirl or Lolita look – a kind of seductress who tended to exist not only in the minds of men (such as writer Vladimir Nabokov) or in the film *Baby Doll* starring Carroll Baker, but also in Twiggy and other models, who appeared young and girl-like despite being adult, and who were aware of their allure. But the skinny body of the sixties, "all 32-inch bosom and twig-like legs," [3] as Fogg describes it, was completely different from the blonde bombshells of the previous generation, with their fleshy curves and stiletto heels. Now Twiggy's sporty, futuristic, even anti-maternal image made them look old-fashioned, part of an old order that existed before the "white heat of technology," as Prime Minister Harold Wilson defined the characteristics of the new decade.

In the late 1960s, however, designers began to re-examine the past nostalgically, and Biba in particular began to revive the sultry seductress look of the pre-war years with Barbara Hulanicki's designs in its new Kensington High Street store. One fashion journalist described "slithery gowns in glowing satins, hats with black veils [and] shoes stacked for sirens," [4] and Marnie Fogg sees the Biba look as a "recognition of the body again, one that was not

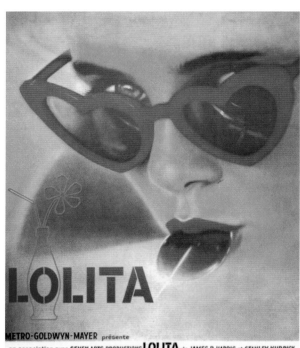

METRO-GOLDWYN-MAYER présente

en association avec SEVEN ARTS PRODUCTIONS **LOLITA** de JAMES B. HARRIS et STANLEY KUBRICK
JAMES MASON · SHELLEY WINTERS · PETER SELLERS
et **SUE LYON** dans le rôle de "Lolita"
Réalisation: **STANLEY KUBRICK** · Scénario: **VLADIMIR NABOKOV** · Production: **JAMES B. HARRIS**

above *The film version of Vladimir Nabokov's novel* Lolita *caused a storm when it opened in 1962, with actress Sue Lyon's portrayal of Lolita as a precociously seductive underage girl.*

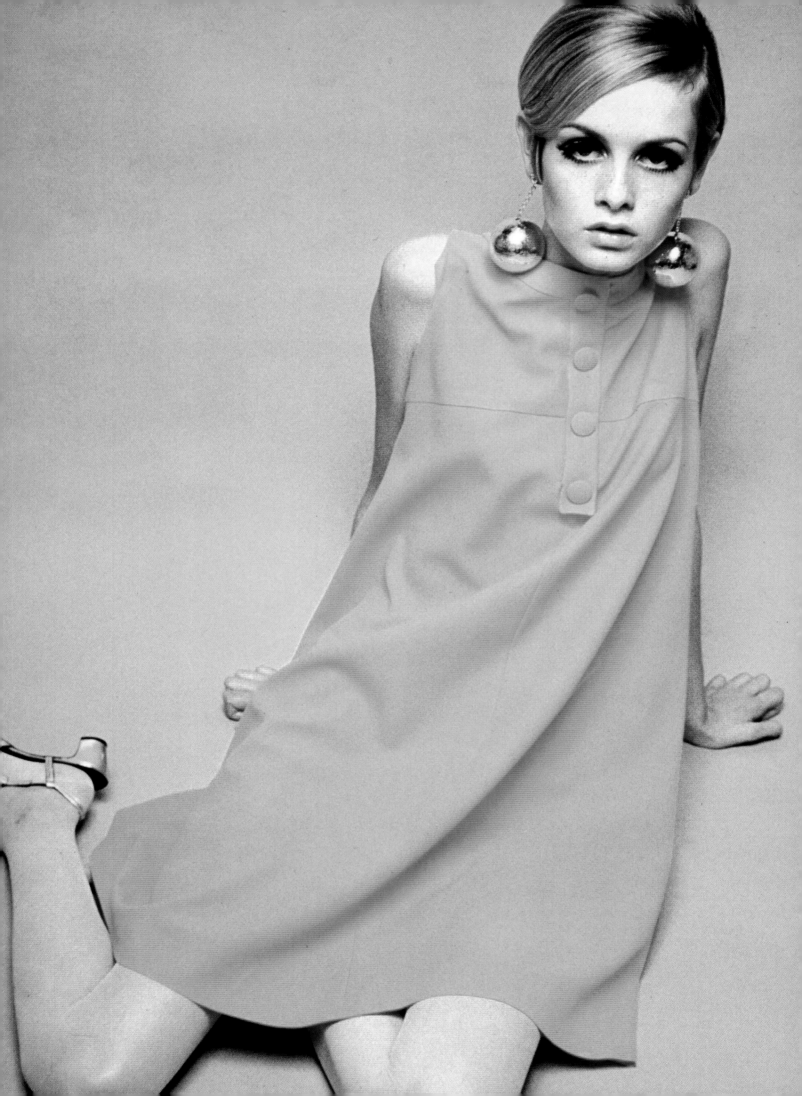

below *The designs of Barbara Hulanicki at Biba used the imagery of the* femme fatale *of 1930s Hollywood to create a look of old-school seduction, aimed at a new audience of women satiated by the sexless androgyny of high fashion.*

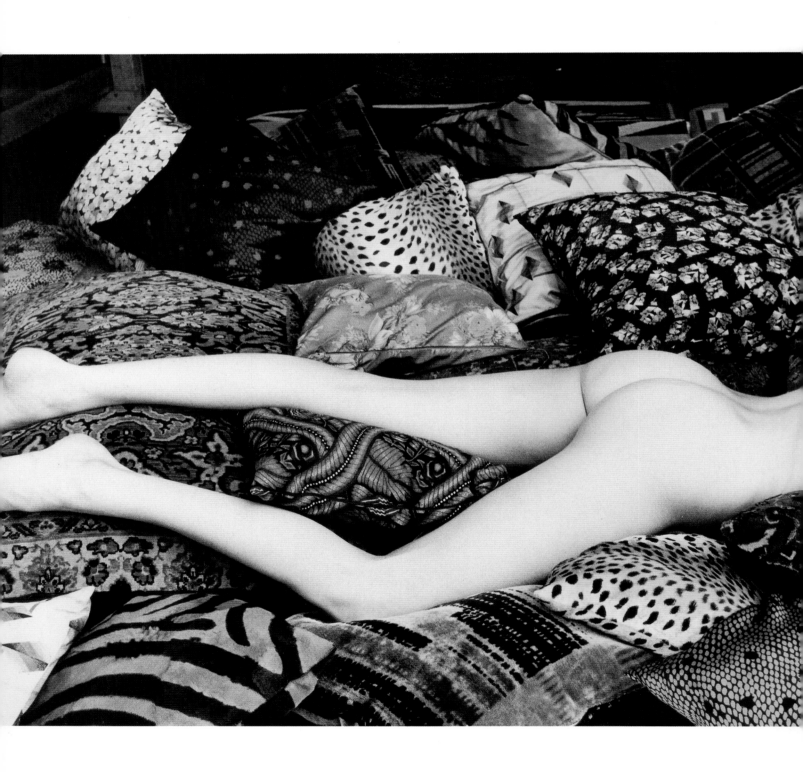

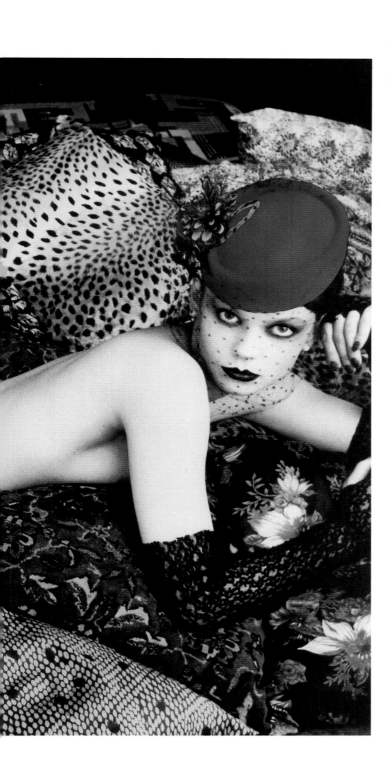

constrained by underwear or hidden by fashion. Biba clothes were liquid: satin and velvet that slithered over the body with an emphasis on textures such as panne velvet. Mediated through Sarah Moon's photographs, the vamp of the "twenties and thirties re-appeared with a perverse, edgy quality." [5] When an Angry Brigade bomb was set off in the Biba store in 1971, the *Guardian* newspaper mused on whether it was in protest at "the rising tide of capitalist deco-decadence" displayed in the sumptuous store. As Biba historian Alwyn Turner writes, "in the confused quasi-Marxist rhetoric of the times, Biba was the enemy. It was too successful, too visible, too seductive." [6] In the mid-1970s, Biba closed down – its era of sultry Art Nouveau and Art Deco designs truly over.

Sexual relationships also changed dramatically by the end of the 1960s, because the increased availability of the Pill meant that sex became radicalized. Practising sex freely as a physical release like any other and without restraint was celebrated as a freedom from the constraints of bourgeois values. Traditional seduction was old-fashioned, and the seductress a throwback to less enlightened times. As Fogg relates:

"Seduction implies flirtation and withholding, the late sixties were about raw sex. Women were 'chicks' and 'birds' – implicitly un-sexy terms. If you didn't have sex on the same night you met a man at a party you were dull and bourgeois – you didn't even date anyone any more. Everything was up front – you were supposed to say what you felt and feel no jealousy. If a man said 'I really fancy you, let's fuck' you felt you had to." [7]

The perversity of seductive dress was celebrated in 1970s fashion photography, in particular the work of Guy Bourdin and Helmut Newton, and subverted by punk women by the end of the decade. Fishnet stockings, killer heels, and peroxide hair created an image of tribal strength rather than seduction, with the woman appearing ready to bludgeon men into submission rather than subtly coerce them with any kind of feminine wiles.

opposite *In the 1980s, Madonna cut a powerfully seductive figure, here transforming a Lolita-like pose from one of precociousness into one of power and control – no longer the seduced but the active seducer, no longer dependent on men, but using them entirely for her own ends.*

below *Debbie Harry of Blondie combined the iconography of the 1950s blonde bombshell with the edgy rawness of punk rock to create a new vogue for trashy glamour by the late 1970s.*

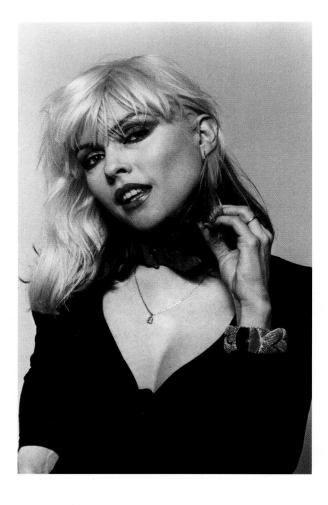

Fashion was a place where subversion, pleasure, and danger could all take place together. Fashion could be used to empower rather than victimize women, and feminist thinking began to reinstate the seductress as a figure of female power rather than rejecting her outright as a figure of male oppression, as Betty Friedan and Germaine Greer had done in the past. In 1971, the feminist polemicist Germaine Greer regarded seductive fashion as a kind of feminine drag that forced women to perform culture's ideal of "femininity":

"I'm sick of the masquerade. I'm sick of pretending eternal youth I'm sick of peering at the world through false eyelashes, so everything I see is mixed with a shadow of bought hairs; I'm sick of weighting my hair with a dead mane, unable to move my neck freely I'm sick of being a transvestite. I refuse to be a female impersonator. I am a woman, not a castrate." 8

By the mid-1980s, feminists were lauding the singer Madonna as a new post-feminist role model. Here, it was claimed, was a new icon of womanhood, a woman of seductive appeal and sexual strength, totally in charge of her men. Every change of her image was analysed by commentators, and the conclusion was that constructing an overtly erotic appearance through dress and make-up didn't necessarily invite the wolfish attentions of the male, but was instead a way of taking pride in one's sexuality – dressing up for the sake of it rather than dressing just to please a man. As Natasha Walter explained in *The New Feminism* (1998):

"Madonna used her swagger and costume changes to demonstrate not her powerlessness but her sexual and financial independence. She played directly into the joy women take in their own bodies and sexuality, without screening it through the approval of men." 9

Women were picking and choosing their lovers rather than waiting for the phone to ring, as Elizabeth Wurtzel wrote in *Bitch* (1998):

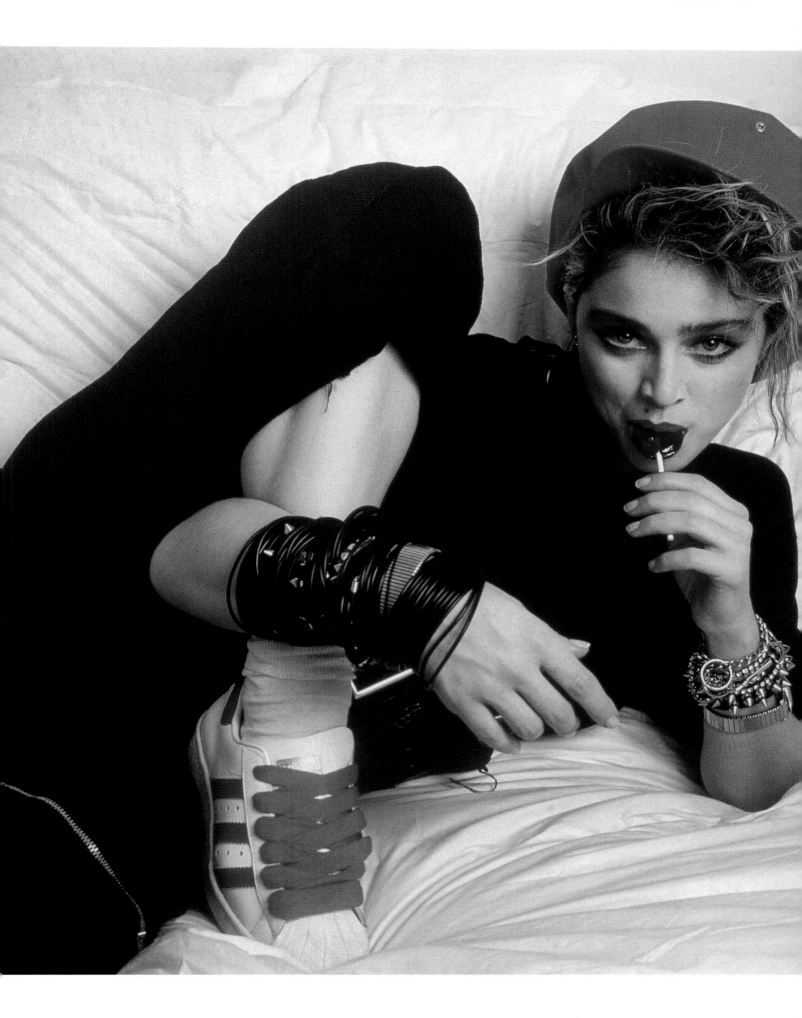

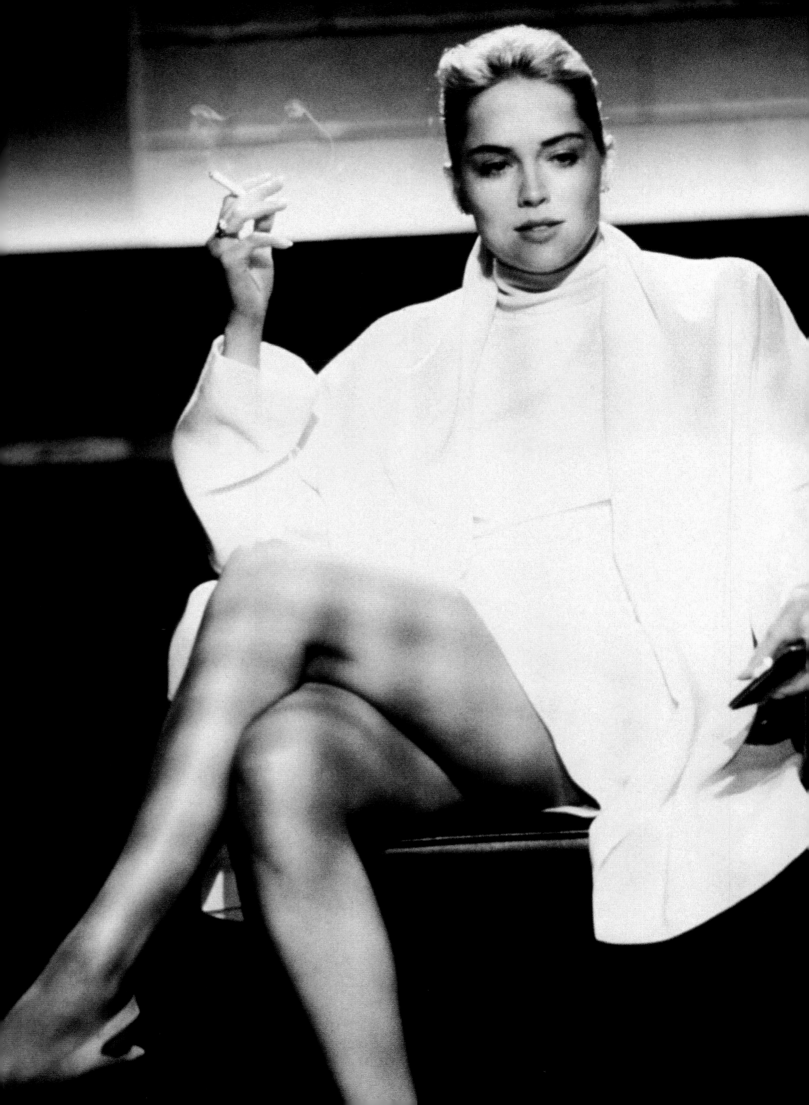

"to hell with dignity. It seems far more exciting to be a Siren beckoning with her song or Calypso captivating on her island than to be a Penelope, the archetype of female fidelity, weaving and unweaving at her loom, sending her suitors away, waiting for the errant Odysseus to return, waiting while he luxuriates in lotus land …. Bad girls don't wait around – one doesn't get to go everywhere by sitting by the phone." [10]

Was all this control a little too speedy though? Some men seemed to think so, particularly when in film the dangerous *femme fatale* made a reappearance in the form of Sharon Stone as Catherine Tramell, the ice pick-wielding seductress quite literally using her sex as a weapon in *Basic Instinct* (1992), and Demi Moore as the sexually harassing boss who responds with anger when her advances are rejected by Michael Douglas in *Disclosure* (1994). Men were in retreat, and the popular press began documenting what appeared to be a "crisis of masculinity", questioning the role of man in twentieth-century culture. If he was no longer the hunter-gatherer with his wife as the keeper of hearth and home, what did he have to contribute? These questions were exacerbated by unemployment, as traditional male industries such as coal and steel went into freefall. Huge swathes of male workers in Europe and America became reliant on their wives for an income, and many were forced to turn their hands to childcare and domestic work, not least because women were demanding it. Women appeared to be coming out on top, and men were running scared – at least in popular representations of masculinity.

If men found the seductive techniques of post-feminist woman a little too harsh, her polar opposite could be found in popular culture in the figure of Bridget Jones, a woman completely lacking in guile. Jones was a confused yet loveable "singleton" who wrote of her hapless performance on the field of late twentieth-century love in the eponymous *Bridget Jones's Diary* of 1996. On Valentine's Day, for instance, she writes: "Ooh, goody. Valentine's Day. Wonder if the post has come yet. Maybe there will be

opposite *Calvin Klein caused a storm of controversy in 1979 with the use of a Lolita-esque pubescent Brooke Shields in an advertising campaign for jeans shot by Richard Avedon.*

below *The G-string has been the most popular form of underwear in the early Noughties, no longer hidden but deliberately displayed over the top of low-slung hipster jeans. Seduction appears to have been replaced by a more overt expression of female sexuality.*

a card from Daniel. Or a secret admirer. Or some flowers or heart-shaped chocolates. Quite excited actually. Brief moment of wild joy when discovered bunch of roses in the hallway. Daniel!" [11] Of course, the chocolates turn out to be for poor old Bridget's enviable neighbour, Vanessa

The seductive weapon of choice wielded by Jones was the thong, or the more slimline and thus risqué version, the G-string, which had become the most popular form of underwear for women by the beginning of the twentieth century. In the film version of her diary (2001), Bridget muses on what to wear for her potentially lustful date with the caddish Daniel Cleaver: should she wear the G-string, which presumes a carnal end to the night, or large elasticized control pants, which will keep her body in check and virtue intact? Jones, played by Renée Zellweger, opts for the latter, and when the inevitable sexual interlude later occurs, she remembers, with horror and too late, her decision. As he works his way up her body, her date murmurs:

"'Now, these are very silly little boots, Jones. And this is a very silly little dress. And um, these are ... fuck me, absolutely enormous pants!'
'Jesus, fuck!'
'No, no, don't apologise; I like them. Hello Mummy!'"

Cleaver's predilections notwithstanding, G-strings were regarded as the most provocative form of underwear, as the revealing of the bottom's cheeks appeared to be an overt expression of a rather raunchy sexuality. The G-string was originally worn by strippers in the 1950s, and had been marketed by Fredericks of Hollywood as "scantie-panties" in a range that included crotchless knickers and edible underwear. Brazilian women had also worn a form of thong called a tanga as part of their bikini in the late 1970s, in a Latino culture that celebrated the beach and the rounded bottom – known as the "bubble butt". This rather saucy background was forgotten in the 1980s, when G-strings and thongs were rebranded in response to the fashion for skin-tight designer jeans,

opposite *By the early 2000s, the waif of the 1990s was being overtaken by a more curvaceous look inspired by Afro-American performers such as Beyonce Knowles, whose womanly body provided a fleshier alternative.*

below *Jennifer Lopez was as famed for her prominent bottom as for her performances on screen and reflected a cultural shift in erogenous zones, as fashion began to frame the rear rather than the midriff.*

which were being sported by women who wanted to display more of their gym-honed bodies in an era that was becoming obsessed with a newly muscled body shape. G-strings were practically invisible under clothing and so combated that great fashion faux pas, the VPL, or Visible Pantie Line.

By 2003, the thong had become the fastest-growing segment of women's underwear, making full-bottomed panties almost redundant among the young, and it had become *de rigueur* to wear hipster jeans cut as low as was acceptable to reveal areas of midriff at the front and the strings of the thong at the back, vanishing enticingly. This new "butt cleavage" was an entirely new focal point in women's fashion, and it was reinforced by designers such as Cosabella and Frost French who covered the straps with diamanté or embroidered butterflies, and by women as diverse as actress Gillian Anderson, famed for her portrayal as Agent Scully in *The X Files*, who revealed her thong while in a backless evening dress, glamour model Jordan in England, and singers Britney Spears and Mariah Carey in the United States. The G-string and thong also reflected a cultural shift in the sexual zoning of women's bodies, as the prominent, fleshy bottom now mythologized in Afro-American culture by songs such as *The Thong Song* by American R&B star Sisquo and embodied in the shape of film star Jennifer Lopez, began to take over from the breasts as the sexiest part of a woman's body.

The newly bootilicious body was a clear move away from the waif look that had dominated the catwalks throughout the 1990s, and it expressed itself in seductive dress in varied ways. Corsets enjoyed a revival, in the main due to Vivienne Westwood's work in the 1980s and her Portrait Collection of 1990, which introduced the concept of "easy-to-wear" into this formerly constricting undergarment. Westwood corsets became part of a whole change in the understanding of underwear – no longer kept hidden or solely for the private enjoyment of a lover, they were now paraded as outerwear.

opposite *Vivienne Westwood's Portrait Collection of 1990 used the imagery of the eighteenth century to create a new version of the* maîtresse en titre *of the French court. In this seminal deisgn, Boucher moved from the decoration of boudoir walls to corsetry.*

Harking back to the pampered *maîtresse en titre* of the eighteenth century, Westwood subverted the notion of the pampered courtesan by giving her more social and physical mobility. Boucher no longer adorned the walls of the boudoir, but was emblazoned across the front of a Lycra corset that could be whipped off over the head and body in one easy movement.

The corseted vamp was steadily embraced by fashion in the 2000s, as the silhouette began to move away from the sterility of 1990s minimalism to a look of luxurious and decadent excess. Cutting-edge designers Alexander McQueen and John Galliano resurrected the *femme fatales* of the *belle époque* and imbued them with a threatening sexual desire and siren seduction. In Galliano's autumn/ winter 1998/9 collection, the designer drew on photographs of La Belle Otéro as an *objet de luxe*, specifically referencing her celebrated diamond necklace and opulent hourglass silhouette, and, as fashion historian Caroline Evans describes it, "reconfiguring the belle époque" with his "fascination with sensational historical figures of the late nineteenth and early twentieth centuries, and particularly with woman who used their sexuality spectacularly to make their way in the world." [12] For Evans, McQueen's *femmes fatales* recall "the etymology of the words 'glamour' and 'vamp' as something potentially terrifying and bewitching rather than reassuring. Allying glamour with fear rather than allure, McQueen's avowed intent was to create a woman 'who looks so fabulous you wouldn't dare lay a hand on her.' As he put it, 'I like men to keep their distance from women, I like men to be stunned by an entrance.'" [13]

Two established companies that recognized the new corseted trend and acted accordingly were Rigby & Peller and Vollers, whose hand-finished corsets are some of the most sought-after today. Rigby & Peller have been bestriding the market as the Rolls Royce of underwear since 1939, when a small, understated workroom in South Molton Street catered to the needs of Britain's aristocratic ladies and their "unmentionables". Vollers,

opposite *A handmade corset by Vollers, a British firm established in1899, who have successfully re-branded the corset as outer- rather than underwear.*

below *A contemporary catwalk design that uses the 1950s girdle as inspiration, displaying that which is normally kept hidden – a key look in fashion through the 1990s and 2000s.*

too, has a long pedigree, established in 1899 and originally operating under the name of Madame Voller, their specialism has always been handmade corsets. Both companies now provide the same service, but the original "unmentionables" they produced discreetly for subtle body restraint are being worn openly as objects of luxury fashion, conveying what journalist Laura Barton calls:

"a very different kind of sexuality to that routinely peddled on the covers of lads' mags and available for a few crisp notes at the likes of [lap-dancing club] Spearmint Rhino. It is at once a marriage of pure sexuality and a level of restrained social respectability The corset projects a sort of womanliness, as opposed to the attractions of a vest-wearing slip of a girl." [14]

This new womanliness began to appear in high fashion in 2005 in the work of Roland Mouret, Marc Jacobs, and Nicolas Ghesquière for Balenciaga. More and more women were responding to the exhortation to dress up. As fashion journalist Jo Adams wrote, "I find myself in the mood for high heels, a sexy blouse and a fitted skirt that gives me a waddle in my walk. In other words I want to be a woman again – I want clothes that reveal my curves, and to hell with anything Boho." [15]

Many of the fashion-savvy saw this as a direct result of the New Burlesque revival, which had originated in New York in the 1990s and then moved out to San Francisco, London, and Paris. Burlesque, a titillating form of kitschy striptease in which the naked body is never actually shown, had dancers using props such as fans, feathers, and twirling nipple-tassels to tantalize, while at the same time invoking a retro 1950s femininity. Journalist Tricia Romano described one such show featuring the classic burlesque "reverse-strip":

"the woman onstage is nearly naked. A ravishing redhead with a Rita Hayworth hairdo, she has porcelain-perfect skin and a lithe body. She takes her sweet time putting on sheer black thigh-high stockings – gently caressing one

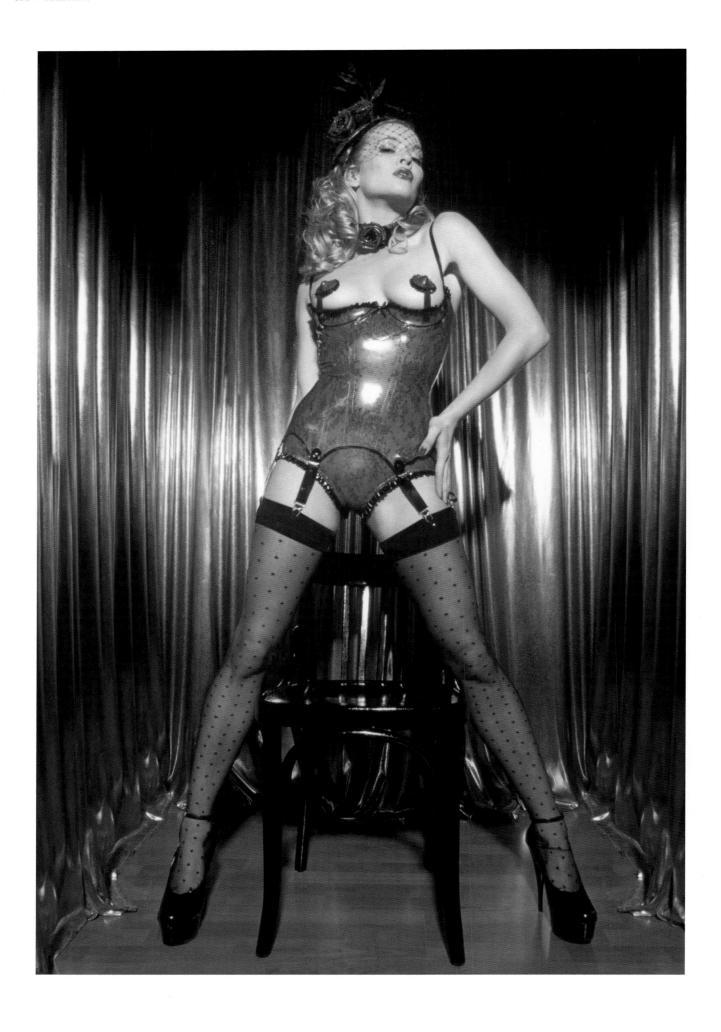

opposite *A contemporary image by photographer Ben Westwood uses the imagery of burlesque to display the designs of fetish couturier Atsuko Kudo, who uses the traditional props of the fantasy showgirl in this scene of raunchy seduction.*

below *Immodesty Blaize, one of the key performers of the New Burlesque movement, introduces a modern audience to the art of tease using retro styling, music and moves in this image by photographer Richard Heeps.*

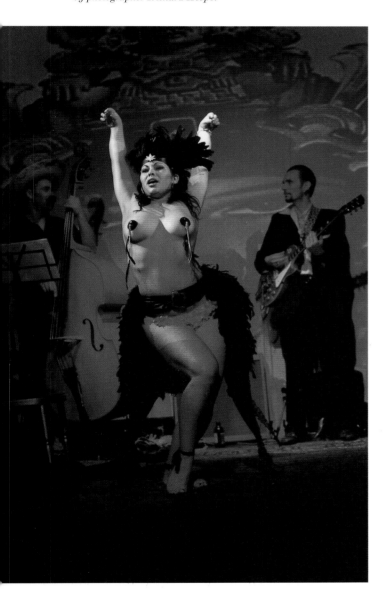

lean leg, then the next. She flicks her toes and stands up as she fastens garters in place, and with a sly smile she slowly pulls on a luscious burgundy-and-black corset over which her glittering pasties twinkle in the spotlight. The strains of Gloria Wood's 'Oh Honey' play, and the audience at the midtown Palace of Variety Theatre sits rapt as she laces up the garment. With each tug, the music releases an ecstatic groan and her face contorts with pain and pleasure." [16]

The revival of the reverse strip in a culture where blatant representations of the female body are common currency all over the world through advertising, cinema, and the Internet, and at a moment when the covers of men's lifestyle magazines are virtually indistinguishable from their pornographic equivalent, is curious. It seems that the art of seduction is being retrieved just at a time when nudity is commonplace: the art of tease flirtatiously toying with the idea of concealment and exposure is re-emerging when, as a culture, we appear satiated with human flesh.

Burlesque performers wear bustiers and corsets, stockings and suspenders, gold lamé gowns, and maribou mules – the classic props of the seductress of the past but now strutted on the twenty-first century stage. Artistes Dita von Teese, Dirty Martini, and Immodesty Blaize have introduced a curvaceous "va va voom" figure that is interpreted as overwhelmingly erotic in its more obviously fleshy state, and the look has entered the mainstream. By 2006, burlesque imagery featured in fashion design and advertising, the styling of pop videos and stage performance, and countless lingerie shoots, such as Cosabella's of 2006. Atsuko Kudo's work, as photographed by Ben Westwood, exemplifies the New Burlesque look, with its mix of 1950s glamour and modern fetish in garments of lace-printed latex to be worn on stage, to a salon, or in the bedroom; and international fashion expert Tony Glenville pertinently describes this new wave in fashion as moving away from body exposure to something quite different: "It's not about the body, or unwrapping it, it's not let's find out what's in the box,

opposite *The four seductresses of* Sex and the City *showed the many faces of the modern* femme fatale *in the twenty-first century, from Charlotte's girlish approach to Samantha's pure unbridled lust. The series has been instrumental in bringing the frank discussion of female sexuality to a modern global audience.*

let's just look at the box." [17] There is a move away from the body as the sexual object to clothes as the main focus of erotic interest.

The new womanly woman, older, wiser, and very much in control, using seductive fashion as well as the force of her personality to grab her man, has also made her mark in popular culture in the form of Samantha Jones, one of the leading characters in the popular HBO television series *Sex and the City*, which ran from 1998 to 2004. The series portrayed turn-of-the century New York as a city where "the rules of heterosexual relations are in a state of flux," according to theorist Joanna di Mattia, "with women no longer content to adopt the traditional models of femininity." [18] Samantha, played by Kim Cattrall, was a sexual libertine who saw Mr Right as no more than a romantic fantasy and was "using sex as a physical rather than emotional experience," according to Julia Gash, owner of Gash, one of the first erotic emporia and lifestyle brands directed expressly at women. She continues, "there's been such a turnaround in attitudes, and *Sex and the City* has been one of the driving forces. The women were stylish, successful and glamorous – aspirational, and we identified with facets of their characters. Samantha made it fun and cool to be sexual and *de rigueur* to have a vibrator – it became a sign of autonomy, a real sign of the times." [19]

Samantha used the traditional seductive techniques of the *femme fatale*, a contemporary Mrs Robinson playing with her prey like a cat with a mouse and always, but always, in control. Her dress was glamorous in its most traditional sense – she was blonde, always in full *maquillage*, with cleavage on display and killer heels. Her friends Charlotte and Miranda tended to dress in classics that were less openly sexual in the amount of body on display, and Carrie, of course, played by Sarah-Jessica Parker, was the quirky, catwalk flirt who was more openly questioning of relationships and life as a single woman in the city, but always believing in the possibility of old-fashioned romance.

In *Sex and the City*, Samantha's seductive techniques acted as a prelude to athletic and sometimes downright kinky sex without any retribution – to "fuck like a man," as Samantha put it. Seduction almost always resulted in sex, and it was sex without emotional ties or physical taboos. For these girls, seduction was multi-faceted, moving on from the original encounter, where fashion was a key part of the attraction process, right through to the act of sex itself, where, for Samantha in particular, the man was to be seduced through her physical prowess. The bedroom was also another arena in which to show good taste: money could be spent on the latest erotic accoutrements, which were now branded in the same way as a pair of Jimmy Choo shoes were in the series.

In a fine example of fact following fiction, designer boudoirs such as Coco de Mer and Myla have opened up for modern-day Samanthas, specifically catering for the physical needs of sophisticated women of pleasure by providing their latest playthings. Myla was created by Charlotte Semler and Nina Hampson in 2000 to cater for the high end of the erotic marketplace, and more specifically for women who were, as they put it, "more girly and feminine than S and M". [20] Charlotte explains, "Sex and a little bedroom fun shouldn't be seedy. It should all be about romance, intimacy and luxury." [21] A major breakthrough came when they invited some of the world's best designers to employ their talents in designing upmarket sex toys, an area where no real design aesthetic had been applied before. Tom Dixon OBE and creative director of Habitat, Marc Newson, and Mari-Ruth Oda all created new objects of desire with an organically fluid look, works of art that are lusted after in the same way as a Gucci handbag.

It has now become the height of chic for women to enter a soigné sex shop containing objects that in the past would have been found only in mail-order catalogues or in the dodgier ends of Soho in London, Pigalle in Paris, and Times Square in New York. Revelling in their sexuality, stars such as actress Sienna Miller, designer Jade Jagger, and singer Beyonce Knowles have been snapped walking

above *Internationally renowned designer Tom Dixon and artist Mari-Ruth Oda were invited by Myla to design sex toys of sculptural beauty as well as erotic function in 2000. The results were Oda's* Pebble *(left) and Dixon's* Bone *(right).*

opposite *La Perla, a company created in 1954 by Ada Masotti, at first specialized in swimwear and corsetry. It's now the leading international brand in luxurious underwear.*

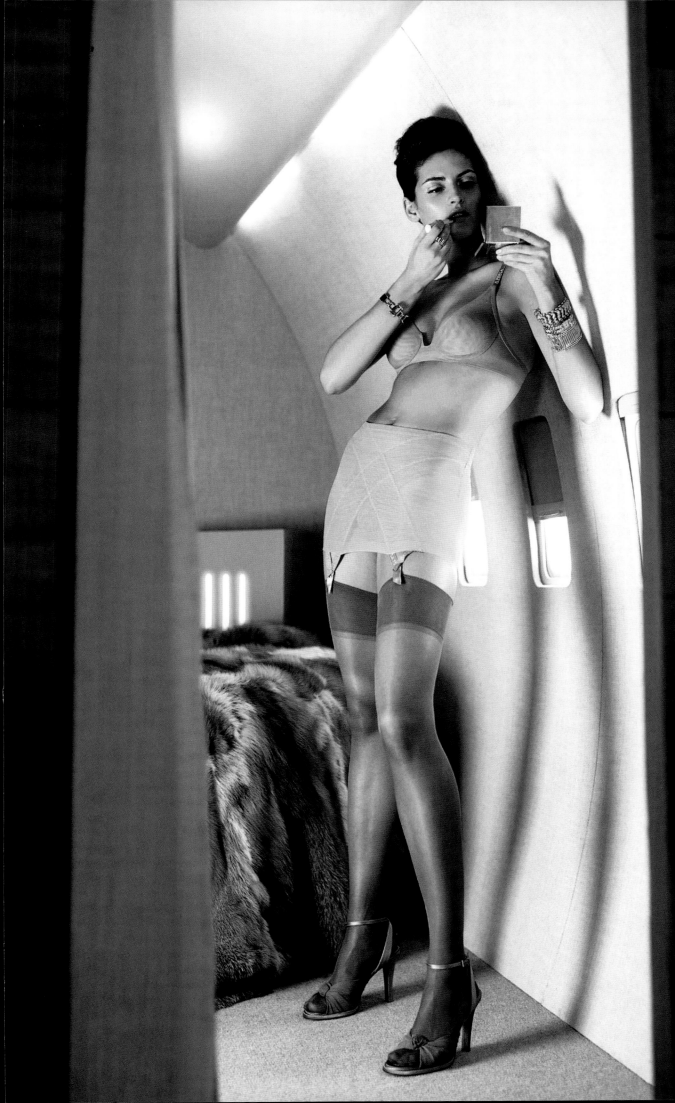

opposite *A pair of knickers by Damaris for display rather than function, with the signature Bow back presenting a modern woman as an* objet de luxe, *an exquisite object to be unwrapped.*

below *Strumpet and Pink create underwear that is at odds with the contemporaray obsession with the G-string and paves the way for a new kind of underwear that harks back to the Edwardian designs of Lucile.*

through Myla's portals and nobody blinks an eye. Women are now seeing seduction as the pathway to sexual adventure over which they have the utmost control, rather than pandering to the wishes of men. American journalist Debbie Stoller also attests to the new sexually adventurous spirit of feminism's "next generation": "Lusty feminists of the third wave, we're more than ready to drag race down sexual roads less travelled." [22]

The obviousness of the G-string is being slowly replaced by underwear that is less revealing and more suggestively seductive, covering more of the body in exquisite wrappings so that the body is a package to be slowly unwrapped rather than immediately bared. Damaris and Strumpet and Pink are at the forefront of this new trend, which almost harks back to the days of Lucile's luxurious lingerie of the Edwardian era. Strumpet and Pink is a collaboration between artists Liza Morgan and Melanie Probert, which was formed to create the perfect pair of hand-dyed, hand-painted knickers in fine silk chiffon, at once functional and decadent. Each perfect pair is individually named with a lyrical title to evoke a nostalgic Edwardian eroticism, such as The Garden of Delights, Lady Hume's Blush, and Happy Days at the Courtesan's House. Damaris' designs are high-end fashion bought by stars such as Angelina Jolie and Kirsten Dunst, hand-crafted out of the most luxurious fabrics and glittering with Swarovski crystal. Her signature Bow Knicker wittily subverts the notion of cleavage by displaying fashion's new erogenous zone.

The lingerie revival has also seen Californian companies Victoria's Secret and Fredericks of Hollywood attracting legions of both male and female consumers – at one point in 2000, Victoria's Secret was estimated to be selling 600 items of lingerie per minute. In London, the shop Agent Provocateur, founded by Joe Corre and Serena Rees in 1994, successfully integrated the glamour of 1950s underwear with the catwalk, and, as Corre put it, placed lingerie and underwear "fairly and squarely on the fashion map. It's now something that both high street and couture

opposite *The contemporary bedroom is less a place of minimalism these days and more one of luxury, a place that evokes the traditional boudoir, as leopard-skin and 1950s pink are mixed with faux Louis XV chandeliers and white fur throws.*

below *The Duvet restaurant in New York has introduced American punters to a new concept in dining out, with traditional tables replaced by beds on which to recline in an atmosphere of relaxed seduction.*

ends of fashion design take seriously." [23] Rees and Corre re-created seminal garments, including the Baby Doll nightie and French knickers, by sourcing vintage undies and amalgamating them with new fabrics such as Lycra and high-fashion design concepts, thus redefining lingerie as a luxury item for the fashion aware.

And women are spending money, pots of it, on lingerie. A former TV producer in New York, Karyn Bosnak, who famously ran up huge debts in department stores because of her shopaholic tendencies, writes of her obsession with designer lingerie and its promise of a luxurious lifestyle. Most significantly, we learn how it is considered a vital factor in seducing and so securing a man:

"'How much?' I asked, shocked that it was so expensive. '$778,' she repeated…. I stood there in awe not knowing what to do. It was expensive, but I had to be honest with myself. I was twenty-seven years old and wasn't going to be a spring chicken much longer. So I needed these nighties to look as sexy as I could because I needed to land a man. So they were kind of like an investment. An investment in my sex life and an investment in my future." [24]

The bedroom is now the boudoir, a place of pampering after a hard day's work, a place in which to indulge, to eat Belgian chocolates, and to pose in the latest lingerie in front of a shimmering Venetian-inspired mirror. White-painted rococo revival furniture has now replaced the minimalism that had dominated the last decade, and chaise longues, Philippe Starck Louis Ghost chairs, faux fur throws, and feather trim have returned to interior design. In fact, the boudoir aesthetic of seduction has moved away from the intimacies of the domestic or the cinema screen to more public rather than private spaces. The Duvet restaurant in New York, the Supperclub in Amsterdam, Rome, and San Francisco, and the Bedroom Boudoir in London are bars and restaurants where the punter books a bed rather than a table. Writer Jan Moir describes the scene: "a large curved room with about twenty beds ranged around the edges and a huge buffet

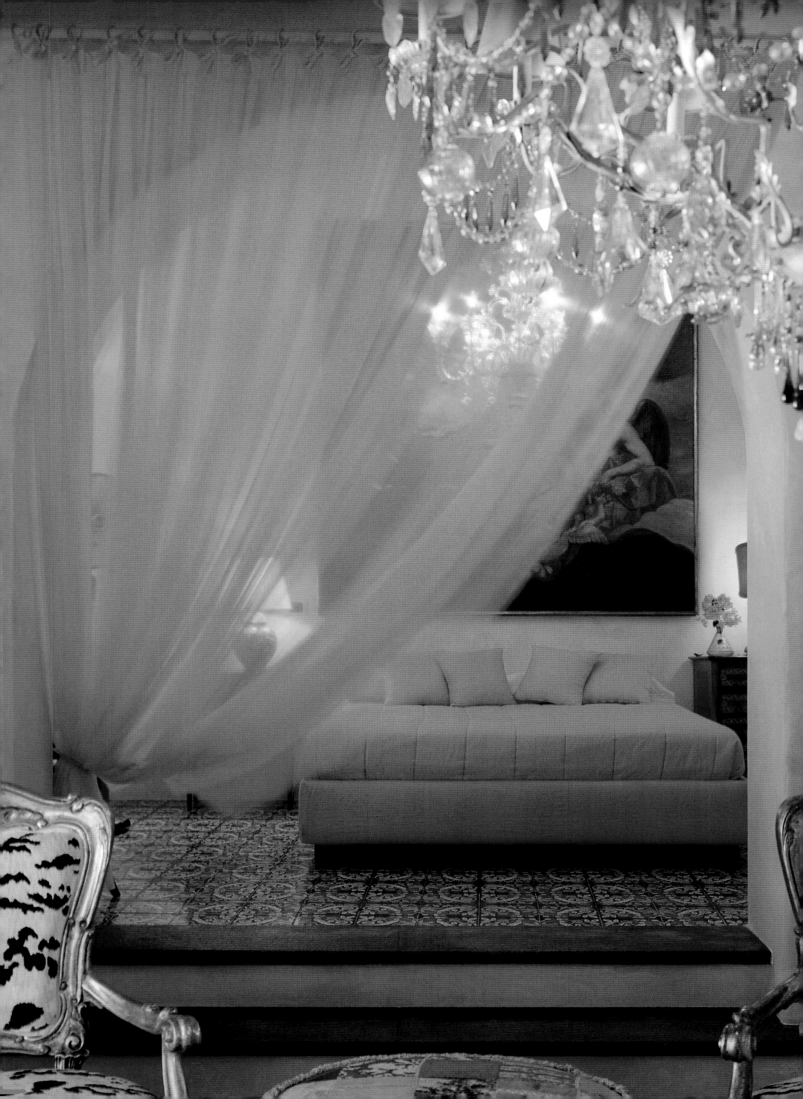

opposite *The contemporary seductress in the form of actress Angelina Jolie dressed in her lover's white shirt, a signifier of seduction since Claudette Colbert wore Clark Gable's shirt in* It Happened One Night *in 1934.*

laden with oysters and crab claws in the middle. Couples are lying on the beds, drinking pink champagne and talking in low voices as waiters scurry to and fro. The theme music from *Sex and the City* plays, while a hostess in a sparkly red evening gown smiles and nods …. Oh God. Here is our bed. It is a large single, tucked into a slight recess and laid with a billowing white duvet and lots of squashy pillows. There is a small table in font of it, strewn with fresh rose petals and beads of pink glass, with a candle flickering in a single holder…." [25]

Women are confident in their powers of seduction and (if they want it) can have complete control in both bedroom and boardroom, as Madonna and thrice-married Jennifer Lopez have shown so successfully in their careers. Women feel free to buy expensive lace fripperies of lingerie by Janet Reger and Frost French, magnums of champagne and mink throws to please themselves, as much as to satisfy the erotic demands of a lover. Perhaps succeeding generations of women will see the myriad constructions and contradictions of femininity as a cause for celebration.

Women have been seducing for centuries using lingerie, soft lights, perfume, frills, and feathers, but it must be remembered that seduction is also an attitude and a state of mind. Some of the world's greatest seductresses were not necessarily the most beautiful or talented women in culture – or even the women with the most finely honed brains. What they did possess, however, was confidence in their powers to bewitch and, of course, luck that their looks counted for currency in decades dominated by men. Today's seductress has more control in culture, and it is sometimes her very independence that attracts. A woman such as actress Angelina Jolie, for instance, holds down the demanding and sometimes conflicting roles of actress, mother, lover, and campaigner. Although stunningly beautiful, Jolie eschews the popular Hollywood route of exposing inches of flesh on the red carpet, instead favouring a more sophisticated approach. She seems seductive in her own skin, with or without a man – although a little bit of styling always helps.

FOOTNOTES

INTRODUCTION

1. Jean Baudrillard, *Seduction*. 1990, p.83
2. Ibid., p.88
3. Jane Billinghurst, *Temptress: From the Original Bad Girls to Women on Top*, 2003, p.7
4. C. Hayward, *The Courtesan in Literature and Life*, 1926, p.197
5. Charles Castle, *La Belle Otéro; The Last Great Courtesan*, 1981 p.120
6. Bernard Rudofsky, *The Unfashionable Human Body*, 1971, pp.12–13
7. Tony Glenville, interview with author
8. Quentin Bell, *On Human Finery*, 1992, p.51
9. Betsy Prioleau, *Seductress: Women who ravished the World and their Lost Art of Love*, 2003, pp.283–4
10. Jan Birks, interview with author
11. No specific source. The discussion takes place in James Laver, *Modesty in Dress: An Inquiry into the Fundamentals of Fashion*, 1969.
12. John Chandos, *Guide to Seduction*, 1965, p.3
13. Billinghurst, p.11
14. Ibid., p.22
15. Hazel Curry, "The Art of Seduction" in a supplement for Hugo Boss Intense, *Vogue* 2004

CUPIDS & COURTESANS

1. Herrick in the poem "Delight in Disorder" from Douglas Brooks-Davies, *Robert Herrick*, p.15
2. Colbert in Valerie Steele, *Paris Fashion: A Cultural History*, 1988, p.23
3. Nancy Mitford, *Madame de Pompadour*. 1968, p.16
4. Ibid., p.17
5. Peter Cryle, *Geometry in the Boudoir: Configurations of French Erotic Narrative*, 1994, p.79
6. Horace Walpole in Christine Pevitt, *Madame de Pompadour: Mistress of France*, 2002, p.86
7. Le Camus in Nicole Reynolds, *Boudoir Stories: A Novel History of a Room and Its Occupants* in

Literature Interpretation Theory Online, 2004, p.108
8. Ibid.
9. J.J. Mangen, *The King's Favour; Three eighteenth-century monarchs and the favourites who ruled them*, 1991, p.144
10. Mitford, p.73
11. Robert B. Douglas, *The Life and Times of Madame du Barry*, 1896, p.175
12. Walpole in Ann Hollander, *Seeing Through Clothes*, 1993, p.58
13. Ibid., p.59
14. Casanova in Daniel Roche, *The Culture of Clothing: Dress and Fashion in the 'ancien regime'*, 1994, p.414
15. John Logan, "Ode to Woman" (1770) in C. Willett and Phyllis Cunnington, *The History of Underclothes*, 1981, p.50
16. Choldéros de Laclos, *Les Liaisons dangereuses* (1782), 1992, p.25
17. Gertrude Aretz, *The Elegant Woman From the Rococo Period to Modern Times*, 1932, p.22
18. Douglas, pp.61–2
19. Hollander, p.60
20. Casanova in Antonia Fraser, *Marie Antoinette*, 2001, p.72
21. Casanova in Richard Corson, *Fashions in Make-Up*, 2001, p.218
22. Charles Kunstler, *The Personal Life of Marie Antoinette*, 1940, p.159
23. Fraser, p.165
24. Restif de la Bretonne, *La Paysanne pervertie* (1784) in Cryle, p.207
25. Victor de Mirabeau, *Le Rideau levé* (1786) in Cryle, p.208
26. Mmle Sapho and Mme Furiel Mairobert, *La Secte des Anandrynes: Confession de Mademoiselle Sapho* (1786) in Cryle, p.215
27. Aretz, p.19
28. Reynolds, p.117

A GLIMPSE OF STOCKING

1. La Belle Otéro in Michael Harrison, *A Fanfare of Strumpets*, 1971, p.187
2. Susan Griffin, *The Book of the Courtesan*, 2002, p.141
3. Raymond Rudorff, *Paris in the Nineties*, 1972, p.14
4. Andrea Stuart, *Showgirls*, 1996, p.20

5. Muriel Barbier and Shazia Boucher, *The Story of Lingerie*, 2004, p.143.
6. Cornelia Otis Skinner, *Elegant Wits and Grandes Horizontales*, 1962, p.22
7. Stuart, p.31
8. Charles Castle, *La Belle Otéro: The Last Great Courtesan*, 1981, p.6
9. Bram Dijkstra, *Idols of Perversity: Fantasies of Feminine Evil in Fin-de-Siècle Culture*, 1986, p.246
10. Castle, p.66
11. Kate Hickman, *Courtesans*, 2003, p.12
12. Ibid.
13. Jean Cocteau in Castle, pp.14–15
14. Liane de Pougy, *My Blue Notebooks*, 1977, p.61
15. Skinner, p.64
16. Valerie Steele, *Paris Fashion: A Cultural History*, 1988, pp.159–61
17. Octave Uzanne in Gertrude Aretz, *The Elegant Woman From the Rococo Period to Modern Times*, 1932, p.260
18. Aretz, p.251
19. de Pougy, p.50
20. Ibid., p.98
21. Ibid., p.50
22. Ibid.
23. Stuart, p.8
24. de Pougy, p.51
25. Ibid., p.86
26. Valerie Steele, "Femme Fatale: Fashion and Visual Culture in Fin-de-Siècle Paris" in *Fashion Theory*, Volume 8, Issue 3, September 2004, pp.315–16.
27. Edith Wharton and Ogden Codman, *The Decoration of Houses*, 1898, p.75
28. Lady Barker, *The Bedroom and the Boudoir*, 1878, p.14
29. Steele, 1988, p.190
30. Ibid.
31. Octave Uzanne in Aretz, pp.272–3
32. Valerie Steele, *Fetish*, 1996, p.117
33. Alison Adburgham, *Shops and Shopping 1800–1914*, 1989, p.249
34. Lady Duff Cooper (Lucile), *Discretions and Indiscretions*, 1932, pp.44–5
35. Valerie Steele, *Fashion and Eroticism: Ideals of Feminine Beauty from the Victorian Era to the Jazz Age*, 1985, p.205
36. Elsie de Wolf, *The House in Good Taste*, 1914, p.159

37. Ibid., p.160
38. Ibid., p.163
39. Ibid., p.169
40. Ibid.
41. Ibid., p.224
42. Hickman, p.26

NIGHTS IN WHITE SATIN

1. Dorothy Parker, *The White Satin Dress* (1926) in *The Best of Dorothy Parker*, 1995, p.32
2. Aldous Huxley, *Antic Hay* (1923) in Judith Watt, *The Penguin Book of Twentieth-century Fashion Writing*, 1999, p.41
3. Gertrude Aretz, *The Elegant Woman From the Rococo Period to Modern Times*, 1932, p.290
4. Zelda Fitzgerald in Colin McDowell, *The Literary Companion to Fashion* 1995, p.64
5. Rebecca Arnold, *Fashion, Desire and Anxiety: Image and Morality in the 20th Century*, 2001, p.66
6. Ibid.
7. Ellen Welles Page, "A Flapper's Appeal to Parents" in *Outlook*, 6 December 1922
8. Michael Arlen, *The Green Hat*, 1924, p.47
9. Evelyn Waugh, *Brideshead Revisited* (1945), 1977, p.735
10. Arlen, p.89
11. Ibid., p.118
12. Ibid., p.16
13. Ibid., p.42
14. Antoine de Paris, *Antoine by Antoine*, 1946, p.45
15. Aretz, p.292
16. Bruce Blixen, "Flapper Jane" in *The New Republic*, 9 September 1925, www.geocities.com/ flapper_culture
17. Muriel Barbier and Shazia Boucher, *The Story of Lingerie*, 2004, p.13
18. *Ladies' Home Journal*, 1920s
19. Parker, p.44
20. Alexander Walker, *Sex in the Movies*, 1969, p.95
21. Ibid., p.36
22. Ibid., p.41
23. Irving Shulman, *Harlow: An Intimate Biography*, 1964, p.91
24. Ibid.
25. Josephine Huddleston, *Secrets of Charm*, 1929,

p.114

26. Parker Tyler, "The Awful Fate of the Sex Goddess" (pp.20–8), in *Sex Psyche Etcetera in the Film*, 1971, p.25
27. Walker, p.124
28. Julie A. Willett, *Permanent Waves: The Making of the American Beauty Shop*, 2000, p.47
29. Rebecca West in Watt, p.177
30. Anne Hollander, *Seeing Through Clothes*, 1988, p.342
31. Cecil Beaton, *The Glass of Fashion: A Personal History of Fifty Years of Changing Tastes and the People who Have Inspired Them*, 1954, p.208
32. Kurt Moreck in Aretz, pp.294–5
33. Kathy Peiss, *Hope in a Jar: The Making of America's Beauty Culture*, 1998, p.186
34. Ibid., p.144
35. Ibid., p.156
36. Parker, p. 201

PRETTY IN PINK

1. www.jaynemansfield.com
2. Vance Packard, *The Status Seekers*, 1961, p.15
3. Thomas Hine, *Populuxe*, 1986, p.126
4. Diana Dors, *For Adults Only*, 1978, p.143
5. Parker Tyler, *Sex Psyche Etcetera in the Film*, 1971, p.23
6. Penny Sparke, *As Long as It's Pink: The Sexual Politics of Taste*, 1995, p.197
7. Ibid.
8. Ibid., p.198
9. Dors, p.152
10 Donald Spoto, *Marilyn Monroe: The Biography*, 1993, p.231
11. www.jaynemansfield.com
12. Peter Lewis, *The Fifties*, 1978, p.50
13. Glenys Roberts, "The Peak of Perfection", in the *Daily Mail*, 17 December 2005
14. Caroline Cox, *Lingerie: A Lexicon of Style*, p.247
15. Dengel, p.111
16 Spoto, p.246
17. Ibid., p.260
18. Zolotow, p.145
19. Ibid., p.202
20. Jackie Stacey, *Star Gazing: Hollywood Cinema and Spectatorship*, 1994, p.206
21. Dors, p.201

22. Lois Wyse, *Blonde Beautiful Blonde: How to Look, Live, Work and Think Blonde*, 1980, p.159
23. Betty Page, *On Fair Vanity*, 1954, p.163
24. Dengel, p.172
25. Ibid., p.31
26. Thomas Vail, *Bizarre Harem, c.*1950, p.39
27. Meg Cohen Ragas and Karen Kozlowski, *Read My Lips: A Cultural History of Lipstick*, 1998, p.76
28. Ibid., p.30
29. Susan Brownmiller, *Femininity*, 1984, p.164
30. Kenneth Anger, *Hollywood Babylon*, 1975, p.262
31. Ibid., p.269
32. Ibid., p.270
33. Lynne Reid Banks, *The L-shaped Room*, 1960, p.101
34. Betty Friedan, *The Feminine Mystique*, 1965, p.229
35. Ibid., p.243

KISS & TELL

1. *Vogue* (1995) quoted in Elizabeth Wurtzel, *Bitch*, 1998, p.9
2. Marnie Fogg, interview with author
3. Ibid.
4. Alwyn W. Turner, *Biba: The Biba Experience,* 2004, p.25
5. Fogg interview
6. Turner, p.49
7. Fogg interview
8. Germaine Greer, *The Female Eunuch*, 1971, p.58
9. Natasha Walter, *The New Feminism*, 1998, p.98
10. Wurtzel, 1998, p.98
11. Helen Fielding, *Bridget Jones's Diary*, 1996, pp.49–50
12. Caroline Evans, *Fashion at the Edge*, 2003, p.124
13. Ibid., p.149
14. Laura Barton, "The Big Squeeze" in the *Guardian*, 22 March 2005
15. Jo Adams, "Dressing for the Heat" in *The Observer*, 31 July 2005
16. Tricia Romano, "Bombshells Away! The New Burlesque Hits Gotham," in *Village Voice*, 5 March 2003
17. Tony Glenville, interview with author, 2005
18. Joanna di Mattia in Kim Akass and Janet McCabe, *Reading Sex and the City,*

2004, p.18
19. Julia Gash, interview with author
20. Grace Saunders, "What a girl wants, what a girl needs" in *Shoo Magazine*, Issue 9, Summer, 2005, p.56
21. Ibid.
22. Debbie Stoller in Akass and McCabe, p.77
23. The British Council, *Inside Out: Underwear and Style in the UK,* 2000, p.124
24. Karyn Bosnak, *Save Karyn: A true-life shopaholic's journey to debt and back*, 2004, p.140
25. Jan Moir, "Are you ready to order?" in *The Daily Telegraph*, 1 October 2005

BIBLIOGRAPHY

Adburgham, Alison. *Shops and Shopping 1800–1914*. London, Barrie and Jenkins, 1989

Akass, Kim and McCabe Janet, *Reading Sex and the City*. London, I.B. Tauris, 2004

Anger, Kenneth. *Hollywood Babylon*. New York, Delta Publishing, 1975

Aretz, Gertrude. *The Elegant Woman From the Rococo Period to Modern Times*. London, George G. Harrap, 1932

Arlen, Michael. *The Green Hat*. London, Collins, 1924

Arnold, Rebecca. *Fashion, Desire and Anxiety: Image and Morality in the 20th Century*. London, I.B. Tauris, 2001

Barbier Muriel and Boucher, Shazia. *The Story of Lingerie*. New York, Parkstone Press, 2004

Barker, Lady. *The Bedroom and the Boudoir*. London, Macmillan. 1878

Baudrillard, Jean. *Seduction* (1979). New York, St Martin's Press, 1990

Beaton, Cecil. *The Glass of Fashion: A Personal History of Fifty Years of Changing Tastes and the People who have inspired them*. London, Cassell, 1954

de Beauvoir, Simone. *The Second Sex*. London, Penguin, 1972

Bell, Quentin. *On Human Finery* (1947). London, Allison and Busby, 1992

Billinghurst, Jane. *Temptress: From the Original Bad Girls to Women on Top*. New York, Greystone Books, 2003

Bosnak, Karyn. *Save Karyn: A true-life shopaholic's journey to debt and back*. London, Corgi, 2004

British Council, *Inside Out: Underwear and Style in the UK*. London, Black Dog Publishing, 2000

Brooks-Davies, Douglas. *Robert Herrick*. Everyman Poetry Library, 1997

Brownmiller, Susan. *Femininity*. London, Hamish Hamilton, 1984

Castle, Charles. *La Belle Otéro: The Last Great Courtesan*. London, Michael Joseph, 1981

Chandos, John. *A Guide to Seduction* (1953) London, Brown and Watson, 1965

Christiansen, Rupert. *Tales of the New Babylon: Paris 1869–1875*. London, Sinclair-Stevenson, 1994

Cohen Ragas, Meg and Kozlowski, Karen. *Read My Lips: A Cultural History of Lipstick*. San Francisco, Chronicle, ????

Cooper, Lady Duff (Lucile), *Discretions and Indiscretions*. London, Jarrolds, 1932

Corson, Richard. *Fashions in Make-Up*. London, Peter Owen, 2001

Cox, Caroline. *Lingerie: A Lexicon of Style*. London, Scriptum Editions, 2000

Craik, Jennifer, *The Face of Fashion: Cultural Studies in Fashion*. London, Routledge, 1994

Cryle, Peter. *Geometry in the Boudoir: Configurations of French Erotic Narrative*. Ithaca and London, Cornell University Press, 1994

Dengel, Veronica. *Can I Hold my Beauty*. London: John Westhouse, 1946

Dijkstra, Bram. *Idols of Perversity: Fantasies of Feminine Evil in Fin-de-Siècle Culture*. New York, Oxford University Press, 1986

Dors, Diana. *For Adults Only*. London, W.H. Allen, 1978

Douglas, Robert. B. *The Life and Times of Madame du Barry*. London, Leonard Smithers, 1896

Evans, Caroline. *Fashion at the Edge*. New Haven and London, Yale University Press, 2003

Evans, Caroline and Thornton, Minna, *Women and Fashion: A New Look*. London, Quartet, 1989

Fielding, Helen. *Bridget Jones's Diary*. London, Picador, 1996

Flugel, J.C., *The Psychology of Clothing* (1930). New York, International Universities Press, Inc., 1971

Fogg, Marnie, *Boutique*. London, Mitchell Beazley, 2003

Fraser, Antonia. *Marie Antoinette*. London, Weidenfeld and Nicholson, 2001

Freedman, Rita, *Beauty Bound: Why Women Strive for Physical Perfection*. London, Columbus, 1988

Freud, Sigmund, *On Sexuality*. London, Penguin, 1977

Friedan, Betty. *The Feminine Mystique*. London, Penguin, 1965

Gardiner, James. *Gaby Deslys: A Fatal Attraction*. London, Sidgwick and Jackson, 1986

Greer, Germaine. *The Female Eunuch*. London, Paladin, 1971

Griffin, Susan. *The Book of the Courtesan*. London, Macmillan, 2002

Harrison, Michael. *A Fanfare of Strumpets*. London, W.H. Allen, 1971

Hayward, C. *The Courtesan in Literature and Life*. London, The Casanova Society, 1926

Hickman, Kate. *Courtesans*. London, Harper Perennial, 2003

Hine, Thomas. *Populuxe*. London, Bloomsbury, 1986

Hollander, Ann. *Seeing Through Clothes*. Berkeley, University of California Press, 1993

Huddleston, Josephine. *Secrets of Charm*. London, G.P. Putnam's Sons, 1929

Jones, Jennifer M. *Sexing la Mode: Gender, Fashion and Commercial Culture in Old Regime France*. New York: Berg, 2004

Kirkham, Pat (ed.), *The Gendered Object*. Manchester, Manchester University Press, 1996

Kunstler, Charles. *The Personal Life of Marie Antoinette*. London, G. Bell and Sons, 1940

de Laclos, Choderos *Les Liaisons dangereuses* (1782), London, Everyman's Library, 1992

Langner, Lawrence, *The Importance of Wearing Clothes*. London, Constable and Co. Ltd, 1955

Laver, James. *Modesty in Dress: An Inquiry into the Fundamentals of Fashion*. London, Heinemann, 1969

Lewis, Peter. *The Fifties*. London, Heinemann, 1978

de Mairobert. *Memoirs of Madame du Barry*. London, The Folio Society, 1956

Mangen, J.J. *The King's Favour; Three eighteenth-century monarchs and the favourites who ruled them*. New York, St Martin's Press, 1991

McDowell, Colin. *The Literary Companion to Fashion*. London, Reed International, 1995

Margetson, Stella. *Leisure and Pleasure in the 19th Century*. London, Cassell and Company, 1969

Melman, Billie. *Women and the Popular Imagination in the Twenties: Flappers and Nymphs*. London, Macmillan, 1998

Mitford, Nancy. *Madame de Pompadour*. London, Hamish Hamilton, 1968

Neustatter, Angela. *Hyenas in Petticoats: A Look at Twenty Years of Feminism*. London, Penguin, 1989

Packard, Vance. *The Status Seekers*. London, Pelican, 1961

Page, Betty. *On Fair Vanity*. London, Convoy Publications, 1954

de Paris, Antoine. *Antoine by Antoine*. London, W.H. Allen, 1946

Parker, Dorothy. *The White Satin Dress* (1926) in *The Best of Dorothy Parker*. London, The Folio Society, 1995

Peiss, Kathy. *Hope in a Jar: The Making of America's Beauty Culture*. New York, Metropolitan, 1998

Pevitt, Christine. *Madame de Pompadour: Mistress of France*. London, HarperCollins, 2002

de Pougy, Liane. *My Blue Notebooks*. New York, HarperCollins,1977

Prioleau, Betsy. *Seductress: Women Who Ravished the World and their Lost Art of Love*. New York, Penguin, 2003

Reid Banks, Lynne. *The L-shaped Room*. London, Penguin, 1960

Reynolds, Nicole. *Boudoir Stories: A Novel History of a Room and Its Occupants*, in Literature Interpretation Theory Online. Taylor and Francis, 2004

Ribeiro, Aileen. *The Art of Dress: Fashion in England and France 1750-1820*. London and New Haven. Yale University Press, 1995

Roche, Daniel. *The Culture of Clothing: Dress and Fashion in the 'ancien regime'*. New York, Cambridge University Press, 1994

Rounding, Virginia. *Grandes Horizontales: The Lives and Legends of Four Nineteenth-Century Courtesans*. London, Bloomsbury, 2003

Rudofsky, Bernard. *The Unfashionable Human Body*. New York, Doubleday. 1971

Rudorff, Raymond. *Belle Epoque: Paris in the Nineties*. London, Hamish Hamilton, 1972

*Saunders, Grace. "What a girl wants, what a girl needs," in *Shoo*, Issue 9, Summer 2005

Shulman, Irving. *Harlow: An Intimate Biography*, London, Mayflower, 1964

Skinner, Cornelia Otis. *Elegant Wits and Grand Horizontals*. Cambridge, The Riverside Press, 1962

Sparke, Penny. *As Long as It's Pink: The Sexual Politics of Taste*. London, HarperCollins, 1995

Spoto, Donald. *Marilyn Monroe: The Biography*. London, Chatto and Windus, 1993

Stacey, Jackie. *Star Gazing: Hollywood Cinema and Spectatorship*. London, Routledge, 1994

Steele, Valerie. *Paris Fashion: A Cultural History*. New York, Oxford University Press, 1988

Steele, Valerie. *Fashion and Eroticism: Ideals of Feminine Beauty from the Victorian Era to the Jazz Age*, New York, Oxford University Press, 1985

Steele, Valerie. *Fetish*. New York, Oxford University Press, 1996

Stuart, Andrea. *Showgirls*. London, Jonathan Cape, 1996

Turner, Alwyn W. *Biba: The Biba Experience*. London, The Antique Collectors' Club, 2004

Tyler, Parker. *Sex Psyche Etcetera in the Film*. London, Pelican, 1971

Vail, Thomas. *Bizarre Harem*. Chicago, Merit, c.1950

Walker, Alexander. *Sex in the Movies*. London, Penguin, 1969

Walter, Natasha. *The New Feminism*. London, Little, Brown, 1998

Watt, Judith. *The Penguin Book of Twentieth-century Fashion Writing*. London, Penguin, 1999

Waugh, Evelyn. *Brideshead Revisited* (1945), London, Book Club Associates, 1977

Wharton, Edith and Codman, Ogden. *The Decoration of Houses*. London, B.T. Batsford, 1898

Willett, C. and Cunnington, P. *The History of Underclothes*. London, Faber and Faber, 1981

Willett, Julie A. *Permanent Waves: The Making of the American Beauty Shop*. New York, New York University Press, 2000

Wilson, Elizabeth, *Adorned in Dreams: Fashion and Modernity*. London, Virago, 1985

Wilson, Elizabeth and Taylor, Lou, *Through the Looking Glass*. London, BBC, 1989

de Wolf, Elsie. *The House in Good Taste*, New York, The Century Company, 1914

Wurtzel, Elizabeth. *Bitch*. London, Quartet, 1998

Wyse, Lois. *Blonde Beautiful Blonde: How to Look, Live, Work and Think Blonde*. New York, Mary Evans, 1980

Zolotow, Maurice. *Marilyn Monroe: An Uncensored Biography*. London, W.H. Allen, 1960

DIRECTORY

Where to buy

AGENT PROVOCATEUR
London
6 Broadwick Street
London W1F 8HL
+44 (0)20 7439 0229
Paris
Printemps Haussman
64 Boulevard Haussman
75009 Paris
+33 (0)1 42 82 57 87
New York
133 Mercer Street
New York 10012
+1 212 965 0229

BALENCIAGA
Paris
10 Avenue George V
75008 Paris
+33 (0)1 47 20 21 11
New York
542 West 22nd Street
New York 10011
+1 212 206 0872

BEDROOM BOUDOIR
London
Sheraton Park Tower
Knightsbridge
London SW11 7RN
+44 (0)20 7290 7101

COCO DE MER
London
23 Monmouth St
London WC2H 9DD
+44 (0)20 7836 8145

DUVET RESTAURANT
New York
45 West 21st Street
New York 10010
+1 212 989 2121

FREDERICKS OF HOLLYWOOD
Westfield Century City
10250 Santa Monica
Boulevard
California 90064
+1 602 760 2111

FROST FRENCH
London
Studio 121
Highgate Studios
53–79 Highgate Road
London NW5 1TC
+44 (0)20 7267 9991

GIVENCHY
London
Harrods
Knightsbridge
London SW1X 1XL
+44 (0)20 7730 1234
Paris
8 Avenue Georges V
75008 Paris
+33 (1) 44 31 51 09
New York
710 Madison Avenue
New York 10021
+1 212 688 4338

GUCCI
London
34 Old Bond Street
London W1S 4QL
+44 (0)20 7629 2716
Paris
2 Rue du Faubourg St
Honoré
75008 Paris
+33 (1) 44 94 14 60

DEBORAH MARQUIT
New York
158 West 15th Street
Chelsea
New York 10011
+1 212 478 3092

MAXIM'S
Paris
3 Rue Royale
75008 Paris
+33 (1) 42 65 27 94

MYLA
London
4 Burlington Gardens
off Old Bond Street
London W1
+44 (0)20 7491 8548
New York
20 East 69th Street
New York 10021
+1 212 327 2676

RIGBY & PELLER
London
22a Conduit Street
London W1S 2XT
+44 (0)20 7491 2200

JANET REGER
London
2 Beauchamp Place
London SW3 1NG
+44 (0)20 7584 9368

SUPPERCLUB
Amsterdam
Jonge Roelensteeg 21
1012 PL
Amsterdam
+31 (0)20 344 6400

VICTORIA'S SECRET
New York
34 East 57th Street
New York 10022
+1 212 758 5592

VIVIENNE WESTWOOD
London
44 Conduit Street
London W1S 2YL
+44 (0)20 7439 1109
New York
71 Green Street
New York 10012
+1 212 334 5200

VOLLERS
6–9 The Approach
Claybank Road
Copnor
Portsmouth
PO3 5LL
UK
+44 (0)23 9266 0150

Where to see

CHATEAU DE VERSAILLES
78000 Versailles
France
(20km/12 miles west of
Paris)
+33 (0)1 30 84 74 00

THE COSTUME INSTITUTE METROPOLITAN MUSEUM OF ART
1000 Fifth Avenue
New York 10028-0198
+1 212 535 7710

THE FASHION AND TEXTILE MUSEUM
83 Bermondsey Street
London SE1 3XF
+44 (0)20 7403 0222

MUSEE DES ARTS DE LA MODE ET DU TEXTILE
Palais du Louvre
107 Rue de Rivoli
75001 Paris
+33 (0)1 44 55 57 50

THE MUSEUM OF COSTUME
Assembly Rooms
Bennett Street
Bath
BA1 2QH
UK
+44 (0)12 2547 7173

THE MUSEUM OF THE FASHION INSTITUTE OF TECHNOLOGY
West 27th Street at
Seventh Avenue
New York 10029
+1 212 217 5800

VICTORIA AND ALBERT MUSEUM
Cromwell Road
South Kensington
London SW7 2RL
+44 (0)20 7942 2000

THE WALLACE COLLECTION
Hertford House
Manchester Square
London
W1U 3BN
+44 (0)20 7563 9500

Where to surf

www.annsummers.com
www.atsukokudo.com
www.cosabella.com
www.damaris-london.com
www.dita.net
www.dior.com
www.edithwharton.org
www.fredericks.com
www.foliesbergeres.com
www.gash.co.uk
www.guybourdin.org
www.janetreger.co.uk
www.madamedepompadour
.com
www.marie-antoinette.org
www.moulinrouge.fr
www.myla.com
www.prada.com
www.richardheeps.co.uk
www.shaunleane.com
www.strumpetandpink.com
www.tallulahs.com
www.victoriassecret.com
www.vogue.com
www.vollerscorset.co.uk

INDEX

ACKNOWLEDGMENTS

To my cool son, Lionel

Thanks to Sheila Ableman, Hannah Barnes-Murphy, Catherine Emslie and Giulia Hetherington at Mitchell Beazley, Jan Birks, Alwyn R. Coates, Hazel Curry, Edward Darley and all my friends at Vidal Sassoon, Catherine Ellis at Shaun Leane, Marnie Fogg, Julia Gash, Tony Glenville, Tim Hartley, Richard Heeps, Louisa Jarman and Harriet Mellor at Damaris, Jill Kenton, Atsuko Kudo, Deborah Marquit, Liza Z. Morgan at Strumpet and Pink, Maggie Norden, Sarah Rock, Robin Sacks at Cosabella, Francesca Santoro at La Perla, Khalid Siddiqui, Arabella Simpson at Myla, Ian Voller, Ben Westwood.

PICTURE CREDITS

6 Embassy Pictures/Album/akg-images; 9 Hulton Archive/Slim Aarons/Getty Images; 10 Universal Pictures/Ray Jones/Album/akg-images; 13 Paramount Pictures/Ronald Grant Archive; 14 Time Life Pictures/Getty Images; 16 Stapleton Collection/Corbis; 19 Private Collection/Bridgeman Art Library; 20 Rochdale Art Gallery/Bridgeman Art Library; 21 Private Collection; 22 Araldo de Luca/Corbis; 23 Victoria & Albert Museum, London/ Bridgeman Art Library; 24 Alte Pinakothek, Munich/Bridgeman Art Library; 25 akg-images; 26 Wallace Collection, London/ Bridgeman Art Library; 28 Musée du Louvre, Paris/Réunion des Musées Nationaux; 29 akg-images/Erich Lessing; 34 Wallace Collection, London/Bridgeman Art Library; 35 Private Collection; 37 Guildhall Art Gallery, City of London/Bridgeman Art Library; 38 Château de Versailles, France, Giraudon/Bridgeman Art Library; 39-41 Private Collection; 43 Stapleton Collection/ Corbis; 45 Collection Diry/Kharbine-Tapabor; 46-53 Private Collection; 54 Private Collection/© Christie's Images/Bridgeman Art Library; 56 Tony Glenville Collection; 57-60 Private Collection; 62 Tony Glenville Collection; 63 Private Collection; 64 Tony Glenville Collection; 67-69 Private Collection; 70 Private Collection, Archives Charmet/ Bridgeman Art Library; 71 Réunion des Musées Nationaux, Paris - ©Bulloz; 72 Tony Glenville Collection; 74 Private Collection; 75 Swim Ink 2, LLC/Corbis; 76 Fine Art Photographic Library/Corbis; 78 Sunset Boulevard/Corbis Sygma; 81-82 Private Collection; 83 Corbis; 84-85 Private Collection; 86 Underwood & Underwood/Corbis; 88 John Springer Collection/Corbis; 89 Private Collection; 90 Bibliothèque des Arts Décoratifs, Paris, France, Archives Charmet/ Bridgeman Art Library; 91 Private Collection; 92 Lake County Museum/Corbis; 93 K.J Historical/ Corbis; 95-97 Hulton Archive/Getty Images; 98-103 Bettmann/Corbis; 104 Boyer Raymond/Sunset Boulevard/ Corbis Sygma; 106 Private Collection; 107 Mary Evans Picture Library; 108 John Springer Collection/Corbis; 109 Private Collection; 110 Hulton Archive/Getty Images; 113 Horace Abrahams/Keystone/Getty Images; 114 Private Collection; 116 Hulton Archive/Getty Images; 117 Time Life/Getty Images; 118 Bettmann/Corbis; 119-121 Private Collection; 122-123 Hulton Archive/Getty Images; 125 CinemaPhoto/Corbis; 126 Private Collection; 127-128 Hulton Archive/Getty Images; 129-131 Private Collection; 132 Hulton Archive/Getty Images; 134 Universal International/Ronald Grant Archive; 135 Hulton Archive/Getty Images; 136-139 Private Collection; 140 Miramax/Album/ akg-images; 142 Metro-Goldwyn-Mayer/Moviestore Collection; 143 Popperfoto/Alamy; 144-145 James Wedge; 146 Lynn Goldsmith/Corbis; 147 Deborah Feingold/Getty Images; 148 Carolco/Kobal Collection; 149 Everett Collection/Rex Features; 150 Courtesy of Myla; 151 The Advertising Archive; 152 Martin Philby/ ZUMA/Corbis; 153 Armando Gallo/Retna; 16 Courtesy of Alwyn R Coates and Ian Voller; 157 Julio Donoso/Corbis Sygma; 158 Courtesy of Ben Westwood; 159 Courtesy of Richard Heeps; 160 Darren Star Productions/Kobal Collection/Demarchelier, Patrick; 162 Courtesy of Myla; 163 Courtesy of La Perla; 164 Courtesy of Damaris; 165 Courtesy of Strumpet and Pink; 166 Rex Features; 167 Beateworks/Fernando Bengoechea; 169 20th Century Fox/ Stephen Vaughan/ Album/akg-images